mapping web sites

Paul Kahn and Krzysztof Lenk

mapping web sites

RotoVision

A RotoVision Book

Published and distributed by RotoVision SA

Rue du Bugnon 7

CH-1299 Crans-Près-Céligny

Switzerland

RotoVision SA, Sales & Production Office

Sheridan House, 112/116A Western Road

Hove, East Sussex BN3 1DD, UK

Tel: +44 (0) 1273 72 72 68

Fax: +44 (0) 1273 72 72 69

E-mail: sales@rotovision.com

Web site: www.rotovision.com

Distributed to the trade in the United States by

Watson-Guptill Publications

770 Broadway, 8th Floor

New York, NY 10003-9595

10 9 8 7 6 5 4 3 2 1

ISBN 2-88046-464-1

Book design by Krzysztof Lenk at Dynamic Diagrams

Cover design by Navy Blue Design Consultants

Design co-ordination by Design Revolution

Production and separations in Singapore by ProVision Pte. Ltd.

Tel: +65 334 7720

Fax: +65 334 7721

RotoVision

Contents

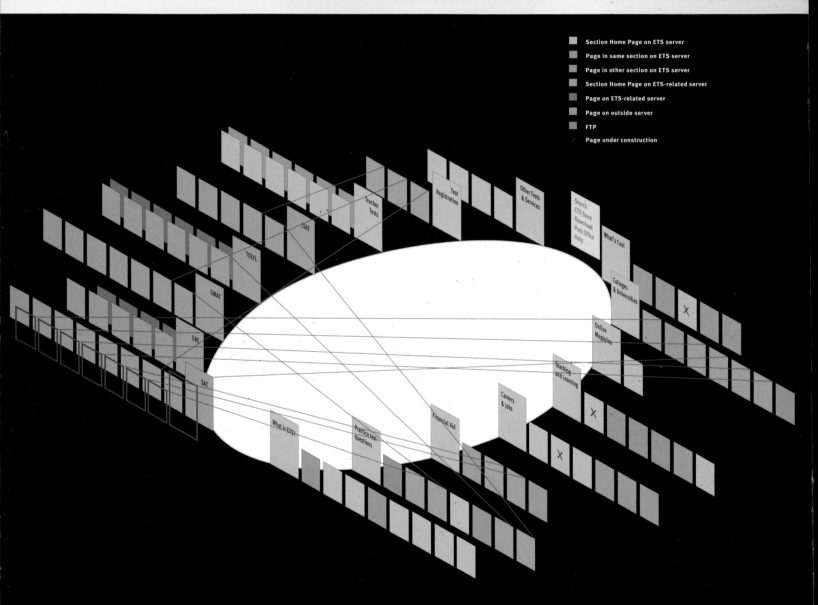

Section Home Page on ETS server
Page in same section on ETS server
Page in other section on ETS server
Section Home Page on ETS-related server
Page on ETS-related server
Page on outside server
FTP
Page under construction

THE EDUCATIONAL TESTING SERVICES (ETS) NETWORK ANALYSIS DIAGRAM AND HOME PAGES
This "wheel" diagram (above) shows all the pages linked to the ETS (www.ets.org) home page when the site was originally launched in 1996.

The first-level pages, represented as large rectangles, were a mixture of pages on what was then called the ETS.net web site and pages on other web sites run by ETS partners such as College Board. Color is used in the diagram to show the different kinds of

pages. The lines between pages represent links between pages in different sections of the site. The appearance of the web site evolved quickly, as shown by the three screen shots of the home page (right). Analyzing the link structure with diagrams such as this one,

capturing and refining to the user experience, identifying the audiences the web site serves, and applying visual design to express the web site's organization all contribute to the evolution process.

1

Introduction

The assumption that web sites should be visualized to facilitate their planning, analysis, and navigation is the basis for this book. Visualization is good information design practice, which in turn is good graphic design practice. Visualization supports and facilitates cooperative group authoring – coordination of the writers, designers, and programmers – needed to create the complex hybrid of publication and computer program that is a web site. Visualization provides context and orientation for readers and it helps the reader see a larger pattern in which to place the object before him.

1996

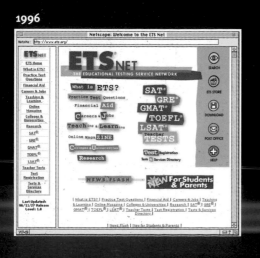

1997

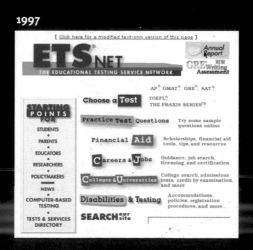

2000

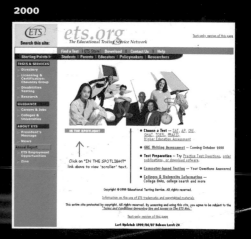

PROCESS OF PERCEPTION

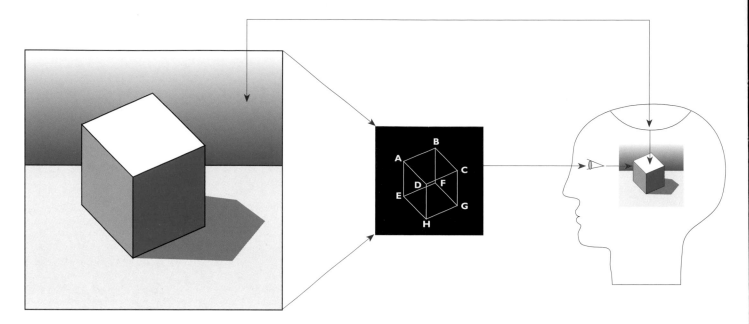

Finding our way around a web site is no different than finding our way around a building. We use our eyes, we make assumptions, we look for consistency, and learn from experience. If there is no visual difference between a door that leads to a bathroom, a basement stairway, or a clothes closet, then we have to test each one to find where to hang our coat. If there is a floor plan on the wall that contains symbols for each, we will find the bathroom without having to open every door. Building a web site is not unlike building a physical structure, such as a house. One can start by planning the bedroom, then furnishing the kitchen and insisting on the best speakers for the stereo. But how do you get from the bedroom to the bathroom? Where does the plumbing hook up to the sewer? And is the foundation strong enough to support the walls when you need a second floor?

The map of a web site is the equivalent of a floor plan for a house. Here the architecture analogy will help illustrate why there are many different kinds of maps or visualizations needed. There is no such thing as *a map*, there are only maps for specific purposes. "The map is not the territory," as Alfred Korzybski pointed out (*Science and Sanity*, 1933). In other words, the representation is not the thing being represented. So what is being represented? Gregory Bateson asks this question and points out that what we see is difference. "What gets onto the map, in fact, is difference, be it a difference in altitude, a difference in vegetation, a difference in population structure, a difference in surface, or whatever. Differences are the things that get onto the map." ("Form, Substance, and Difference" in *Steps to an Ecology of Mind*, 1972.)

The level of detail required, or difference to use Bateson's term, depends entirely on the intended use. The floor plan of the Charlotte, North Carolina airport in the back of the US Air magazine contains enough detail for the passenger to visualize how to move from one gate to another to catch a connecting flight. The floor plan of the same building required by a mechanical engineer to check the structural soundness of the roof will represent the same space with a different kind of visual detail. The blueprints required by the contractor modifying an arrival gate will be different again.

Another way of visualizing the same process is in the form of a wheel. The wheel (below) represents the series of steps required to plan, create, test, launch, and then revise a web site. By visualizing the process as a wheel we emphasize the cyclic nature of the enterprise. Each step leads to the next task, which finally leads back to the point of revision.

PROCESS OF CREATION/PRODUCTION

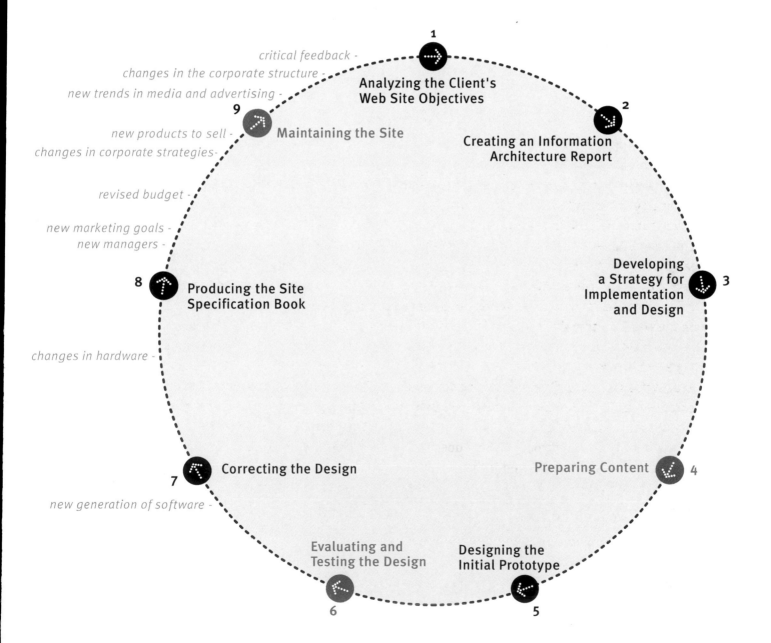

1 Analyzing the Client's Web Site Objectives

critical feedback -
changes in the corporate structure -
new trends in media and advertising -

9 Maintaining the Site

2 Creating an Information Architecture Report

new products to sell -
changes in corporate strategies -

revised budget -

new marketing goals -
new managers -

8 Producing the Site Specification Book

3 Developing a Strategy for Implementation and Design

changes in hardware -

7 Correcting the Design

4 Preparing Content

new generation of software -

6 Evaluating and Testing the Design

5 Designing the Initial Prototype

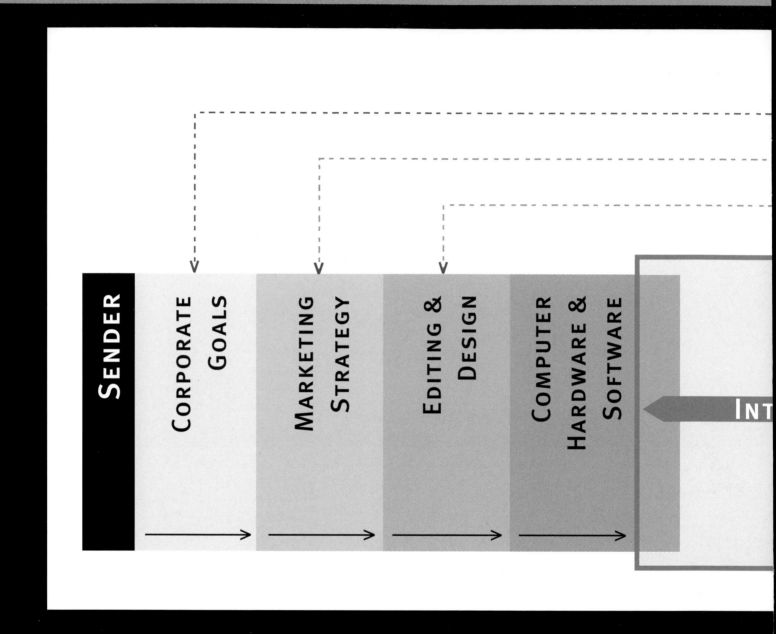

The Communication Model diagram we developed in 1996 is a visualization of the factors required to create a web site. It is a combination of a layered signal transmitted from a Sender to a Receiver and a series of feedback cycles.

The Sender, the creator of the web site, moves a message through a series of layers: corporate strategy which must be interpreted into a marketing strategy, which in turn is shaped by editorial and design techniques, and shaped further by the hardware and software technology of the medium. This signal is then passed along the communications channel of the Internet. On the receiving end, the signal must be able to pass through the hardware and software technology employed by the Receiver, must be understood by the

Receiver's cognitive and perceptual abilities, must appeal to the Receiver's cultural and social attitudes and preconceptions, and finally must successfully match the Receiver's expectation.

In addition to illustrating this pipeline of signal transmission, this diagram shows the relationships that should exist between the layers. The Sender's marketing strategy must match the Receiver's expectations. There must be a feedback loop in this outer layer to keep the system in balance. Similarly there is a content loop between the Sender's marketing strategy and the Receiver's cultural and social influences. The form of the message must balance between the Sender's editorial and design style and the Receiver's cognition and perception.

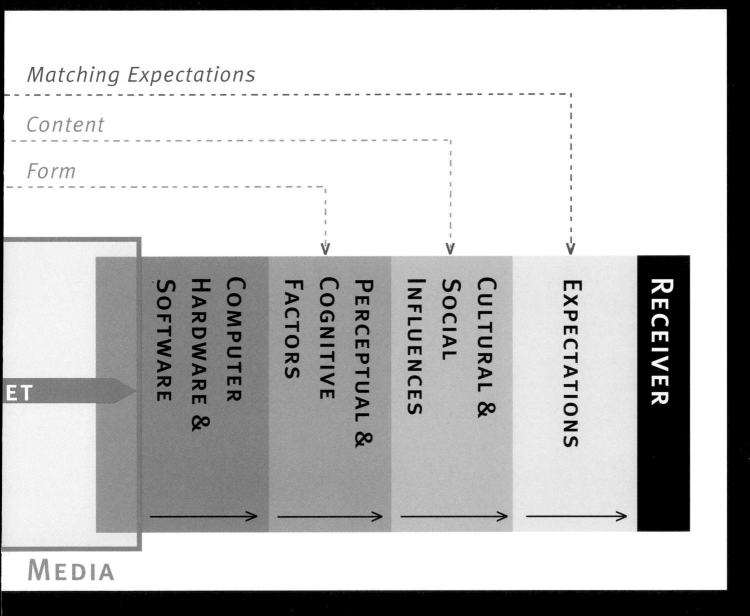

This book will explore several questions. Why do we want to map a web site? How can these abstract collections of data be mapped? For what purpose are these maps created? Who benefits from the result of the work? We will do our best to type and describe what we have found. In conclusion we will try to share what we have learned from the experience of mapping web sites.

While the World Wide Web first came into existence in the early 1990s, the advent of commercial web sites, and the rapid explosion of web site creation and use began in earnest around 1995. A few of the map examples date from this early period. Our focus and research in this area has led us to collect hundreds of examples. We will draw on many examples of our own practice, contributions from several leading design studios in the field and numerous examples found on the web over the past few years.

We are both design educators and practitioners. We have the pleasure – and challenge – of working with the talented design students at Rhode Island School of Design, presenting lectures and workshops at academic and commercial conferences, and providing workshops for clients. Our design studio, begun in 1990, is also part of a larger design education, as we develop and share ideas with our colleagues.

The following text is taken from an essay by Krzysztof Lenk on the subject of the impact of computers on design education. The remarks seem equally appropriate for the topic of this book.

On Computers and Design Education

I think that the appearance of computers on designers' desks since the mid-eighties has revolutionized the process of design and design education in three ways:

1. Words, photographs and illustrative images have been set free from their physical attachment to surfaces such as paper and film. As a sequence of zeros and ones in a computer program, they are easy to manipulate and free from the tangible resistance of a surface material and the high labor cost of such manipulation. Typography no longer needs typesetters and digital photography does not require darkrooms and laboratory assistants. Access to the media of publication has been democratized.

The problem is that standards of good typography and print design are not rooted in the technology of production, but in the complex processes of human perception. Good design is based on an active understanding and application of cognitive factors by a designer which create in the reader's mind the sense and pleasure of easily grasping meaning, appreciating the dynamic order of a page, and an overall sense of harmony. The touch of a book, the sense of its weight, the sound of browsing its pages, the smell of paper and ink – these factors add a cultural and semiotic context to the reading of a text. These are aspects which give our mind a sense of the overall structure of a publication before we even begin to read its pages.

2. The traditional language of visual communication has no notion of verbs. All time-related processes like instructions and manuals are presented sequentially, with the additional support of symbolic arrows and hands. The use of these symbols and other methods of visualizing time in art is based on agreement between an artist and a viewer about the convention in use. Visual narration used to have its place in the moving images of film and TV, but its production depended on expensive technology and labor. For the first time in history we have in our computer labs software like Hypercard, Director, and Flash, which allows us to design a real-time narration of text and images, and – what is more important – to link parts of a narration to create a net of hypertext connections. Time and Interactivity are with us.

The problem is that narrative media are content-related. Our students have difficulty finding, writing, and editing their story without the active participation of a liberal arts faculty. Investigated problems and student papers from language, art history, and social studies could be used for interactive delivery in a studio class, and the liberal arts and studio faculty should work together on content and form of student projects. The appearance of computers in our daily life, digitalization of mass communication, and the explosion of the Internet are creating revolutionary changes in our society. These changes are going on NOW, and they have to be named, studied and defined by specialists who will make it their academic careers, and who will prepare graduates to succeed in a new social and cultural environment. The best effort of practitioners from the design field to substitute for a lack of critical theory in the Liberal Arts programs is not enough. Traditional division of design education between studio-oriented departments, and Liberal Arts having its own program, without any significant link to design methodology, language, and practice in society, no longer makes sense.

3. To the set of traditional channels of communication like print, radio, movies, and TV, we recently added the Internet, together with its consequences for cultural, educational and social life of the society. These consequences are impossible to predict.

The problem is that in the new concept the surface of a computer monitor acts as a permanent meeting place between a Sender and an active receiver of incoming messages. A participating Receiver should have certain skills in retrieving information, and should develop a new kind of spatial imagination and memory, to navigate successfully through a virtual space. The most significant innovations of the Internet are not related to the computer technology, but to the new organization and architecture of hypertext information. Today to be a good designer, a student needs not only an excellent visual training, but foremost a much better education in structural aspects of human knowledge, language, and

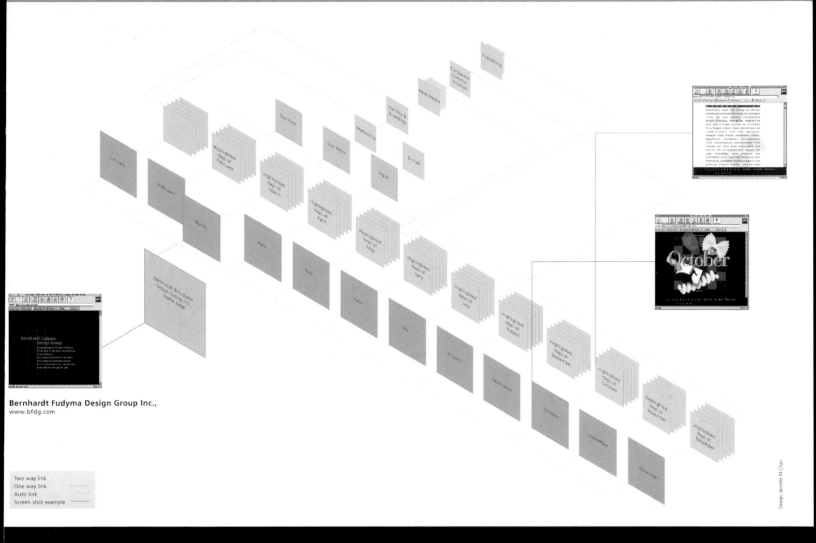

Bernhardt Fudyma Design Group Inc.,
www.bfdg.com

Two way link
One way link
Auto link
Screen shot example

Design: Jennifer M Chan

communication. *This is the field for our partners in the Liberal Arts program.*
We are teaching students to design for the Internet when these concepts themselves are in constant change, further confused by a stream of new technology. How to weave all these aspects into a coherent curriculum? We should discuss it.

I am happy to live in an era of revolution in communication, probably the most significant since Gutenberg. What makes me worry?

– That progress in media is going against the human experience of using all of our senses – smell, sight, touch, hearing – to communicate with other human beings and the outside world. I don't like the over-visualization of communication, which offers us a stream of easy-to-digest images of a world, at the expense of reading experience, which stimulates imagination (Hans Christian Andersen vs. Disney).

STUDENT WORK FROM RHODE ISLAND SCHOOL OF DESIGN
This map is a description of the Bernhardt Fudyma Design Group web site, created by Jennifer M. Chan in the spring of 1998 as part of an assignment for Krzysztof Lenk's information design class. The map explains the structure of the site from the user's point of view. Chan shows page types, link types, and page level using color and size coding. Example screen shots are added as points of reference.

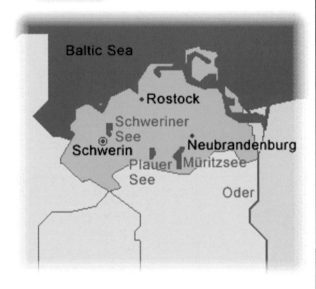

Mecklenburg-W. Pomerania

population	1.89 million
area	23,598 sq km
capital	Schwerin

FACTS ABOUT GERMANY MAP
This screen from the Facts About Germany CD ROM (Siemens Nixdorf, 1995) (left) shows the sixteen Federal states with Mecklenburg West Pomerania selected. The state boundaries are shown in simplified form on the country map, then in a more realistic form in the detail of the selected state.

2

What is a Map?

Maps are a special form of visual communication, a representation of the three-dimensional world in a coded two-dimensional form. They are found in one form or another in every culture. They have served many purposes. The map is a form of code, a geometry to feed the visual imagination.

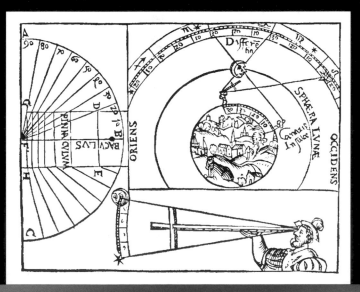

A Narrative Diagram
The process of calculating latitude is shown in this multi-window diagram from Cosmographia (1539) by Peter Apian (left). The three panels show the steps in the process. At the bottom is the surveyor using the cross-staff to sight celestial bodies in relation to the observer's location on the earth. Above we see the observation being made at two locations. The results are recorded on the graph on the left side.

A map is what we think of the world. In the European tradition, visualizations of the world begin with illustrations of classical Greek and Biblical geography. The so-called TO maps (*orbis terrarum* or "circle of the earth") represented the world as a circle divided into three parts: Asia, Europe, and Africa. Claudius Ptolemy, the Alexandrian astronomer, wrote his *Geographia* in the second century A.D. and established a method for locating parts of the Mediterranean world that was to inform illustrated maps for hundreds of years. These projections mix information from the text with forms of visual experience to create an image of the world as we want to know it. In contemporary software tools, the same technique is sometimes used in reverse, as in the example of the Cartia Themescape program. Our familiarity with topographical maps can be used to help us locate points in the abstract vector space created by information retrieval programs.

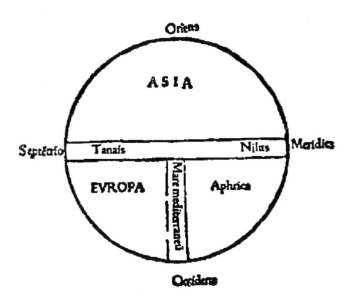

PTOLEMY MAP:
This detail from a German edition of Ptolemy's *Geographia* published in Ulm, now in the British Museum collection, dates from 1482, twelve hundred years after the book was written (right). While the shapes and geographic details of the map are far from realistic, the basic relationships are entirely sound. The general shape of Europe in relation to the Atlantic and the Mediterranean coast is visible. England (Albion) and Ireland (Ibenna) are seen at the northwest edge of the Continent. The heavy yellow rope-like areas represent the mountain ranges that by common experience divide the regions.

TO MAP:
This classic TO map is taken from Zachias, *Orbis Breviarium*, published in Florence 1493 (above). The world is divided into three parts according to the Biblical division of the world among the sons of Noah: Asia, Europe, and Africa. The divisions are marked by three bodies of water: the Don, the Nile, and the Mediterranean Sea. Ocean surrounds the lands.

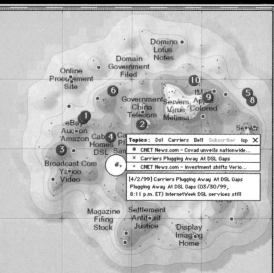

CARTIA THEMESCAPE MAP:
The Cartia Themescape data
visualization (below) looks like
a topographical map of an
island with mountains and
valleys. The program translates
clustering of similar documents
into a visual landscape. The
map is used as a metaphor,
translating our experience in
recognizing and locating
features in space into locating
documents in a search result.
For more examples of this
product see pp. 116–117.

GLOBAL PROJECTIONS OF THE EUROPEAN RENAISSANCE

The problem of rendering the surface of a sphere on a single flat sheet of paper is a complex one. This sequence of global projections by Norman J.W. Thrower (right) summarizes the ways in which the global world map evolved during the sixteenth century. The now-familiar Mercator projection, with its distortion at the poles, is a visual convention we have learned to read as a valid picture of the world.

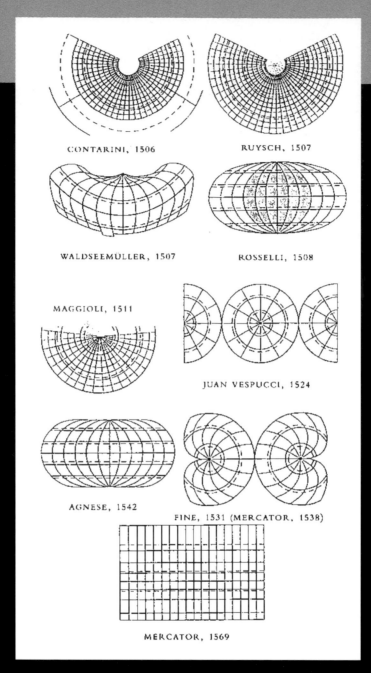

CONTARINI, 1506

RUYSCH, 1507

WALDSEEMÜLLER, 1507

ROSSELLI, 1508

MAGGIOLI, 1511

JUAN VESPUCCI, 1524

AGNESE, 1542

FINE, 1531 (MERCATOR, 1538)

MERCATOR, 1569

TOKYO SUBWAY MAP

The Tokyo Access guide (right) by Richard Saul Wurman, represents the city's railway in an abstract, but entirely functional way. The route looks quite abstract when compared with a map of its real path. But, it clarifies the fact that the route is essentially a circle around the city, making it easier to understand and remember. The actual route is pear-shaped, with a bump at the bottom twisting to the right. The twists and turns of the train route are unimportant to the person riding the train. The path has been abstracted into a circle, which is easier to grasp and remember. What does matter is the essential path and the sequence of stops, with reference to a familiar place – the Imperial Palace.

"The map is a help provided to the imagination through the eyes" stated Henri Abraham Chatelain at the beginning of the eighteenth century. Since that time we have developed many visual conventions to transfer our experience of the real world into codes that conveniently fit onto paper. During the sixteenth century the European understanding of world geography expanded rapidly. Navigation charts grew from detailed experience of mariners tracing the edges of the coast. Compass headings between known points allowed map makers to extrapolate shape and relative location with new sophistication. Dozens of different methods to represent the world were created by map makers. Each one represented a different strategy for distorting reality to fit it onto a printed page. The Mercator projection of the world is an example of a conventional distortion we have all come to recognize as "real". In fact the world does not look like a wall map but we all know that and it is hard to fit a globe into a book. Such conventions are an agreement between the designer and the viewer. To help us grasp the abstract topology of a web site, we must look for conventions that can be applied to this new task.

SATIRIC MAP OF EUROPE

This map of European national politics in 1870 (right) combines caricatures of national types and behavior with an appeal to our experience of a physical map of Europe. We can see the British Isles, Spain, the Danish Peninsula, and the shape of Italy, even though the cartoons are hardly geographically precise. The metaphor appeals to our memory of what Europe should look like.

The green J&R Yamanote line is a raised high-speed line which surrounds the city. Bisecting the circle is the red Marunouchi line which forms the yin-yang imagery. The park-like Imperial Palace is at the center of the map. Since no one can walk through the grounds, it maintains itself as a green center point referencing all the maps in the guide.

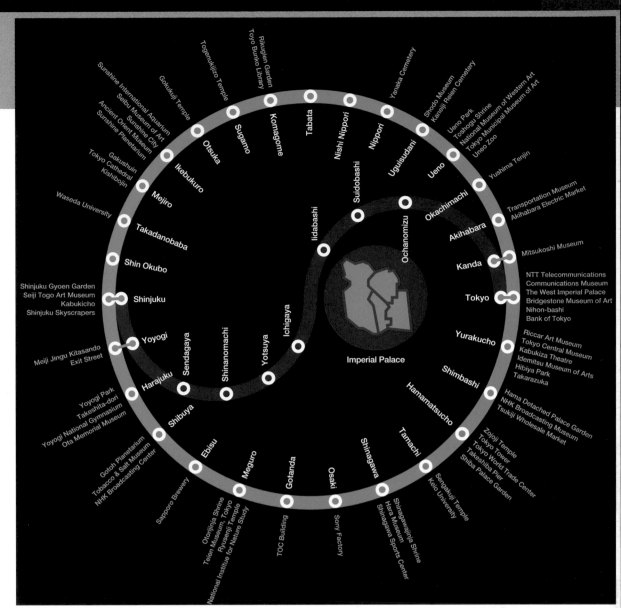

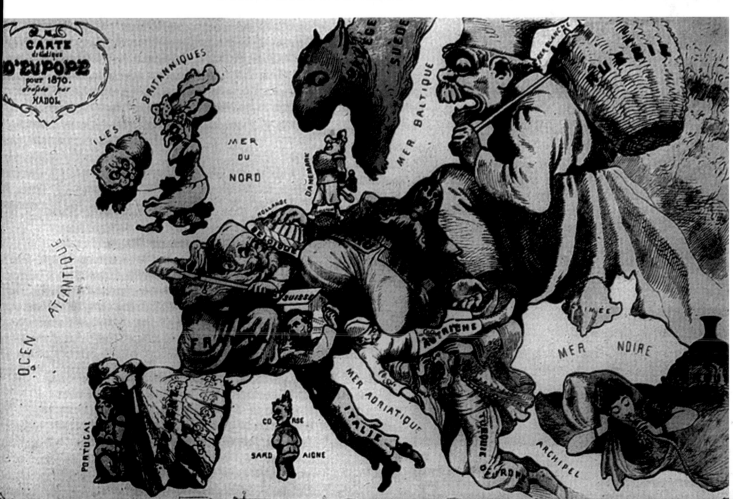

Two other classical examples of maps as "information graphics" inform the way we approach mapping web sites: Turgot's plan of Paris and Beck's London Underground map. The Turgot plan (named not after the designer, Louis Bretez, but after Michel Turgot, the administrator who commissioned it) is a marvel of eighteenth-century design. It reproduces in amazing detail the streets, buildings, and land usage of the city of Paris in the 1730s. Commenting on this often-reproduced work, Southworth notes: "Buildings are shown in axonometric projections, with correct detail and orientation. Streets, however, are widened so that they don't disappear between buildings." (Michael and Susan Southworth, *Maps, A Visual Survey and Design Guide*, 1982) The richness of detail still dazzles the eye, but the lesson we need to learn is the utility of a projection applied by the designer using a raised point of view and parallel lines. This information graphic is rendered in what computer graphics now refers to as two-and-a-half-D rather than 3D. Architectural height is shown without a vanishing point, creating the minimum of distortion. In exchange for photographic realism the mind receives a much more complete picture. Many other town-view maps exist, providing an overview of a metropolis and showing the major architecture and geographic features (a hill, a river). This is a useful model for an overview diagram of a web site, appealing to the visual sense of depth and scope. The MAPA program uses a similar parallel projection to create a navigation map showing three levels of structure for a web site (see pp. 110–111).

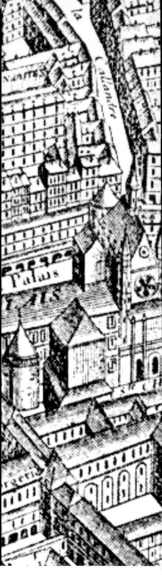

TURGOT MAP
Detail showing part of the Ile de la Cité looking east from Pont Neuf from Michel Turgot's plan of Paris, 1734 (right). See *Le Plan de Paris de Louis Bretez dit Plan de Turgot, présenté et commenté par Bernard Rouleau*, Nördlingen: Verlag Dr. Alfons Uhl.

HARRISON'S ONLINE PLANNING DIAGRAM
This planning diagram for Harrison's Online (below), a web site for a medical encyclopedia, uses an isometric projection similar to that of the Turgot map. Here the carpet holds all the chapters, sections, and subsections of the original encyclopedia text. The angle of presentation allows the viewer to grasp relative depth and position from the home page in the front (lower left).

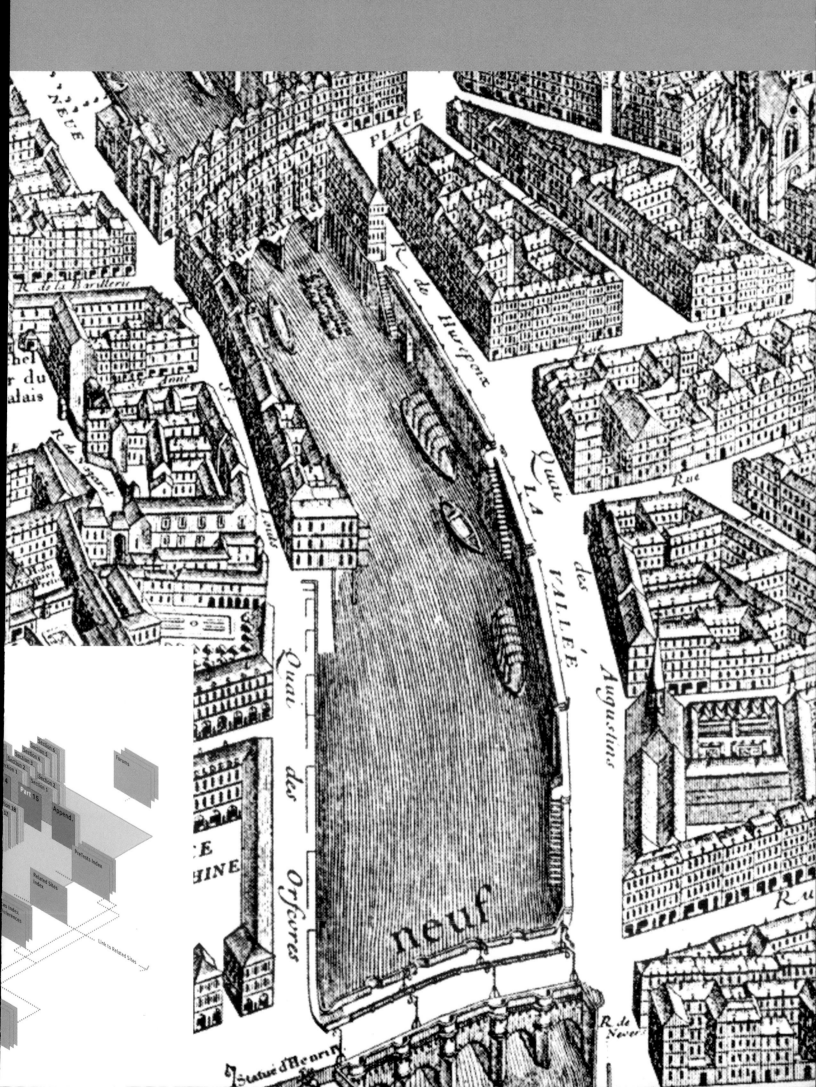

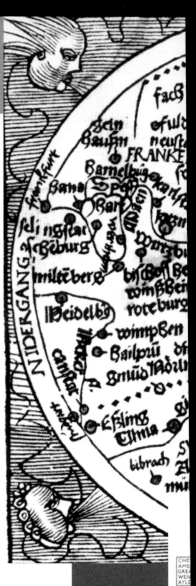

This sixteenth-century German map of trade routes to and from Nuremberg is a useful model. Within the convention of the TO map, the world is shown as a circle with Nuremberg near the center. Essentially it is a node-link diagram, where every town is a node linked by a series of dots representing distance in miles. Since this map radiates from a central town, there is a single road or link that connects each point. This serves the purpose of the trader, who needs to know how to move from town to town and approximately how long each trip will take. The distance between towns that are not linked is unimportant.

The map of the Kunst- und Ausstellungshalle der Bundesrepublik Deutschland web site, created about five-hundred years later, follows a similar strategy. The Merzscope program treats the pages like German towns, drawing navigation lines between selected pages. The distance between the clusters of pages is unimportant. The lines connecting the circles, and the name for each cluster are the visual information that tell the viewer how the web site is organized, and how it can be traveled by following links. Many planning maps and diagrams we will present in later chapters also use this technique.

Finally, Harry Beck's map of the London Underground dates from the 1930s. This is the classic transportation diagram and was quite revolutionary in its time. Beck's stylized alignment of the train lines (and the river banks!) to a grid creates a visual harmony. The River Thames does not run at 45° angles and neither did the District Line in 1932, but Beck's use of a uniform grid reduced the visual noise in an already complex diagram. The bold colors make it easy for the eye to separate the lines. Beck elongates the distances between stations in the central part of the city and reduces the distance in stations away from the center. The distortion of distances between the stations makes the map easy to read. After all, the distance between two stations is far less important than knowing their names and knowing in what sequence they will appear. We will see this technique applied repeatedly in site maps, with color used to separate sets of lines connecting pages and distances between the labels adjusted to the convenience of the diagram.

NUREMBERG MAP	MERZSCOPE MAP	BECK MAP
Route map showing roads from Nuremberg (facing, top left) with each dot equal to one German mile, based on a larger map by Erhard Etzlaub, early sixteenth century.	This Java-based map of the Kunst- und Ausstellungshalle der Bundesrepublik Deutschland web site (facing, top right) shows the home page linked to clusters of pages representing the sections of the web site. This map for web site visitors was created with the Merzscope program, available until it was discontinued in 1999 from Merzcom, a Canadian developer of web map products, whose name referred to the Dada artist Kurt Schwitters.	Detail of the London Underground map poster (right) designed by Harry Beck as it first appeared in 1933. Note the stylized angles (90° and 45°) and the regular spacing between station stops. From *Mr. Beck's Underground Map, a History*, by Ken Garland, Capital Transport, 1994.

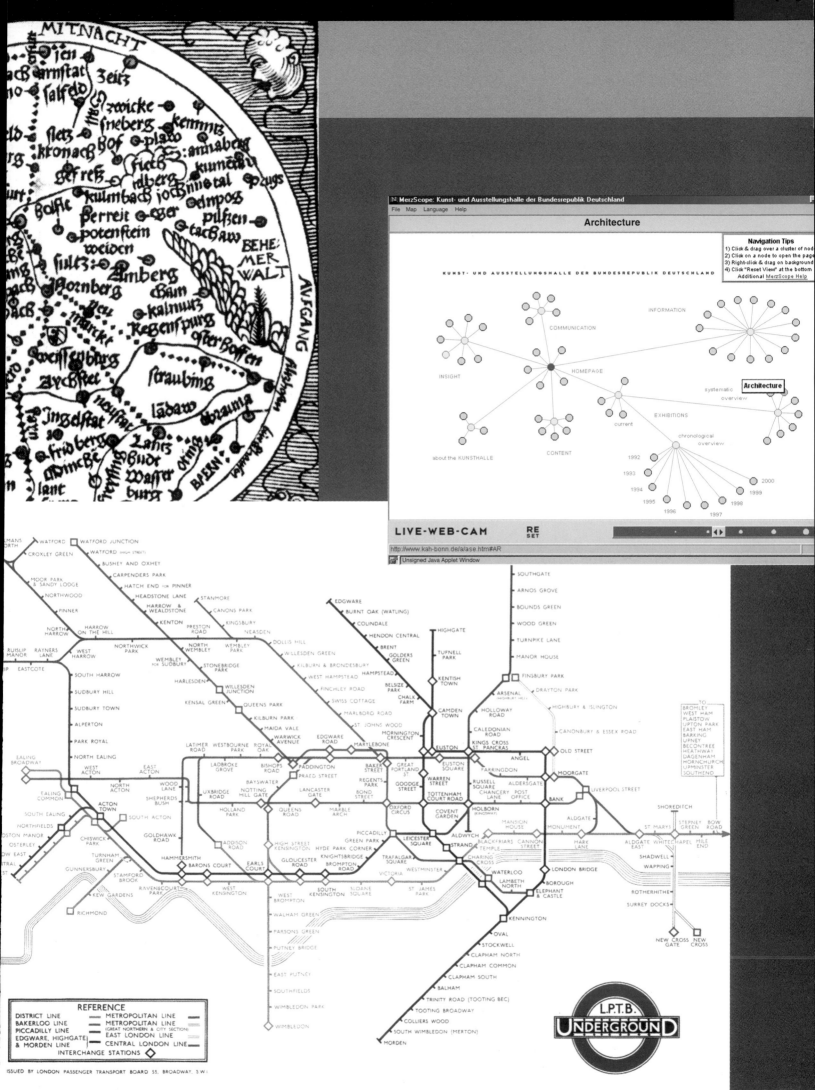

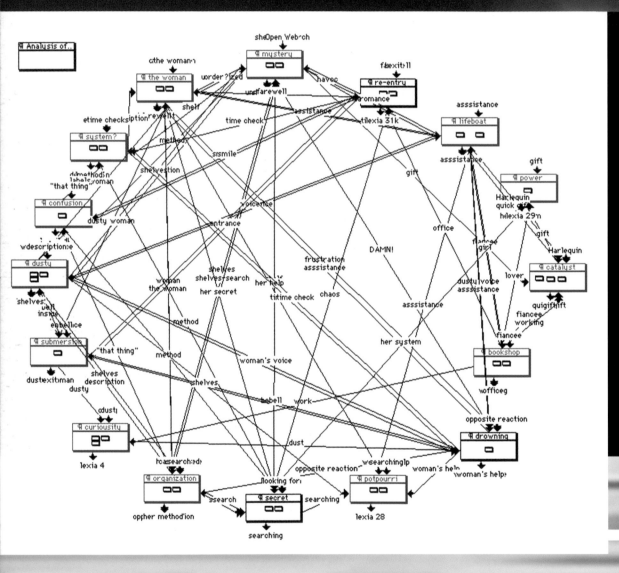

STORYSPACE MAP
This map of the hypertext fiction "Adam's Bookstore" by Adam Wenger (left), was created with Storyspace, a commercially available hypertext system published by Eastgate Systems. The example is taken from a collection of student webs from Brown University, *Writing at the Edge* (1995), edited by George Landow. For more information about Storyspace and hypertext fiction, refer to the Eastgate web site (www.eastgate.com).

Mapping Hypertext

Web sites are made out of hypertext, a word that is much used today but poorly understood. The term was coined by Ted Nelson in 1965 to describe a kind of text on computers that was far beyond the technology of the day. Nelson, whose other neologisms include intertwingled and transpublishing, defined hypertext as "non-sequential or complex text structures" and "text that cannot be conveniently printed."

 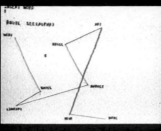

 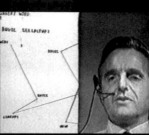 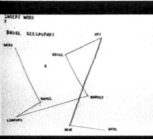

 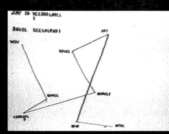

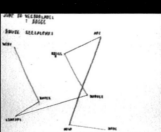

Nelson wrote about his concepts in scientific papers and underground classics, such as *Computer Lib* and *Literary Machines*.

Whatever he meant, it had something to do with the work done by Douglas Engelbart. In the late 1960s, Engelbart led a group that developed the first interactive computer system. That system, known as NLS and later as Augment, contained the seeds of much of personal computing today: a pointing device, a shared network, electronic mail, outlines, combinations of text and graphics, video conferencing, and linked documents. NLS was not strong on visualization, though Engelbart's famous demonstration of the system to an awestruck auditorium in San Francisco captures an early hypertext network visualization, with lines connecting words in a shopping list.

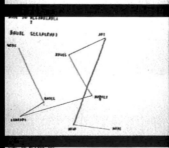

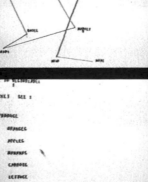

NLS VIDEO 1968
These images (above, left and right) are taken from a record of a live demonstration of NLS. At the National Computer Conference in the fall of 1968 Douglas Engelbart, then director of a group at the Stanford Research Institute (SRI), gave what is now remembered as the most ambitious and influential demo in twentieth-century computing. From an auditorium stage in San Francisco, connected by microwave link to a computer at SRI, with his image projected on a large video screen behind him, Engelbart demonstrated a collaborative work system that mixed live video, hypertext, outline processing, interactive text, and graphics.

A BROWSER CARD
This image (below) shows a browser card in two windows. The smaller window on the left shows the entire tree structure of the hypertext. The larger window in the center shows a part of the graph enlarged so that the user can read the text labels. From "Hypertext Habitats: Experience of Writers in NoteCards" by Randall H. Trigg and Peggy M. Irish, Hypertext '87.

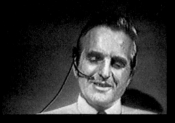

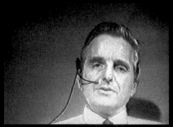

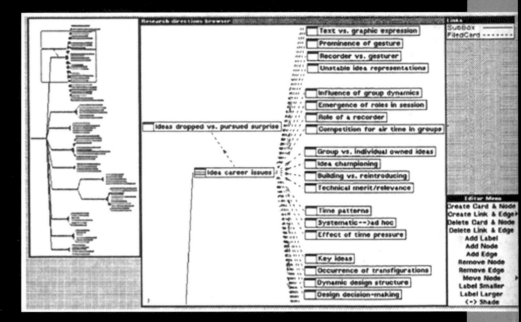

The development of more robust hypertext systems began in earnest in the mid-eighties, as computer software and workstations became more powerful. Xerox Palo Alto Research Center (PARC) was the home of many innovations in computer software at that time. One of the most ambitious hypertext systems, called NoteCards, was developed there by a team that included Frank Halasz, Tom Moran, and Randy Trigg. NoteCards was a writing system that allowed the user to create a set of documents (cards) and link them by embedding references from one document into another document. Clicking on the reference would open the second document.

One of the features of NoteCards was the ability to create a browser that showed how all the cards were linked. The graphic it created is a binary tree starting from a "root" card. Such a graph could get very wide very fast, as the program spreads out the tree of nodes from the root. To provide support for the visualization, NoteCards supported an overview of the entire graph, in which the details were too small to read, linked to an expanded view of a portion of the

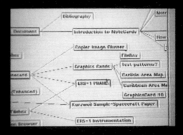

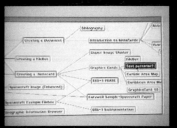

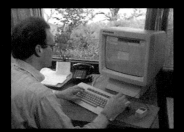

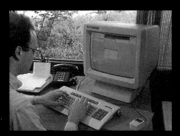
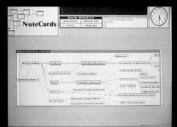

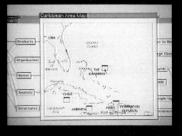

research papers, and through those papers it had an enormous direct and indirect influence on later research and commercial systems, such as HyperCard, developed at Apple Computer.

The relationship between the visualization of the hypertext network and the writing process was always difficult to assess. One story of a writer who printed an enormous hypertext graph before writing a paper was often repeated, but never formally described in the literature. Randy Trigg, one of the scientists involved, recalls the event this way:

"One of the writers who regularly used NoteCards was a linguist at Xerox PARC. During the interviews leading up to the paper I co-authored with Peggy Irish for the Hypertext '87 conference, 'Hypertext Habitats: Experiences of Writers in NoteCards,' this user told us a story of how he wrote a paper using the program. He said he started by writing many small notes, each in a titled notecard, organized in a linked network. After a few weeks of working with these notes, he built a

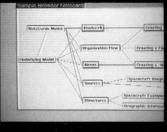
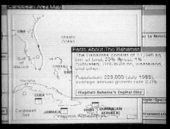

graph. We will see similar techniques used in programs that generate a visualization of web sites from link data. NoteCards was an experimental system and was not widely used outside of a few research laboratories. Its use was cataloged in many

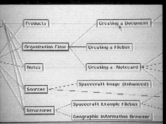
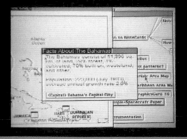

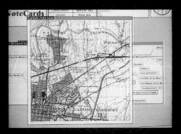

graph view of the network using the NoteCards browser card type. The browser represented each note with its title, and showed the interconnections comprising the network. He then printed the browser which covered several pages, and put the printout up on his office wall.

After staring at the network for a few days, he tore down the browser, opened a word processor window and wrote the entire paper. During the writing process, he no longer referred either to the browser or to his original notes.

In our interviews, we were especially interested in the diversity of writing styles that our users employed, both in order to see how NoteCards was being used in ways that we, its designers, never anticipated, and to learn more generally how hypertext provided added value for the writing process. In this case, we had a user who preferred writing papers from start to finish in basically one pass. One might not expect such a writer to be a fan of hypertext, but he assured

us that he found the hypertext capabilities to be quite valuable early on in the writing process. Other writers remained embedded in their NoteCards networks longer in the writing process, but those are other stories..."
(Randy Trigg, personal communication with Paul Kahn)

NOTECARDS VIDEO 1987
These images (left and facing) are taken from a video demonstration of NoteCards, produced by Xerox PARC. Frank Halasz, one of the program's developers, is shown first arranging material on a set of index cards, then transfering the ideas to electronic notecards in the system. Cards could represent a mixture of text and graphics (maps in this case). The node structure could be automatically generated and interactively manipulated.

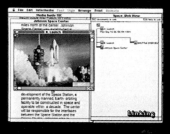

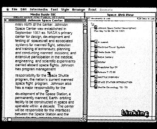

INTERMEDIA VIDEO
Images from a video
demonstration of IRIS
Intermedia by Paul Kahn
(shown), scripted by
Nicole Yankelovich.

Another ambitious research system from this period was Intermedia, developed at Brown University's Institute for Research in Information and Scholarship (IRIS). The Intermedia system focused on several aspects of hypertext visualization. Links could be created between selections in any document. These selections were called "anchors" and their visualization was a linked marker, inserted into the document. The anchors and links between them were collected into "webs". The webs also had several visualizations. The first version of the system experimented with a global map that tried to show how every document was connected to every other document. This idea proved impractical and was replaced by the less-ambitious nearest-neighbor map. In the first version of the program, the current document was shown in the center and each linked document arranged in a star pattern around it, connected by a line. The last version of the system modified this into a more flexible link list, capable of expanding into multiple columns. A method of previewing link destination was introduced, so that selecting a link marker in a document would darken the corresponding line in the web map. Meanwhile, the hypertext authors working with Intermedia began to develop hand-drawn overview diagrams to help guide readers through the collections. These diagrams tended to express the hierarchy of the information being linked. The contrast between the two techniques prefigures the larger question of whether a web site can or should be viewed as a hierarchy or a network of linked documents. The answer, then as now, depends entirely on the requirements of the visualization.

Nineteenth Century Public Health

Discussion of Overviews

- Biology and Medicine
- Women and Children
- Working Class
- Political & Social Background
- Sanitation and its Absence
- Addiction
 - Alcoholism
 - Opium
- Nutrition
 - Adulteration of Food
- Diseases

Typhus | Cholera | Typhoid | Ricketts | Tuberculosis

[GPL, RP]

Tuberculosis

Tuberculosis in Victorian England

[from M.W. Flynn, in Edwin Chadwick, page 11]

"As killers, however, both cholera and typhus were dwarfed by tuberculosis; and tuberculosis scarcely stirred the imagination of any social group in this period. It was so much a part of life, so inevitable, so little understood, that it was accepted mutely.... In the early nineteenth century it may have accounted for one-third of all deaths."

[GPL]

Disease

Disease in Rich and Poor

[from Anthony S. Wohl, pages 1-2]

"Despite its wealth and social prominence the family found that it was unable to isolate itself from the stinks, pollution, and health hazards of the day. As newly-weds they had wanted the latest sanitary appliances, but the inexperience of the workmen putting in the water closet resulted in the waste overflowing into the rainpipe and down the dressing-room window. The cesspools beneath their Thames-side residence were notoriously foul, even by the standards of the day and when, at last, they had a new drainage system installed, the stench from the old cesspools remained and made parts of the dwelling almost uninhabitable. Some twenty years later the sewers blocked up after heavy rains and became 'most offensive and putrid.' Although living by the Thames was certainly most scenic, whenever the river rose their lawns were saturated with the raw sewage, which habitually floated on the surface of the water. Resigned to this inevitability, they simply had the lawns raked and the filth shovelled back into the river. In dry weather, on the other hand, the Thames' muck was left high and dry along the banks and gave off an appalling odour.

"Probably as a consequence of the poor drainage system, the father contracted one of the most lethal and

Victorian Deathbed

Deathbed scenes were almost a cliche of Victorian art, high and low. What does this fact suggest about the realities of Victorian life and health? How would you interpret the open window?

Dickens: Web View

246 documents in web 682 links

- 19C HEALTH OVERVIEW — Mon Feb 4 10:09:39 1991
- Tuberculosis — Mon Feb 4 10:09:46 1991
- Victorian Deathbed — Mon Feb 4 10:09:49 1991
- 19C HEALTH OVERVIEW — Mon Feb 4 10:09:59 1991
- Victorian Deathbed — Mon Feb 4 10:10:05 1991
- 19C HEALTH OVERVIEW — Mon Feb 4 10:10:07 1991
- Disease — Mon Feb 4 10:10:11 1991
- 19C HEALTH OVERVIEW — Mon Feb 4 10:10:16 1991
- Victorian Deathbed — Mon Feb 4 10:10:18 1991
- 19C HEALTH OVERVIEW — Mon Feb 4 10:10:19 1991

- 19C HISTORY OVERVIEW
- Childbirth Risks
- DICKENS OVERVIEW
- Death
- Death of Little Nell
- Deathbed Detail
- Disease
- Filth
- Food Adulteration
- GREAT EXPECTATIONS OVERVIEW
- Milk
- Opium
- Overviews
- Tuberculosis
- Typhus & Cholera

THE DICKENS WEB 1990

This shows a view into Dickens Web (above), a portion of Context 32, the hypertext for teaching British Literature developed by George Landow. The Intermedia web view for the selected document is shown in the lower right. The overview diagram in the upper left was drawn by hand, then linked to the appropriate documents.

INTERMEDIA GLOBAL MAP

This portion of a global map (above right) from an experimental version of Intermedia in 1987 is often reproduced, but was never used in the classroom. It became clear that it was not possible to automatically show how everything is connected to everything else.

Early in the development of hypertext systems, Jeff Conklin wrote a very useful survey article, "Hypertext: An Introduction and Survey," IEEE Computer, 20, 9 Sept. 1987, in which he identified the two major disadvantages of hypertext: disorientation (the tendency to lose one's sense of location and direction in a nonlinear environment) and cognitive overhead (the additional effort and concentration necessary to maintain several tasks or trails at one time). The major technological solutions to disorientation, Conklin suggests, are graphical browsers and search mechanisms. The solutions seem obvious enough, and the problems he describes are greater on large web sites than they were in the small experimental hypertext systems that preceded it.

The advent of web browsers altered the balance between carefully planned hypertext research and its application. The apparent need for visualization fell away as simple HTML authoring tools fell into the hands of millions of authors. But as we will see in the next chapters, the need for visualization of web sites is very real and very broad.

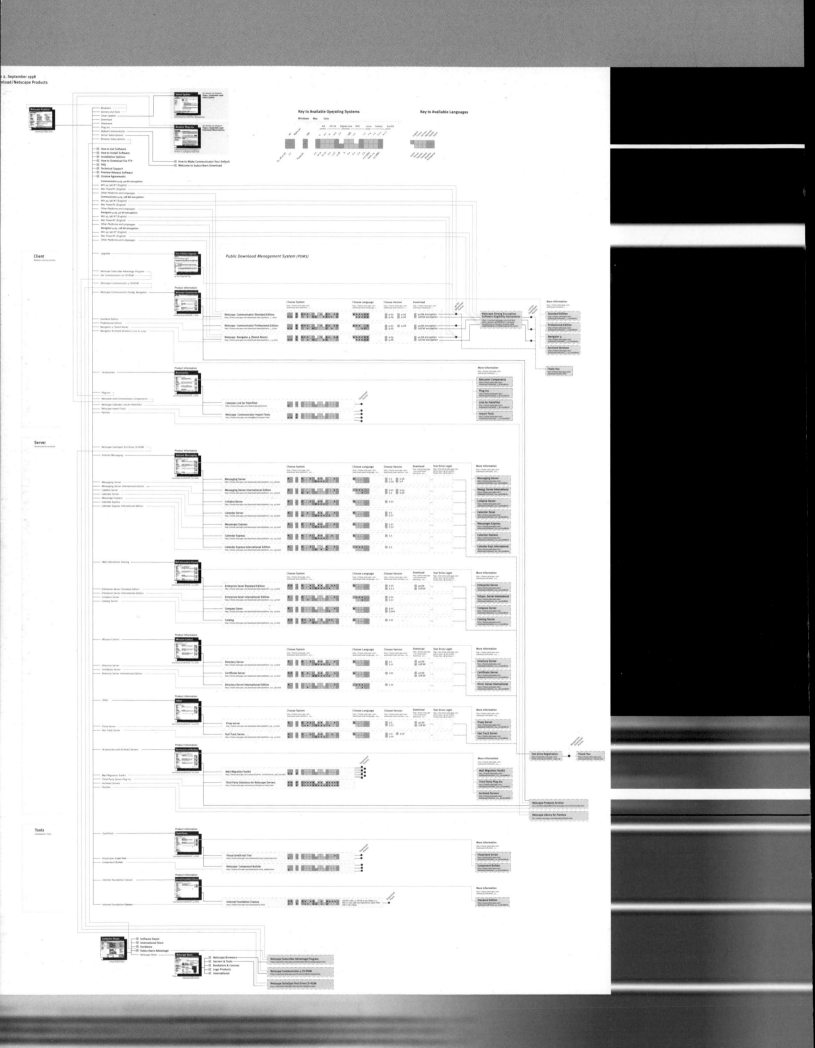

Web site Planning Diagrams

Planning diagrams are the least visible form of web site mapping. The planning diagram is an artifact of the design process. It is usually shared only by the planning group or the designer and the client, and then discarded. Still, it is a critical part of the design process.

ANALYSIS OF NETSCAPE SOFTWARE DOWNLOAD AREA This diagram (left) catalogs the software products available from Netscape through the software download area in September 1998 for the group running this part of the web site. The sequence of selecting an operating system, language, version of the program, and encryption type are shown. The purpose of the diagram was to model the user's experience, enumerate the pattern and variations, and track the number of steps required to download a product.

relationships must be made. The most difficult thing is deciding what the map should reveal about the web site. What are we trying to show? This depends on several variables: the audience for the map, the nature of the web site, and the media in which the map will be viewed.

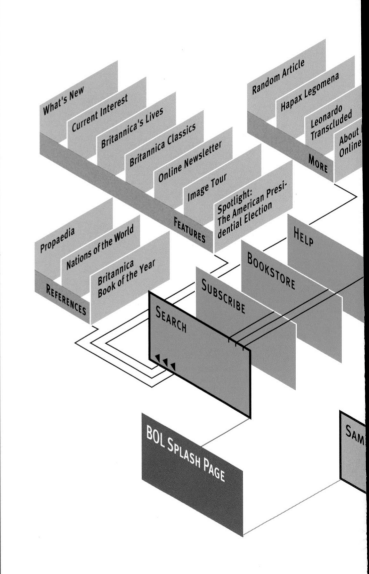

As Edward Tufte has pointed out in *Envisioning Information*, the most rewarding and challenging form of information graphics is compositions that convey multivariate data: diagrams that pack many layers of information into the "flatland" of graphic 2D presentation. The most dramatic variation in the maps within this chapter lies in the use of lines, arrows, colors, visual proximity, and symbols.

Web sites are inherently multi-dimensional, though they exist in an abstract space that does not obey the rules of Euclidean geometry. However, as we have shown in the earlier chapter about maps, visual conventions play a critical role in our ability to perceive the meaning of a diagram. If a web site is actually an invisible, multi-dimensional abstraction, we may understand it as a set of cards or boxes connected by lines, color, or symbols in part because we know, from our previous experience, what cards, boxes, and lines can represent.

Mapping a web site requires several steps. First, the kind of information to be represented must be defined. There are many possible dimensions to illustrate: click depth, page type, logical grouping, major navigation path, link relationships within the site or out to other sites, access rights, etc. Cataloging the content of the site according to these information types comes next. Third, the information must be organized into a visual pattern. Choices of what to use to represent link

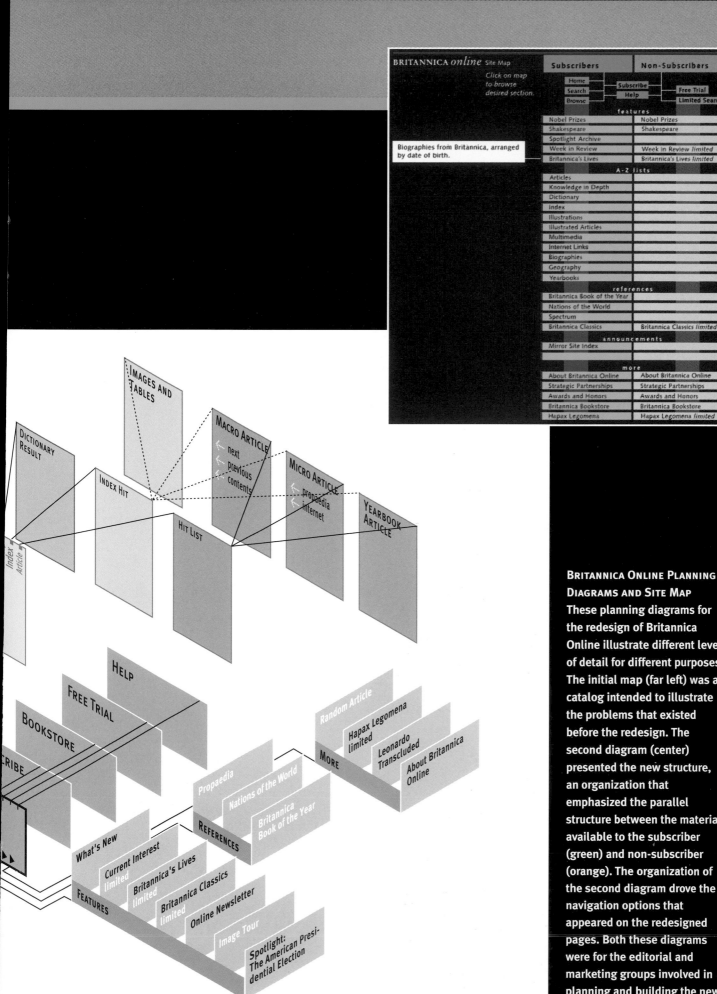

BRITANNICA online Site Map

Click on map
to browse
desired section.

Biographies from Britannica, arranged
by date of birth.

	Subscribers	Non-Subscribers	
	Home	Subscribe	Free Trial
	Search	Help	
	Browse		Limited Search
features			
	Nobel Prizes	Nobel Prizes	
	Shakespeare	Shakespeare	
	Spotlight Archive		
	Week in Review	Week in Review *limited*	
	Britannica's Lives	Britannica's Lives *limited*	
A-Z lists			
	Articles		
	Knowledge in Depth		
	Dictionary		
	Index		
	Illustrations		
	Illustrated Articles		
	Multimedia		
	Internet Links		
	Biographies		
	Geography		
	Yearbooks		
references			
	Britannica Book of the Year		
	Nations of the World		
	Spectrum		
	Britannica Classics	Britannica Classics *limited*	
announcements			
	Mirror Site Index		
more			
	About Britannica Online	About Britannica Online	
	Strategic Partnerships	Strategic Partnerships	
	Awards and Honors	Awards and Honors	
	Britannica Bookstore	Britannica Bookstore	
	Hapax Legomena	Hapax Legomena *limited*	

**BRITANNICA ONLINE PLANNING
DIAGRAMS AND SITE MAP**
These planning diagrams for
the redesign of Britannica
Online illustrate different levels
of detail for different purposes.
The initial map (far left) was a
catalog intended to illustrate
the problems that existed
before the redesign. The
second diagram (center)
presented the new structure,
an organization that
emphasized the parallel
structure between the material
available to the subscriber
(green) and non-subscriber
(orange). The organization of
the second diagram drove the
navigation options that
appeared on the redesigned
pages. Both these diagrams
were for the editorial and
marketing groups involved in
planning and building the new
site. The site map (upper right)
was intended for the general
visitor to the web site.

For example, if the map is for the group planning the web site, or planning a redesign of the site, we can assume a certain amount of familiarity with the content. There is a certain level of detail that will interest the audience. But if the audience is a casual visitor a very different level of detail may be appropriate. If you are going to be visiting the web site for five minutes you want to see the largest pattern we can create from the information and you want to see it quickly, as we discuss in the next chapter on site maps. In contrast, if the viewers have been working on this web site for several years and are about to invest hundreds of thousands of dollars to revise it, then they are willing to spend a few hours paying close attention to the details. If the audience is an engineering group in charge of creating the application that runs the web site, there may be invisible software events, such as reading or writing a cookie or recording a transaction in a database, that should be visualized. The arguments embedded in a URL may be of critical importance.

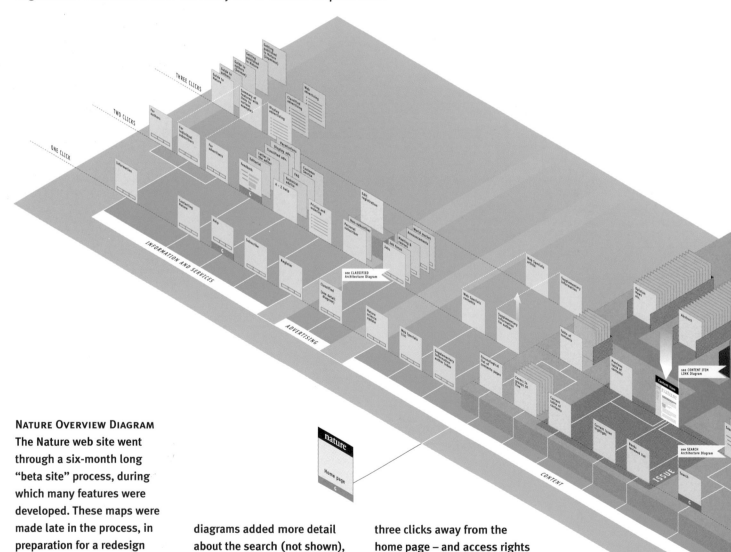

NATURE OVERVIEW DIAGRAM
The Nature web site went through a six-month long "beta site" process, during which many features were developed. These maps were made late in the process, in preparation for a redesign effort that took place just a few months before the official launch in October 1998. The overview diagram (above) shows all the major sections of the site, though three other diagrams added more detail about the search (not shown), the classified advertising (not shown), and connections to an article (above right) indicated with yellow flags. Two dimensions are emphasized: click depth – one, two, and three clicks away from the home page – and access rights shown by a combination of carpet color and height. Pages that represent global links are marked with an orange bar and those with banner advertising are marked with a box pattern.

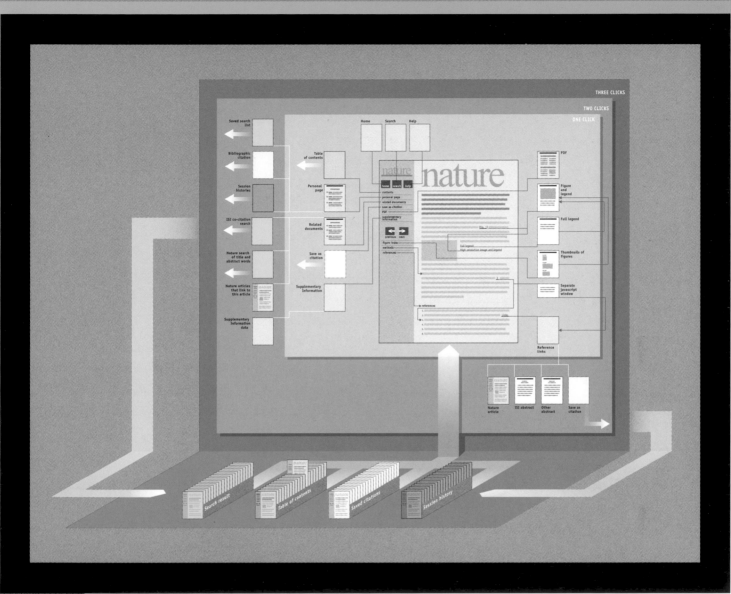

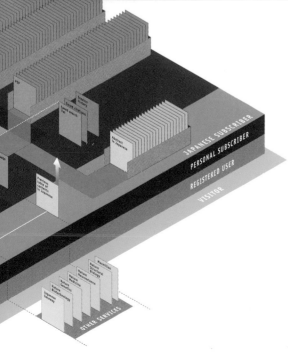

Nature Article Diagram

Since most visitors would come to this site to read individual items in the magazine, we created a diagram showing the material linked to and from each story (above). This diagram uses colored layers to show click depth. Collections of items such as tables of contents and search results are shown as color-coded card boxes in the foreground, while the same colors are repeated for linked pages above to indicate links from the article to individual collections.

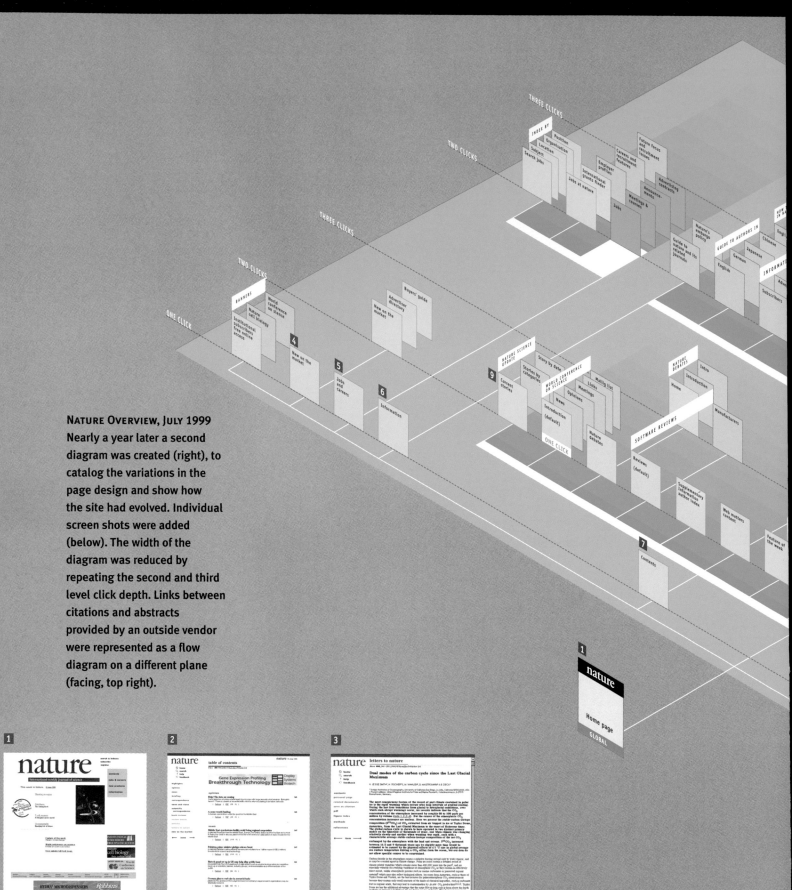

NATURE OVERVIEW, JULY 1999
Nearly a year later a second diagram was created (right), to catalog the variations in the page design and show how the site had evolved. Individual screen shots were added (below). The width of the diagram was reduced by repeating the second and third level click depth. Links between citations and abstracts provided by an outside vendor were represented as a flow diagram on a different plane (facing, top right).

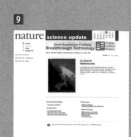

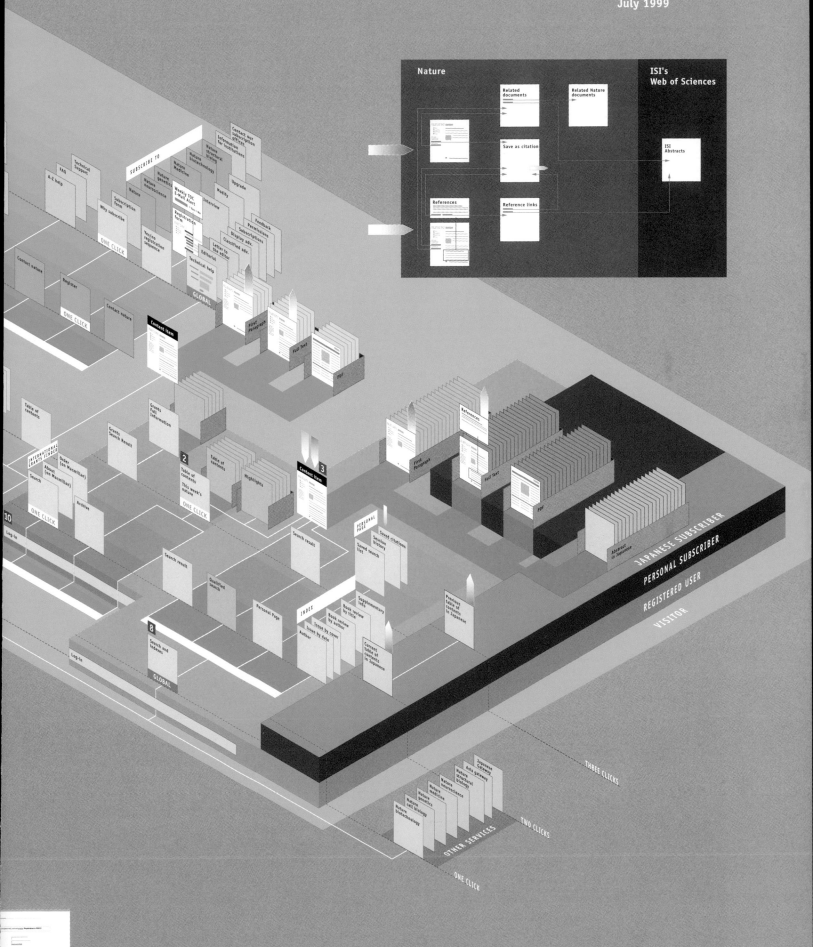

nature WEB SITE Architecture
July 1999

Nature

ISI's
Web of Sciences

Related documents

Related Nature documents

Save as citation

ISI Abstracts

References

Reference links

SUBSCRIBE TO

FAQ

Technical Support

A-Z help

Why subscribe

Subscription form

Nature

Nature neuroscience

Nature genetics

Nature Medicine

Nature biotechnology

Contact our subscription officers

Information for institutions

Nature structural biology

Weekly TOC E-Mail Alert

Upgrade

Modify

Interview

Registration form

Yes/no registration sequence

ONE CLICK

Feedback

Permissions

Subscriptions

Display adv.

Classified adv.

Letter to the editor

Editorial

Technical help

GLOBAL

Contact nature

Register

Contact nature

ONE CLICK

Content item

First Paragraph

Full Text

Pdf

Table of contents

Grants Full Information

Grants Search Result

INTERNATIONAL GRANTS INDEX

Order (on Macmillan)

About (on Macmillan)

Search

Archive

ONE CLICK

10

Log-in

Table of contents

This week's nature

2

Table of contents

Highlights

3

Content item

ONE CLICK

References

First Paragraph

Full Text

Pdf

Search result

Search result

PERSONAL PAGE

Saved citations

Section history

Saved search list

Abstract in Japanese

JAPANESE SUBSCRIBER

PERSONAL SUBSCRIBER

Qualified search

Personal Page

8

Log-in

Search and indexes

GLOBAL

INDEX

Author

Issue by date

Book review by cover

Book review by title

Supplementary info

Previous table of contents in Japanese

Current table of contents in Japanese

REGISTERED USER

VISITOR

Nature biotechnology

Nature cell biology

Nature genetics

Nature medicine

Nature neuroscience

Nature structural biology

Asia gateway

Japanese gateway

THREE CLICKS

TWO CLICKS

OTHER SERVICES

ONE CLICK

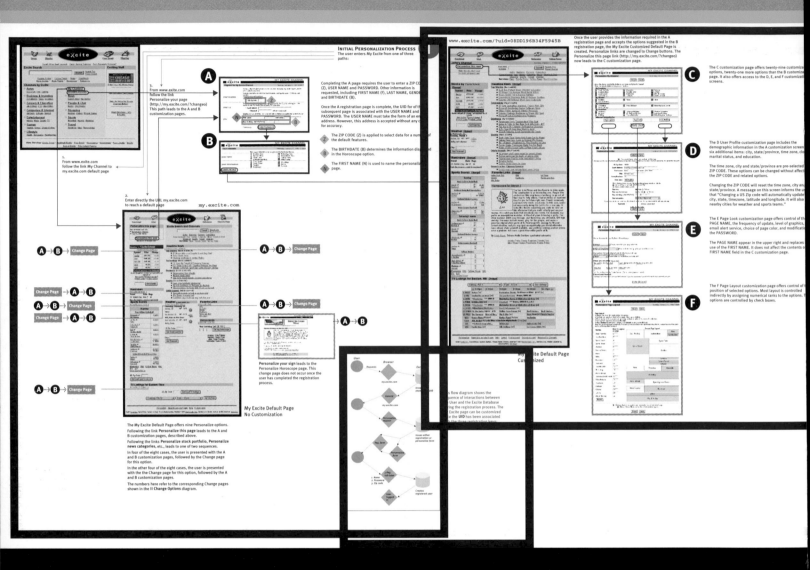

Then there is the choice of what to represent. There are many possible layers of data to choose from: screen image, page title, URL, click depth, etc. Most web sites can be broken down into sections or information categories. Many sites have different levels of access control. How do you show these boundaries? Pages or sections of the web site may be created in different ways, by different processes or different parts of the editorial organization. Showing the difference between database-driven pages versus other pages may be important. We might need to show the revision schedules for sections of the site. The number of variables is as endless as those facing a traditional cartographer. The question is how to combine the variables in a way that allows the intended audience to grasp the appropriate level of detail.

Finally there is the question of the media for presenting the map. Will it be presented on the screen or on paper? How big can it be? Interestingly, the physical size of the print can have a major effect on the way it is designed. It is just easier for people to view a large map in a horizontal orientation than in a vertical one. If it is taller than you are, it is hard to see without a chair. If it is very wide, you can view it in a panoramic glance and then focus in on a portion of the print. If it is viewed on the screen, there is a definite limit to how much text can be represented, and how wide the map can be. Even with a wall projector 1024 pixels is as wide as your design can stretch. But on the screen there are interactive effects that can be added. Interacting with or querying a portion of the map can present or reveal additional information. We will have more to say about the interactive potential of web site maps in Chapter 6 on data-driven site maps.

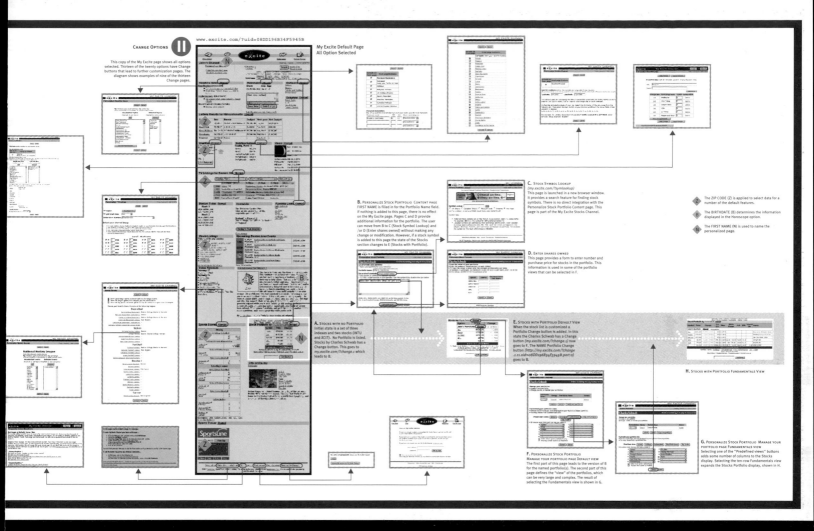

MY EXCITE ANALYSIS DIAGRAMS: SHOWING HOW IT'S DONE

Sometime during 1998 Search Engines became Web Portals. Competing for user attention and loyalty, these web sites brought information together from various sources (aggregation) at the same time as they helped users locate resources on the web (search). An important step in this process was the creation of the personalized start page, pioneered by Microsoft Network and Excite.

The openness of the web is one of its greatest strengths. The Internet itself is based on published standards and HTML is visible to everyone who uses the web. This is one of the reasons for the rapid growth of the web. Each new style and technique that appears comes with its own primer, the source of the document being viewed. Millions of novices become experienced authors simply by imitating and refining the examples that flood into their web browsers. While the technical details of server farms and database management systems for any web site are hidden from view, the basic strategy for serving pages can be inferred by examining the web sites themselves.

We were asked to analyze the personalization features of My.Excite.com when this new feature of Excite (now Excite@Home) first appeared. The task was a competitive analysis. Our client wanted to know how it was done. The audience was the engineering group that would have to match and exceed the standard set by this pioneering application of personalization in the Web Portal market.

We set about creating a series of wall-size posters. The goal was to capture the flow of the customization process, from initial contact with the My Excite page, through creation of an account, into minimum personalization, and onto catalog all the controls offered to the user to customize the My Excite page. On this page we reproduce two of the three diagrams. The first (left) shows the process of creating an account and the initial personalization that results from gathering demographic information. The second (right) shows each of the control widgets for the personal page, with all information options displayed. The third diagram (not shown) showed the destination pages for each type of information, along with the URL that often passed information about some aspect of the user's identity (an ID number, a zip code) to the destination web site. In this reproduction we have added blue boxes to indicate the details enlarged and explained on the following pages.

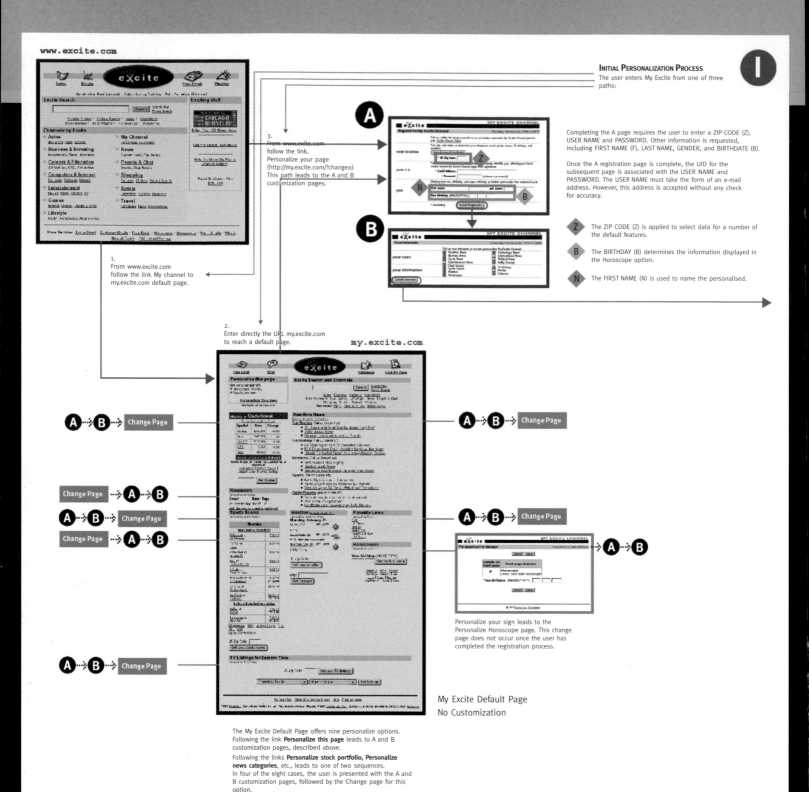

www.excite.com

my.excite.com

INITIAL PERSONALIZATION PROCESS
The user enters My Excite from one of three paths:

3.
From www.excite.com
follow the link.
Personalize your page
(http://my.excite.com/?changeo)
This path leads to the A and B
customization pages.

Completing the A page requires the user to enter a ZIP CODE (Z),
USER NAME and PASSWORD. Other information is requested,
including FIRST NAME (F), LAST NAME, GENDER, and BIRTHDATE (B).

Once the A registration page is complete, the UID for the
subsequent page is associated with the USER NAME and
PASSWORD. The USER NAME must take the form of an e-mail
address. However, this address is accepted without any check
for accuracy.

1.
From www.excite.com
follow the link My channel to
my.excite.com default page.

The ZIP CODE (Z) is applied to select data for a number of
the default features.

The BIRTHDAY (B) determines the information displayed in
the Horoscope option.

The FIRST NAME (N) is used to name the personalised.

2.
Enter directly the URL my.excite.com
to reach a default page.

Personalize your sign leads to the
Personalize Horoscope page. This change
page does not occur once the user has
completed the registration process.

My Excite Default Page
No Customization

The My Excite Default Page offers nine personalize options.
Following the link **Personalize this page** leads to A and B
customization pages, described above.

Following the links **Personalize stock portfolio, Personalize
news categories**, etc., leads to one of two sequences.
In four of the eight cases, the user is presented with the A and
B customization pages, followed by the Change page for this
option.

In the other four of eight cases, the user is presented with the
Change page for this option, followed by the A and B
customization pages.

The numbers here refer to the corresponding Change pages
shown in the **II Change Options** diagram

INITIALIZATION SEQUENCE

The first part of the My Excite diagram focuses on the initialization sequence (left). The user at this time would come to My Excite by following the My Channel link on the Excite Home Page, by choosing the customization option from the Excite page, or by typing in the URL my.excite.com directly. Any of these options leads the user to the two personalization screens, marked A and B in the diagram. The A screen requires the user to provide certain information, as described in the diagram. It was important to highlight the information that would later influence the personalization process. In this case, the user's zip code, birthday and first name appear later, so they are assigned color symbols. This will make the sequence of diagrams easier to read.

MY EXCITE HOME PAGE

This screen shot of an instance of the My Excite Home Page (right) was made several years after these analysis diagrams were created (March 2000). The principles behind the web site product remain the same, and its success has been widely imitated.

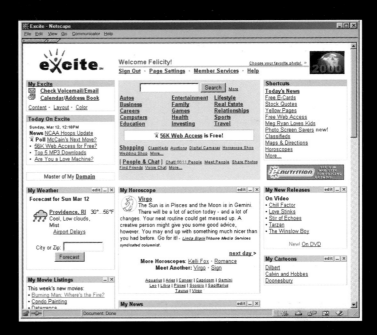

USER/BROWSER/DBMS DIALOG

The point in the sequence at which the user's account information is associated with a unique identification number (UID) is something that is largely invisible, but of some significance to the software developers reading the diagram. A separate block diagram (right) shows the interaction between the user, the web browser, and the database behind the Excite web site.

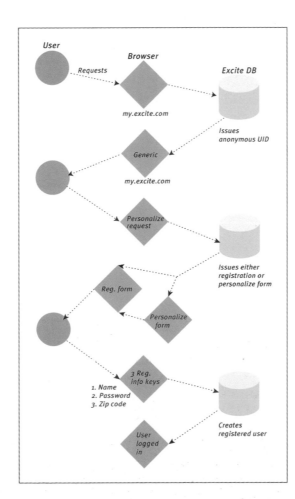

This flow diagram shows the sequence of interactions between the User and the Excite Database during the registration process. The My Excite page can be customized once the **UID** has been associated with the three registration keys: **name**, **password**, and **zip code**.

My Netscape March 2000

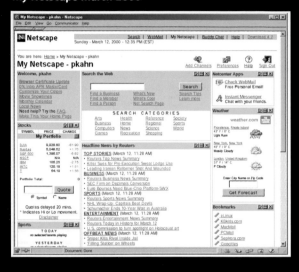

My Yahoo March 2000

My Lycos March 2000

CUSTOMIZED HOME PAGES
The three screen shots (left) are current examples of customized Web Portal home pages. The content and customization options do vary, but the concept is essentially the same.

FURTHER CUSTOMIZATION
The second section of the first diagram (right) shows the customization options available to a user once an account has been created. The process moves from the simple, eight options in B on the previous detail, to the complex, twenty-nine options on the screen marked C, with links to three more options. Since the most common user behavior is to change nothing, the default options are shown in each case.

www.excite.com/?ui

96B34F5945B

Excite Default Page
stomized

Once the user provides the information required in the A registration pages and accepts the options suggested in the B registration page, the My Excite Customized Default Page is created. Personalized links are changed to Change buttons. The Personalized this page link (http://my.excite.com/?changeo) now leads to the C customization page.

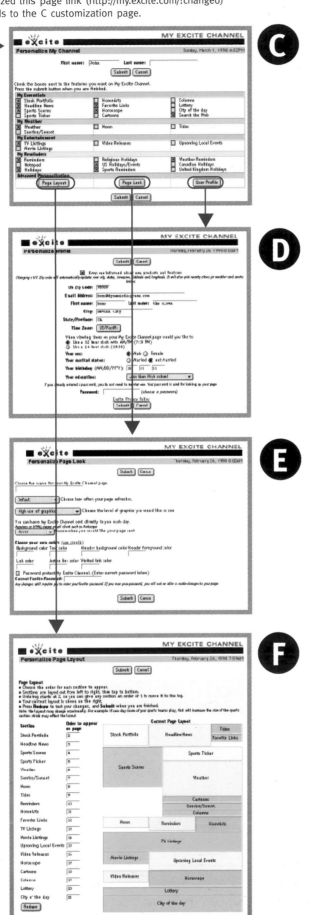

The C customization page offers twenty-nine customization options, twenty-one more options than the B customization page. It also offers access to the D, E, and F customization screens.

The D user Profile customization page includes the demographic information in the A customization screen, plus six additional items: city, state/province, time zone, clock, marital status, and education.

The time zone, city and state/province are pre-selected by the ZIP CODE. These options can be changed without affecting the ZIP CODE and related options.

Changing the ZIP CODE will reset the time zone, city and state/province. A message on this screen informs the user that "Changing a US Zip code will automatically update your city, state, time zone, latitude and longitude. It will also pick nearby cities for weather and sports teams."

The E Page Look customization pages offer control of the PAGE NAME, the frequency of update, level of graphics, an email alert service, choice of page color, and modification of the PASSWORD.

The PAGE NAME appears in the upper right and replaces the use of the FIRST NAME. It does not affect the contents of the FIRST NAME field in the C customization page.

The F Page Layout customization page offers control of the position of selected options. Most layout is controlled indirectly by assigning numerical ranks to the options. Two options are controlled by check boxes.

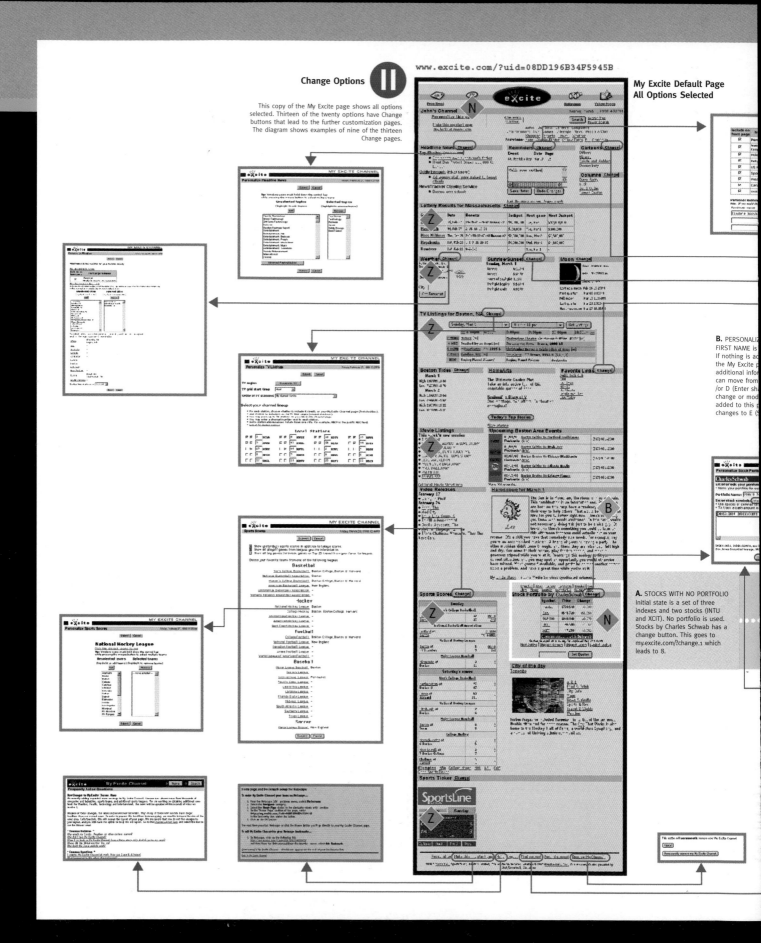

CHANGE WIDGETS
The second diagram focused entirely on the options for changing the settings for a section of the Home Page once it had been placed on the page.

the user could modify. In most cases the options would fit onto a single screen. The major exception was the Stock Portfolio widget, which required as many as six screens

portfolio. The effect of providing zip code, first name, and birthday is shown by overlaying the symbols developed on the first diagram.

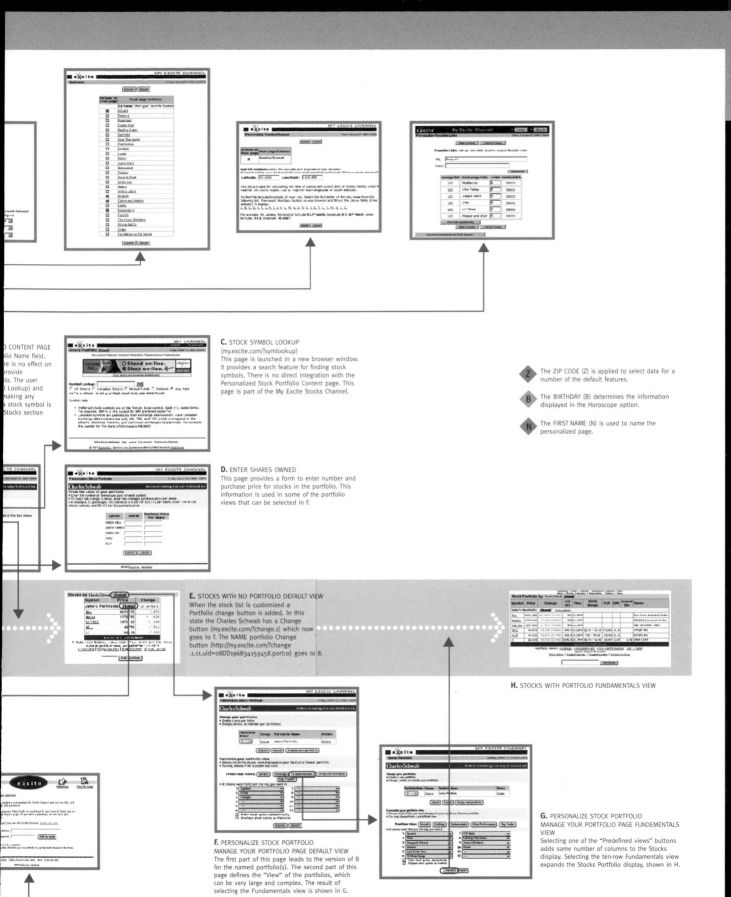

C. STOCK SYMBOL LOOKUP
(my.excite.com/?symlookup)
This page is launched in a new browser window.
It provides a search feature for finding stock
symbols. There is no direct integration with the
Personalized Stock Portfolio Content page. This
page is part of the My Excite Stocks Channel.

D. ENTER SHARES OWNED
This page provides a form to enter number and
purchase price for stocks in the portfolio. This
information is used in some of the portfolio
views that can be selected in F.

Z The ZIP CODE (Z) is applied to select data for a
number of the default features.

B The BIRTHDAY (B) determines the information
displayed in the Horoscope option.

N The FIRST NAME (N) is used to name the
personalized page.

E. STOCKS WITH NO PORTFOLIO DEFAULT VIEW
When the stock list is customized a
Portfolio change button is added. In this
state the Charles Schwab has a Change
button (my.excite.com/?change.1) which now
goes to f. The NAME portfolio Change
button (http://my.excite.com/?change
.1.11.uid=08DD19683415945B.port:o) goes to 8.

H. STOCKS WITH PORTFOLIO FUNDAMENTALS VIEW

F. PERSONALIZE STOCK PORTFOLIO
MANAGE YOUR PORTFOLIO PAGE DEFAULT VIEW
The first part of this page leads to the version of B
for the named portfolio(s). The second part of this
page defines the "View" of the portfolios, which
can be very large and complex. The result of
selecting the Fundamentals view is shown in G.

G. PERSONALIZE STOCK PORTFOLIO
MANAGE YOUR PORTFOLIO PAGE FUNDAMENTALS
VIEW
Selecting one of the "Predefined views" buttons
adds same number of columns to the Stocks
display. Selecting the ten-row Fundamentals view
expands the Stocks Portfolio display, shown in H.

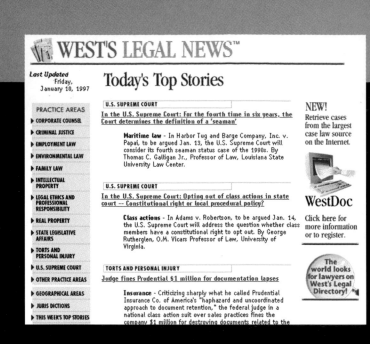

The final Top Stories page (left), shown here in a screen shot captured in January 1997, was built on the concepts presented in these planning diagrams.

A separation of standard and customized features around the story or story list is shown in the page abstract diagram (below).

WEST'S LEGAL NEWS EDITORIAL PROCESS AND PAGE ABSTRACT

The diagram (below) captures the relationship between individual stories in a news service, the editorial system used to create them, and the other databases to which they are linked. In this case each story is given a category, represented by the red circle in the upper right of the card. The story text contains pointers (links) to stories in other databases. The user's view of the story is controlled by the Standard or Custom Home Page presented by the web site.

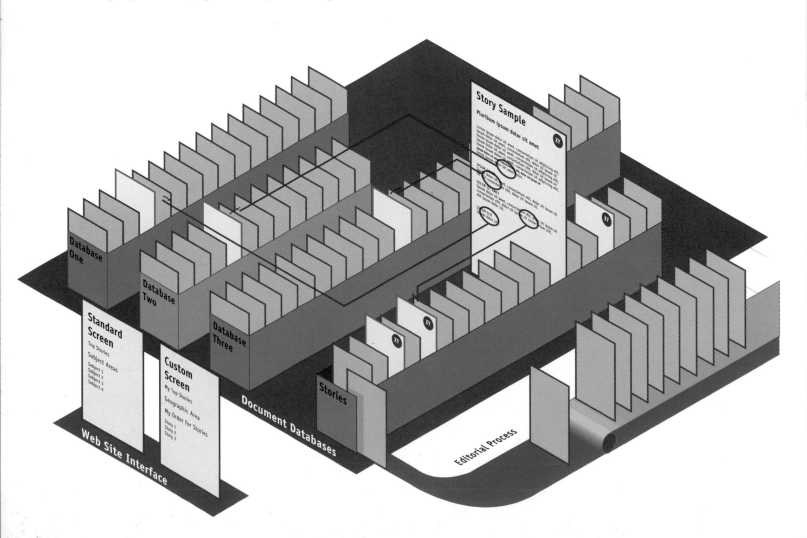

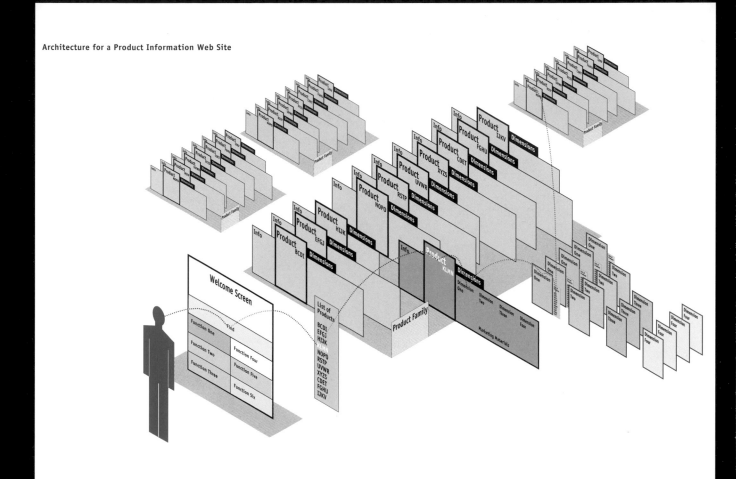

Architecture for a Product Information Web Site

MERRILL LYNCH PRODUCT MARKETING INTRANET ORGANIZATION SCHEME
A planning diagram can be used to solve conceptual problems. Merrill Lynch wanted to replace a simple menu-driven set product marketing information with a more flexible collection available over an intranet. Each product had to be accessible by typing in a code, for those already familiar with the product. Products were also grouped in product families, though could also generate useful navigational links between products, the concept of dimensions was introduced. The diagram model is a financial consultant's experience of selecting a familiar product by code, examining the dimensions of the product, looking at other products that share this dimension, and following a link to a product in another product family. The concept was later embodied in an operational prototype for mutual fund

McGRAW-HILL
www.AccessScience.com

Dynamic Diagrams began to work with the McGraw-Hill Educational and Professional Publishing Group (EPPG) in the winter of 1998 to develop an information architecture for a new web site product based on a print encyclopedia. The *McGraw-Hill Encyclopedia of Science and Technology* is a large multi-volume encyclopedia for the college, professional and library reference market. The print product covers a broad range of science and engineering topics in great depth, with numerous figures and tables. The online product, eventually named AccessScience, would have the same content, as well as many other related collections of material, some derived from other print products, such as the *McGraw-Hill Dictionary of Scientific and Technical Terms*, and others to be created specifically for the online product.

PLANNING DIAGRAMS

The planning process involved the development of several planning diagrams (above and below) intended to capture the concepts on which we would later base the designs. The diagrams themselves are entirely abstract.

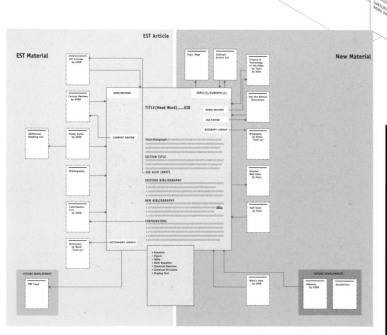

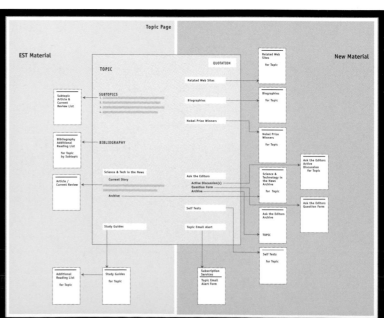

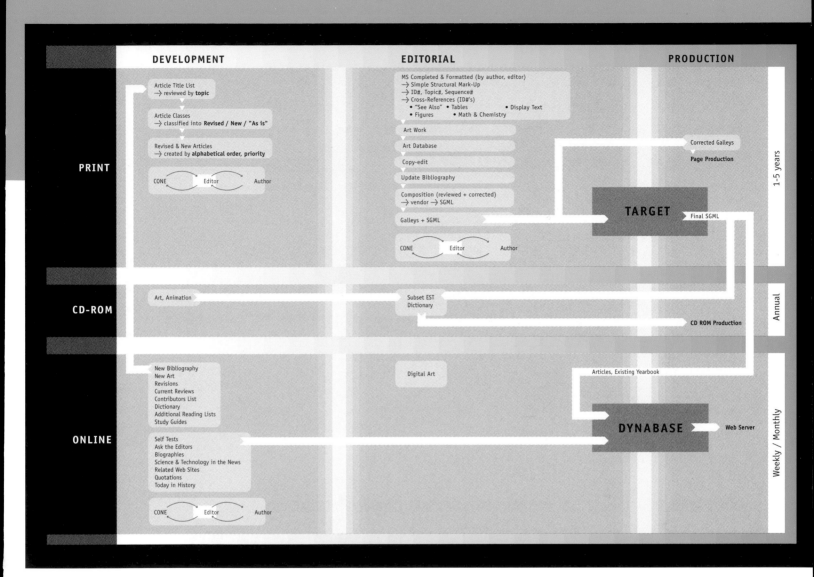

DEVELOPMENT

PRINT

- Article Title List
 → reviewed by **topic**
- Article Classes
 → classified into **Revised / New / "As is"**
- Revised & New Articles
 → created by **alphabetical order, priority**

CONE — Editor — Author

CD-ROM

- Art, Animation

ONLINE

- New Bibliography
 New Art
 Revisions
 Current Reviews
 Contributors List
 Dictionary
 Additional Reading Lists
 Study Guides
- Self Tests
 Ask the Editors
 Biographies
 Science & Technology in the News
 Related Web Sites
 Quotations
 Today in History

CONE — Editor — Author

EDITORIAL

- MS Completed & Formatted (by author, editor)
 → Simple Structural Mark-Up
 → ID#, Topic#, Sequence#
 → Cross-References (ID#'s)
 • "See Also" • Tables • Display Text
 • Figures • Math & Chemistry
- Art Work
- Art Database
- Copy-edit
- Update Bibliography
- Composition (reviewed + corrected)
 → vendor → SGML
- Galleys + SGML

CONE — Editor — Author

- Subset EST
 Dictionary

- Digital Art

PRODUCTION

- Corrected Galleys
- Page Production

TARGET Final SGML

1–5 years

- CD ROM Production

Annual

- Articles, Existing Yearbook

DYNABASE ▷ Web Server

Weekly / Monthly

PRINT/CD ROM/ONLINE PROCESS DIAGRAM
From the publisher's point of view, one of the main challenges in creating AccessScience was to modify the existing editorial process, established for the print and CD ROM products (above).

The editorial process for the print encyclopedia involved a development cycle that was largely paper-based. All of the content originated as paper-based manuscript and was SGML-coded just prior to page production. The SGML data was stored in an electronic repository used for archival purposes. The creation of an article from concept development to galleys usually took about four months. At the start of the project, the production cycle for a new edition of the entire encyclopedia was five years, including the production of annual yearbooks. The content of a CD ROM product drawn from the same encyclopedia came from the SGML repository with some modifications. The CD ROM product was released annually.

New and revised articles would be added to the online product on a monthly basis. The editorial priority had to be changed from alphabetic to topical. The relationship between the three products made it clear that major changes in the editorial process were needed.

McGRAW-HILL

AccessScience @ McGRAW-HILL

○ Search This Site
○ Find a Definition go!
More Search Options ▶
Browse/Explore
In the News
Biographies
Student Center
Related Sites
AccessScience Q&A
Suggestion Box
Help
🏠 Home
Select a Topic ▾
go!

Dictionary: K
A B C D E F G H I J K L M N O P Q R S T U V W X Y Z

To browse the dictionary, please select from the following alphabetical breakdown.

◄◄ PREVIOUS kd ▾ go! NEXT ►►

- **K damage** [ORDNANCE] 1. Combat damage sufficient to cause a vehicle to be destroyed. 2. Combat damage such that an aircraft will fall out of control immediately after the damage occurs.
{ ˈkā ˌdam·ij }
- **K display** [ELECTRONICS] A modified radarscope A display in which a target appears as a pair of vertical deflections instead of as a single deflection; when the radar antenna is correctly pointed at the target in azimuth, the deflections are of equal height; when the antenna is not correctly pointed, the difference in pulse heights is an indication of direction and magnitude of azimuth pointing error.
{ ˈkā diˈsplā }
- **KdV soliton** See Korteweg-de Vries soliton
{ ˈkā ˈdēˌvē ˈsäl·əˌtän }
- **kedge** [NAVIGATION] To move, as a vessel, by carrying out an anchor, letting it go, and hauling the ship up to the anchor.
{ kej }
- **kedge anchor** [NAVAL ARCHITECTURE] A light anchor that is used to warp or kedge a ship.
{ ˈkej·aŋ·kər }
- **keel** [NAVAL ARCHITECTURE] A steel beam or timber, or a series of steel beams and plates or timbers joined together, extending along the center of the bottom of a ship from stem to stern and often projecting below the bottom, to which the frames and hull plating are attached.
[VERTEBRATE ZOOLOGY] The median ridge on the breastbone in certain birds. Also known as carina.
{ kēl }

Diagram labels:

Dictionary — Head Word

Articles (full) — Head Word / ATOPIC / UID

Articles (first paragraph only) — Head Word / ATOPIC / UID

Current Reviews (first paragraph only) — Head Word / ATOPIC / UID

Current Reviews (full) — Head Word / ATOPIC / UID

PDF — ATOPIC / UID

Biography — Person name / Assoc. Article UID / Assoc. Article ATOPIC

NON-SUBSCRIBERS
HOME PAGE

Today in History -First Paragraph
Free Trial
Subscription -Services
Ask the Editors -Archive
Nobel Prize Winners
S&T in the News -First Paragraph -Archive
Search -First Paragraph -Dictionary
Browse - Sample Articles - Sample Biography - Dictionary
Value of EST Online
Feedback

SUBSCRIBER HOME PAGE

Today in History - Full Article
Science & Technology in the News
Self Tests
Study Guides
Subscription Services
Sci & Tech by Topic
Sci & Tech by Date
Ask th...

FREE TRIAL / SUBSC...

The overview diagram (right) illustrates the collections of material that make up the AccessScience web site, along with the top-level pages of the site. The purpose of this diagram is to define the content of the web site from the user's point of view, but the audience of the diagram is the planners and builders of the web site. To address the concerns of this audience the diagram must show the major resources and their relationships from the user's point of view.

www.AccessScience.com

The top-level pages, all visible from the Home Page, should be seen by the user as a series of possible areas to explore. The site is organized into two main areas: the material accessible to non-subscribers (green) and the content available to paid subscribers only (orange), here distinguished by color. The Home Page is a portal to all free material and provides password-protected access to the Subscriber section of the web site.

We determined that the best way to visualize the AccessScience web site is as a set of related collections. The core of the online product consists of the existing Encyclopedia Articles and Yearbook Essays (referred to as Current Reviews in the planning diagrams and later renamed Research Updates in the final designs), and the *McGraw-Hill Dictionary of Science and Technology*. A significant amount of new content has been integrated with core encyclopedia articles to create an innovative and compelling online product. These new collections include Biographies, Nobel Prize Winners, Quotations, Related Web Sites, Self Tests, Science and Technology in the News (news stories), Additional Reading Lists, and Study Guides. An Ask-the-Editors section will develop in response to visitors' queries. The diagram emphasizes the two data "keys" that the collection share: UID (unique identifier) and ATOPIC (topic code). By visualizing how these two data keys are shared by the collections, the planners could see how the linking of related material could be effectively programmed.

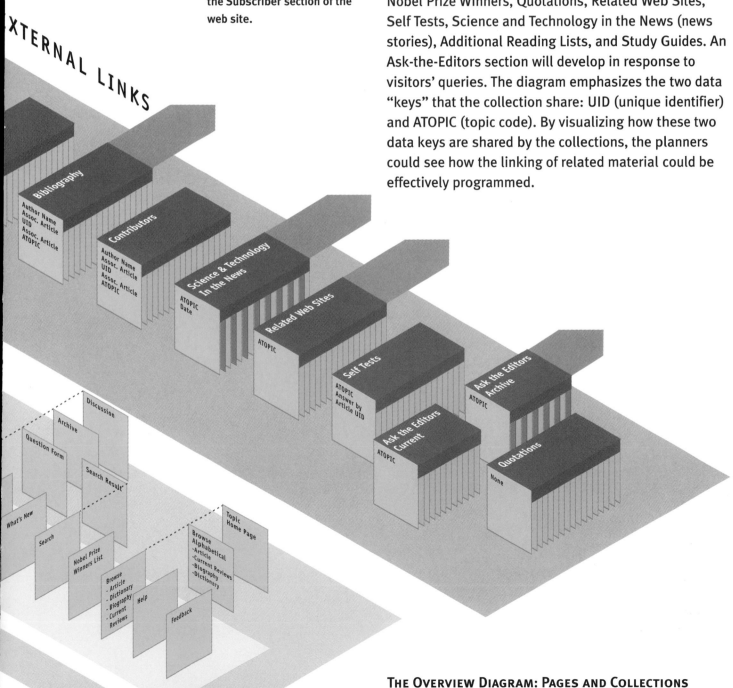

THE OVERVIEW DIAGRAM: PAGES AND COLLECTIONS

Site Map

The site map below provides an overview of the *AccessScience* web site. Click on a navigation button link to go to a selected section of the site.

AccessScience

Subscribers — **Non-Subscribers**

Subscribers	Non-Subscribers
Order Now	Order Now
Subscriber Services	Free Trial
Home	
About Us	About Us
• Consulting Editors	• Consulting Editors
• Contributors	
Help	Help
Suggestion Box	Suggestion Box
More Search Options	More Search Options
Browse/Explore	View Sample Topic
• Topics	• Article
• Articles	• Research Update
• Research Updates	• Biography
• Science Dictionary	Science Dictionary
In the News	
Biographies	Nobel/Fields Winners
Student Center	
• Bibliography	
• Essay Topics	
• Forum	
• Study Guides	
Related Sites	
AccessScience Q&A	

Or select a topic to begin

[Select a Topic ▾] **go!**

Privacy Policy

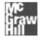

A Division of The McGraw-Hill Companies

SITE MAP

In contrast to the overview diagram, which emphasizes the collections and data keys, the Site Map for the final web site offers a simple navigational summary (above). This symmetrical design, intended for the casual as well as the frequent user, emphasizes the relationship between the Subscriber (paid) and Non-Subscriber (free) collections. The emphasis of the design is a quick visual index combined with the marketing message showing the non-subscriber exactly what he is missing.

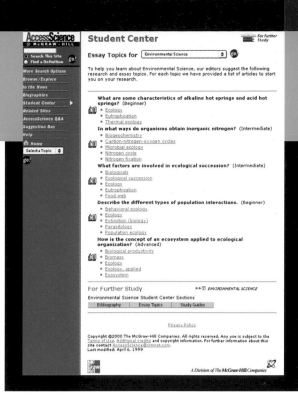

McGraw-Hill
www.AccessScience.com

SUBSCRIBER HOME PAGE

From the overview planning diagram it was clear that the wealth of available material and the various ways to access the information would be presented on the Subscriber Home Page. From here, the user can search for particular information using the search query, navigate to the topic of interest, or browse any category of information. The final design (below) separates the search area on the top left from the topic list, followed by links to the various collections.

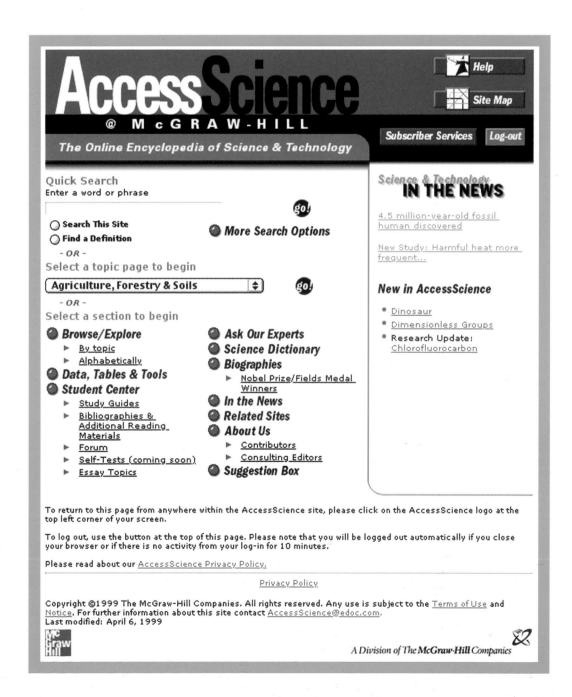

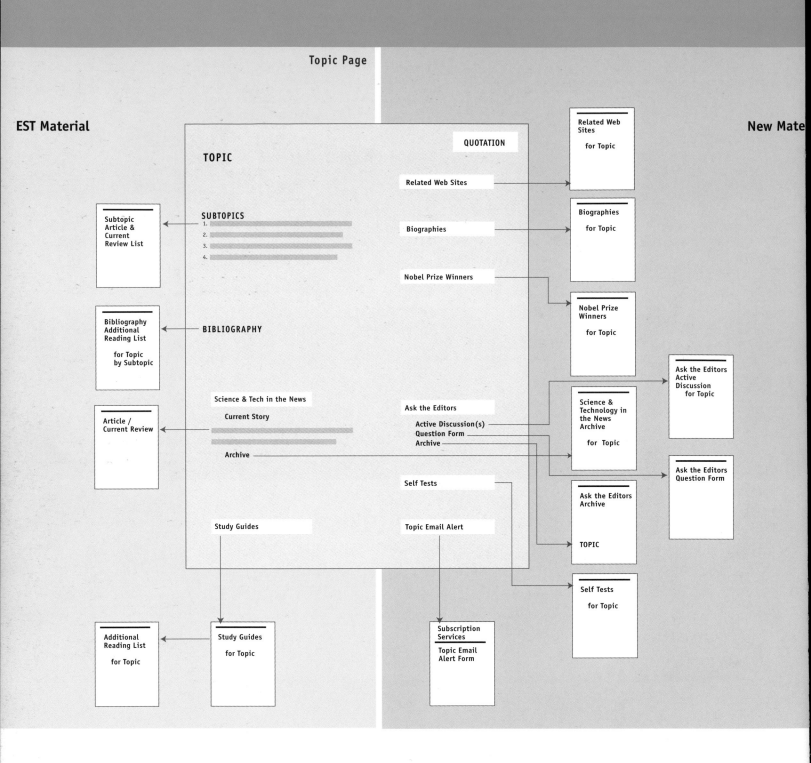

TOPIC PAGE DIAGRAM
Each article prepared for publication in the print edition is assigned a topic classification in the form of a numeric topic code. This topical classification is used primarily for editorial scheduling and tracking in the print encyclopedia, where alphabetic look-up and printed index are the primary access methods.

To enhance the browsing features in the online product, the information architecture suggested the creation of Topic Pages. To create this feature, all new material has been coded with the topical categories already used for the encyclopedia articles. With these "hooks" the Topic Pages can be programmatically generated and updated from the data in the various collections.

The Topic Page planning diagram emphasizes the relationship between the core encyclopedia content and the new materials based on the topical category system. The diagram identifies the content that will be accessible from the Topic Page: Related Subtopics, Biographies, Ask-the-Editors Archives, News Archives, Nobel Prize Winners (where appropriate), Related Web Sites, Self Tests, and a Bibliography. A space for changing scientific quotations is identified.

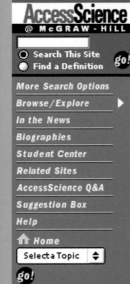

Science and Technology Headline News

Related News Archives: Physics | Chronological

For Further Study

Ion collider, doomsday fears rev up
by P. Weiss

Week of
March 05, 2000

The knob is rattling on a door to the remote past. However, no monster lurks on the other side, say officials at the Relativistic Heavy Ion Collider (RHIC), a $600 million particle accelerator that took its first step toward full operation last month.

On July 16, gold ions began zipping around one of RHIC's two 3.8-kilometer rings at Brookhaven National Laboratory in Upton, N.Y. Rumors were already circulating that the machine, some 8 years in the making, might destroy Earth.

In experiments scheduled to begin in November, nuclei will collide in mighty blasts at six spots around the ring. Researchers expect protons and neutrons in the explosions to dissolve into wads of so-called quark-gluon plasma (SN: 9/21/96, p. 190), the primordial stuff from which all atomic nuclei were born in the Big Bang. "We are creating a new state of matternew, that is, since the Big Bang," says Satoshi Ozaki, RHIC's director.

The lab faces an odd safety question: Will collisions create black holes, starting a chain reaction that eats up Earth?

Each blast is too tiny to make a black hole, Ozaki says. Nevertheless, the lab has convened a panel to address the doomsday scenarios.

As RHIC comes to life, two other large, extraordinary physics tools are also debuting. At the Thomas Jefferson National Accelerator Facility in Newport News, Va., the world's most powerful free electron laser has attained an average power of 1.7 kilowattsmore than 150 times better than its predecessor at Vanderbilt University in Nashville. Both basic researchers and industry scientists are using the unusual laser.

Researchers working at Oak Ridge (Tenn.) National Laboratory have published results for the first time from the Holifield Radioactive Ion Beam Facility. The facilitythe first of its kind in the United States and second in the worldaccelerates beams of short-lived radioisotopes. In the July 5 Physical Review Letters, scientists describe using a beam of unstable fluorine ions to study an elusive nuclear state of neon critical to understanding stellar explosions called novae.

References:

Bardayan, D.W., et al 1999. Observation of the astrophysically important 3+ State in 18Ne via elastic scattering of a radioactive 17F beam from 1H. Physical Review Letters 83(July 5):45.

Further Readings:

Mukerjee, M. 1999. A little Big Bang. Scientific American 280(March):60.

Peterson, I 1997. Proton-go-round. Science News 152(Sept. 6):158.

_____. 1996. Microcosmic bang. Science News 150(Sept. 21):190.

For more information on the Relativistic Heavy Ion Collider and quark-gluon plasma, go to http://www.rhic.bnl.gov.

Further information about accelerator astrophysics can be found at Physical Review Focus at http://focus.aps.org/v4/st2.html.

Sources:

McGraw-Hill
www.AccessScience.com

TOPIC PAGE DESIGN

The abstract design was realized in the final page design in a three-column layout (right). The emphasis on core print vs. new materials is gone. The global navigation options of the Subscriber Home Page have been reduced to a left-side navigation bar. The local navigation options for the topics are grouped into subtopics and three groups that relate to structural elements of the web site. Some of these, such as Student Center, are given much greater visual emphasis than others, such as Related Sites.

AccessScience
@ McGRAW-HILL

○ Search This Site **go!**
○ Find a Definition

More Search Options

Browse/Explore ▶

In the News

Biographies

Student Center

Related Sites

AccessScience Q&A

Suggestion Box

Help

🏠 **Home**

Select a Topic ⬍

go!

Chemistry

News Archive	Related Sites	Bibliography	Biographies
			Nobel Prize Winners

Topics

Please select a topic to view a list of articles and research updates:

- Analytical chemistry
- Chemical instruments
- Chemistry - general
- Inorganic chemistry
- Organic chemistry
- Physical chemistry
- Polymer chemistry

≡ Historical Review of Chemistry.

 Periodic Table
a graphical reference for the elements

AccessScience Wizard

For more than forty years I have selected my collaborators on the basis of their intelligence and their character and I am not willing for the rest of my life to change this method which I have found so good.

– Fritz Haber, Letter of Resignation, 30 April 1938semi; Haber was unwilling to follow the Nazi requirements for racial purity

Biographies

Learn more about the notable people who are leaders in fields relating to Chemistry.

Student Center

Look here for additional study resources for Chemistry:

- Study Guides
- Bibliography & Additional Reading Materials
- Essay Topics
- Forum

AccessScience Q&A

We welcome questions of general interest. Browse the archive to see previous questions and answers on Chemistry.

Privacy Policy

McGraw Hill

A Division of The McGraw-Hill Companies

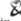

McGraw-Hill

www.AccessScience.com

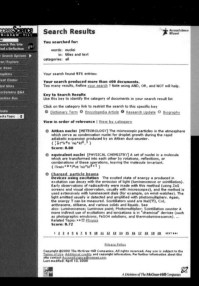

ARTICLE PAGE DIAGRAM

The information architecture takes into account the view from the top of the site, starting from the Home Page, as well as the view from within the site looking out. For this second view we must identify the most common target of the user's attention. The article is the core of the encyclopedia, the main reason for accessing this reference work. The planning diagram for the article page emphasized the same core print vs. new materials dichotomy found in the Topic Page. The directionality of the arrows shows the navigation pathways to and from the article, a feature that is critical for the planning of the site, but not visible in the final designs.

Paleontology: Fossil reptiles

✳ New — For Further Study — AccessScience Wizard

Dinosaur

Select an article section ⬍ *go!*

The term Dinosauria (Greek, "terrible lizards") was coined by the British comparative anatomist Richard Owen in 1842 to represent three partly known, impressively large fossil reptiles from the English countryside: the great carnivore *Megalosaurus*, the duckbilled *Iguanodon*, and the armored *Hylaeosaurus*. They were distinct, Owen said, not only because they were so large but also because they were terrestrial (unlike mosasaurs, plesiosaurs, and ichthyosaurs); they had five vertebrae in their hips (instead of two or three like other reptiles); and their hips and hindlimbs were like those of large mammals, structured so that they had to stand upright (they could not sprawl like living reptiles). Owen's diagnosis was strong enough to be generally valid, with some modification, 150 years later. His intention in erecting Dinosauria, though, as A. J. Desmond noted, seems to have been more than just the recognition of a new group: by showing that certain extinct reptiles were more "advanced" in structure (that is, more similar to mammals and birds) than living reptiles, he was able to discredit contemporary evolutionary ideas of the transmutation of species through time into ever more advanced forms (progressivism).

Over the next several decades, dinosaurs were discovered in many other countries of Europe, for example, *Iguanodon* in Belgium and *Plateosaurus* in Germany, but rarely in great abundance. The first dinosaur discoveries in the United States were from New Jersey as early as the 1850s (*Trachodon*, 1856; *Hadrosaurus*, 1858; *Laelaps* [= *Dryptosaurus*], 1868); the genus *Troodon*, based on a tooth from Montana, was also described in 1856, but at the time it was thought to be a lizard tooth. Spectacular discoveries of dinosaurs from the western United States and 1986 analysis listed nine uniquely derived features of the skull, shoulder, hand, hip, and hindlimb that unite Dinosauria as a natural group; this analysis has been since modified and improved, and today Dinosauria is universally accepted as a natural group, divided into Ornithischia and Saurischia. See also: Ornithischia; Saurischia

page 1/12 NEXT ▶▶|

For Further Study

Paleontology

Research Updates | Biographies | News Archive | AccessScience Q&A | Web Resources

Printable Version

DOI 10.1036/1097-8542.196800

Privacy Policy

A Division of The McGraw-Hill Companies

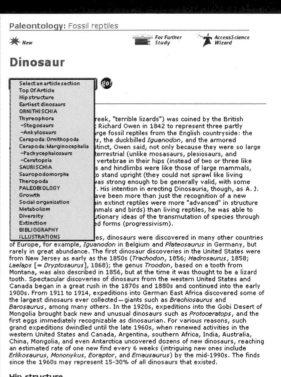

AccessScience @ McGRAW·HILL

○ Search This Site
○ Find a Definition *go!*

More Search Options
Browse/Explore
In the News
Biographies
Student Center
Related Sites
AccessScience Q&A
Suggestion Box
Help
🏠 Home
Select a Topic ⬍
go!

Paleontology: Fossil reptiles

✳ New — For Further Study — AccessScience Wizard

Dinosaur

Select an article section
Top Of Article
Hip structure
Earliest dinosaurs
ORNITHISCHIA
Thyreophora
 –Stegosaurs
 –Ankylosaurs
Cerapoda: Ornithopoda
Cerapoda: Marginocephalia
 –Pachycephalosaurs
 –Ceratopsia
SAURISCHIA
Sauropodomorpha
Theropoda
PALEOBIOLOGY
Growth
Social organization
Metabolism
Diversity
Extinction
BIBLIOGRAPHY
ILLUSTRATIONS

...reek, "terrible lizards") was coined by the British ...t Richard Owen in 1842 to represent three partly ...rge fossil reptiles from the English countryside: the ...s, the duckbilled *Iguanodon*, and the armored ...tinct, Owen said, not only because they were so large ...terrestrial (unlike mosasaurs, plesiosaurs, and ... vertebrae in their hips (instead of two or three like ...s and hindlimbs were like those of large mammals, ...to stand upright (they could not sprawl like living ...was strong enough to be generally valid, with some ...r. His intention in erecting Dinosauria, though, as A. J. ...ave been more than just the recognition of a new ...ain extinct reptiles were more "advanced" in structure ...mmals and birds) than living reptiles, he was able to ...utionary ideas of the transmutation of species through ...ed forms (progressivism).

...es, dinosaurs were discovered in many other countries of Europe, for example, *Iguanodon* in Belgium and *Plateosaurus* in Germany, but rarely in great abundance. The first dinosaur discoveries in the United States were from New Jersey as early as the 1850s (*Trachodon*, 1856; *Hadrosaurus*, 1858; *Laelaps* [= *Dryptosaurus*], 1868); the genus *Troodon*, based on a tooth from Montana, was also described in 1856, but at the time it was thought to be a lizard tooth. Spectacular discoveries of dinosaurs from the western United States and Canada began in a great rush in the 1870s and 1880s and continued into the early 1900s. From 1911 to 1914, expeditions into German East Africa discovered some of the largest dinosaurs ever collected—giants such as *Brachiosaurus* and *Barosaurus*, among many others. In the 1920s, expeditions into the Gobi Desert of Mongolia brought back new and unusual dinosaurs such as *Protoceratops*, and the first eggs immediately recognizable as dinosaurian. For various reasons, such grand expeditions dwindled until the late 1960s, when renewed activities in the western United States and Canada, Argentina, southern Africa, India, Australia, China, Mongolia, and even Antarctica uncovered dozens of new dinosaurs, reaching an estimated rate of one new find every 6 weeks (intriguing new ones include *Erlikosaurus*, *Mononykus*, *Eoraptor*, and *Emausaurus*) by the mid-1990s. The finds since the 1960s may represent 15–30% of all dinosaurs that existed.

Hip structure

As dinosaurs became better known, their taxonomy and classification developed, as well as their diversity. In 1888 H. G. Seeley recognized two quite different hip structures in dinosaurs and grouped them accordingly. Saurischia, including the carnivorous Theropoda and the giant, long-necked Sauropoda, retained the

ARTICLE PAGE DESIGN

The final page designs repeat the global navigation bar on the left found on the Topic Home Page. The local navigation is split between the top and the bottom of the article text block, as shown in this composite screen shot. The structure of the article itself, which can be quite long and complex, is collapsed into a pull-down list, shown in the second screen shot. This list feature gives the user a quick outline of the article along with quick access to any portion, without taking up valuable space at the top of the article text block.

The next case study, the web site presenting the man-machine chess match between Kasparov and Deep Blue, designed for the IBM Internet Program by Studio Archetype, illustrates a similar relationship between abstract planning diagrams and rich page designs. In both cases the relationships between the kinds of material the web site will contain is first worked out in the abstract. Detail is gradually added until the final page designs, built up from the functional requirements, are realized.

KASPAROV VS. DEEP BLUE

www.research.ibm.com/deepblue/

Kasparov vs. Deep Blue Web site
Content map v.1
2.21.97

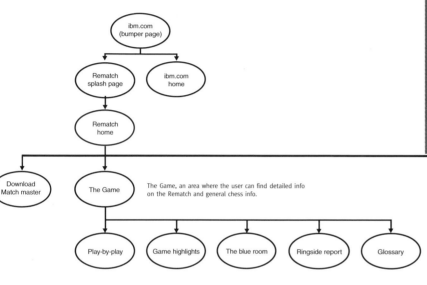

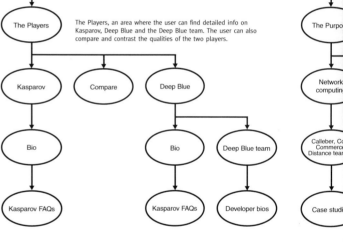

Project objectives

- The purpose of the web site was to advertise, broadcast and archive the Kasparov vs. Deep Blue chess match. The site's architecture needed to change based on the status of the event.

- Most importantly, coverage of the event was only available online – therefore the site had to clearly articulate the live, real-time aspect of the event.

- The site was designed to turn into "a place" during the event and support the Web viewing community.

- The site needed to support both dynamic and static pages.

- An unspecified amount of content was to be generated during the event and broadcast and archived in real time.

- It had to be easy to use.

- It had to support a range of browsers and bandwidth – to be accessible to all users.

- The site had to support both novice and advanced web users and chess enthusiasts.

The rematch between Russian chess master Gary Kasparov and Deep Blue, the chess playing computer program developed by a team at IBM Research, was one of the first major public events presented live on a web site. The result was a dramatic example of applied information architecture and graphic design. The development of the site is captured in this series of planning diagrams, and design schematics, created by the teamwork of Studio Archetype (now a part of Sapient) and the IBM Internet Program. The objectives of the project and the process captured in the maps are summarized by Isabel Ancona, Senior Information Designer, in the bullet pointed text on these pages. The Kasparov vs. Deep Blue web site, containing the summary of the final game on May 11, 1997, can still be found on the IBM Research web site at www.research.ibm.com/deepblue/.

Process – general

- IBM provided Studio Archetype with some existing content, but most of the content was expected to be generated later on in the project and during the event.
- The previous year's event web site was available to learn from.
- Multiple agencies would be working on different areas of the site – therefore a standard system needed to be created to help the production flow of the site. The architecture map became a central tool. It was used to develop and create portions of the site and to help communication within the team.

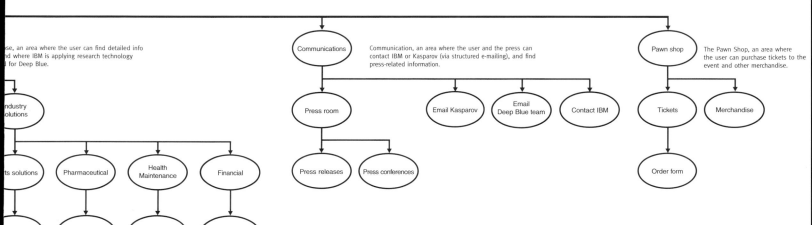

...se, an area where the user can find detailed info ...nd where IBM is applying research technology ...l for Deep Blue.

Communication, an area where the user and the press can contact IBM or Kasparov (via structured e-mailing), and find press-related information.

The Pawn Shop, an area where the user can purchase tickets to the event and other merchandise.

Process – content map

- After an initial brainstorming session with the client, and a quick analysis of existing content and related chess sites, a content map was created.
- The focus of the content map was to show proposed content, content hierarchy/flow and relationships between content. It was not designed to show the actual pages of the site.
- Creating a content map helped the team figure out what was missing in the site, how much content needed to be developed and who would be responsible for the production of the content.
- Since the content was to be developed by another agency, and during the event, it was important to have a solid understanding of the types of content in order to build a flexible architecture that would support static content pages and also dynamically broadcast content pages.

CONTENT MAP

The content map (above) provides an overview of the entire web site. The purpose of this diagram is to define the hierarchy of content within the site. The view is very abstract. The level-one sections are shown, with the structure below represented as single pages connected by lines and arrows. This is a list of page types, not a catalog of pages. A player biography, here shown as a single oval, might develop into several pages. The screen shot (above left) is one of the "biography" pages for Deep Blue. The position of the final page in the level-one hierarchy is reflected in the color of "The players" section tab at the top of the page. Such design details are anticipated, but not specified, in this kind of planning diagram.

KASPAROV VS. DEEP BLUE

www.research.ibm.com/deepblue/

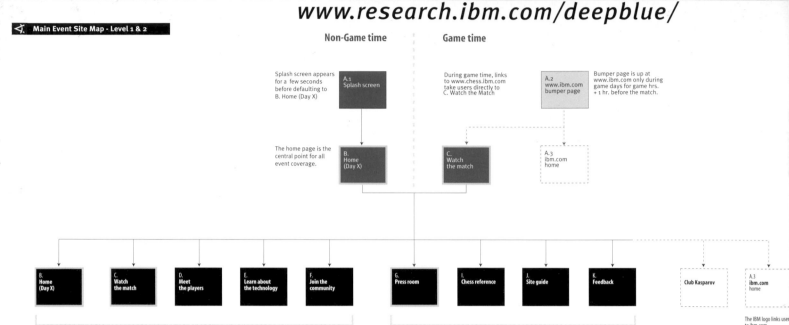

Kasparov vs. Deep Blue: The Rematch Main Event Site Map Version 4.2, April 30

© 1997 Studio Archetype, Inc.

SITE ARCHITECTURE MAP

The site architecture map adds greater structural detail (above). Color is added to distinguish page types as well as structural levels. Color is also used in the lines to represent link types. Link destinations are grouped into navigation bars. These groupings will later determine the position of the links on the page.

Process – architecture map

- With this specific project, the content map became the basis of the architecture of the site. This does not happen with all projects.
- The architecture map showed all the pages of the site. It identified which pages were static, temporary, dynamic, java-based, or supported by another third party site and which pages would be created after the event was over. The map also showed how the site would change based on whether it was pre-event, during the event, during a game or after the event.
- Using color, shape, line weight, and a naming system, each page was coded to help the team quickly identify its purpose.
- The naming system was used by all members of the team to help coordinate production, design content creation and broadcasting to the Web.

A major feature of the web site is the fact that the content of some pages will be quite different depending on whether a game is currently underway. Both diagrams indicated the distinction between Game Time and Non-Game Time on several key pages. On the right, an outline color is used to mark pages that need to support content that will be updated after a match. The mixture of static, dynamic, and quickly updated pages was a complex feature of the site. The diagrams helped support the planning process for both the page designers and the

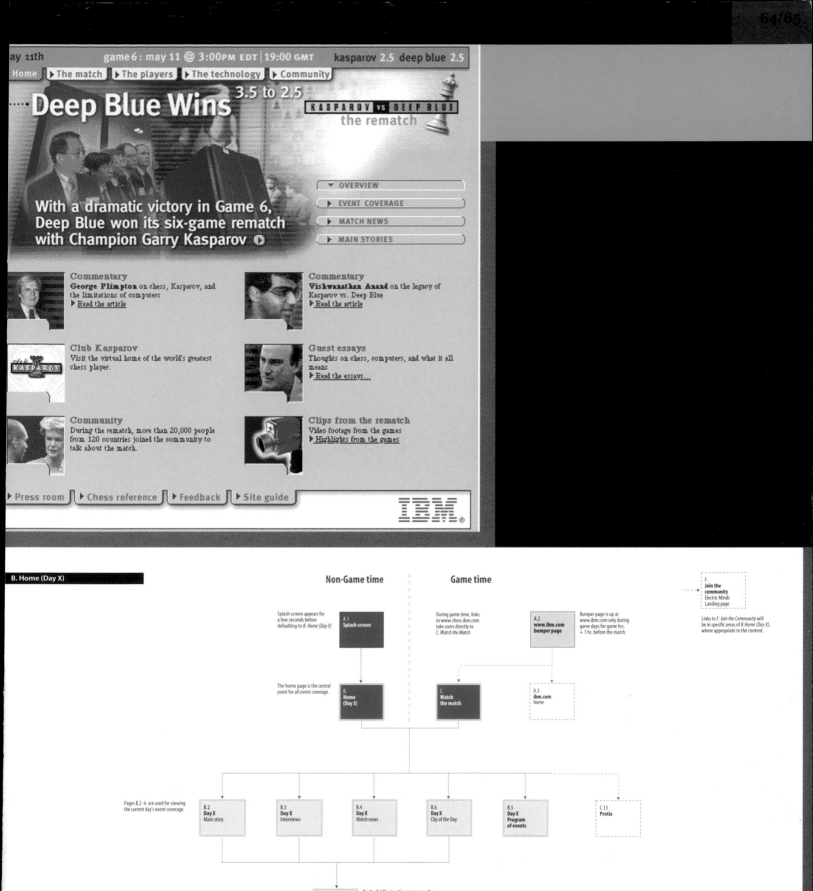

1997 Studio Archetype, Inc.

Kasparov vs. Deep Blue: The Rematch Main Event Site Map Version 4.2, April 30, 1997

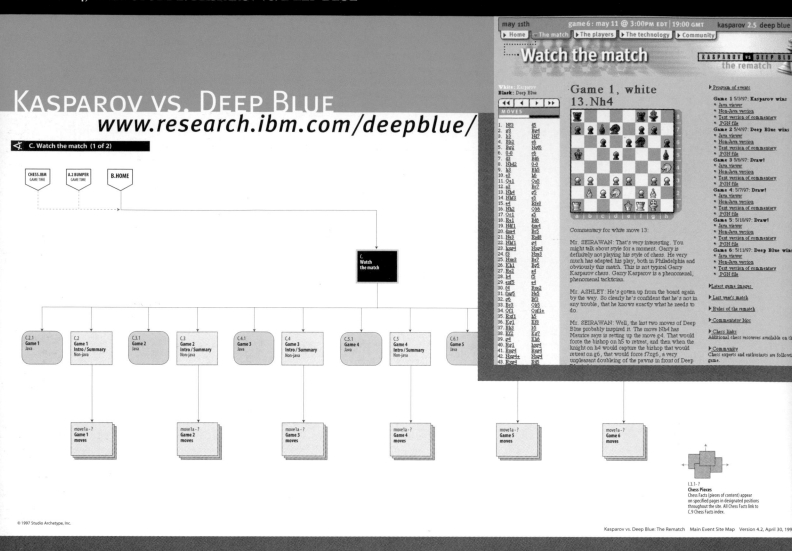

© 1997 Studio Archetype, Inc.

Kasparov vs. Deep Blue: The Rematch Main Event Site Map Version 4.2, April 30, 1997

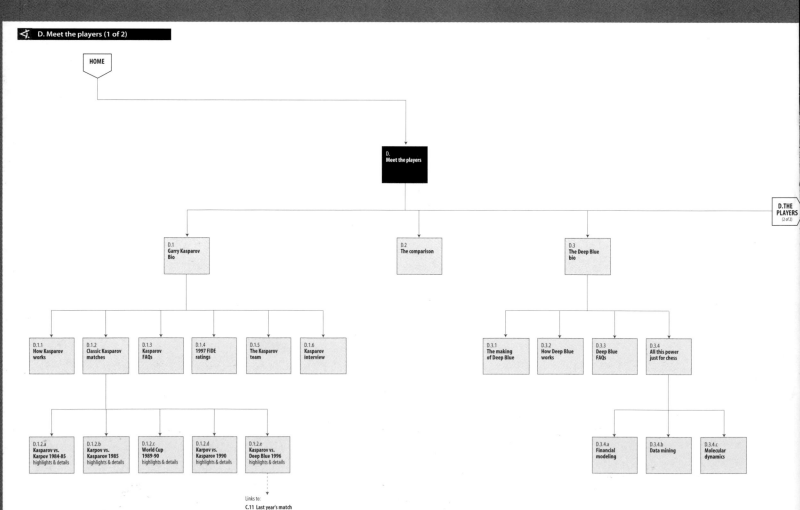

© 1997 Studio Archetype, Inc.

Kasparov vs. Deep Blue: The Rematch Main Event Site Map Version 4.2, April 30, 1997

Process – wireframes
- After both the architecture map and visual design had been finalized, wireframes of different page templates were created. The wireframes were used by both the designers and the writers as guides for creating the content and design of the site.

MAIN-EVENT SITE MAPS

These two maps (left) present details on specific sections of how the event will be played on the site. The example above shows how the event will be watched during the action. Parallel pages of Java-based content and HTML-based content are shown, using color and shape to distinguish the page types. The click depth of the page is represented by the vertical rows of the map. Multiple pages in a series (the game moves) are shown as stacks of rectangles.

In the map below the details of the player biography section are broken down into multiple pages and multiple levels. Such a plan helps the team anticipate the user experience by showing the pathways a user will have to take to reach specific pages.

The wireframe diagrams (above) are a small step away from the final page designs. These are communications between the designers themselves and the writers who must fill the copy holes with the appropriate amount of text. The compositional elements of the page are captured, along with the visual relationships between them. The top and bottom navigation buttons, depicted as abstract groups in the architecture map, are shown as tabs in the wireframe. In the final page design these tabs are carefully raised with shadows and lighting effects to create the illusion of layers on the page. The abstract cross shape at the top of the page will be interpreted through a combination of typography and image to become the logotype for the rematch web site.

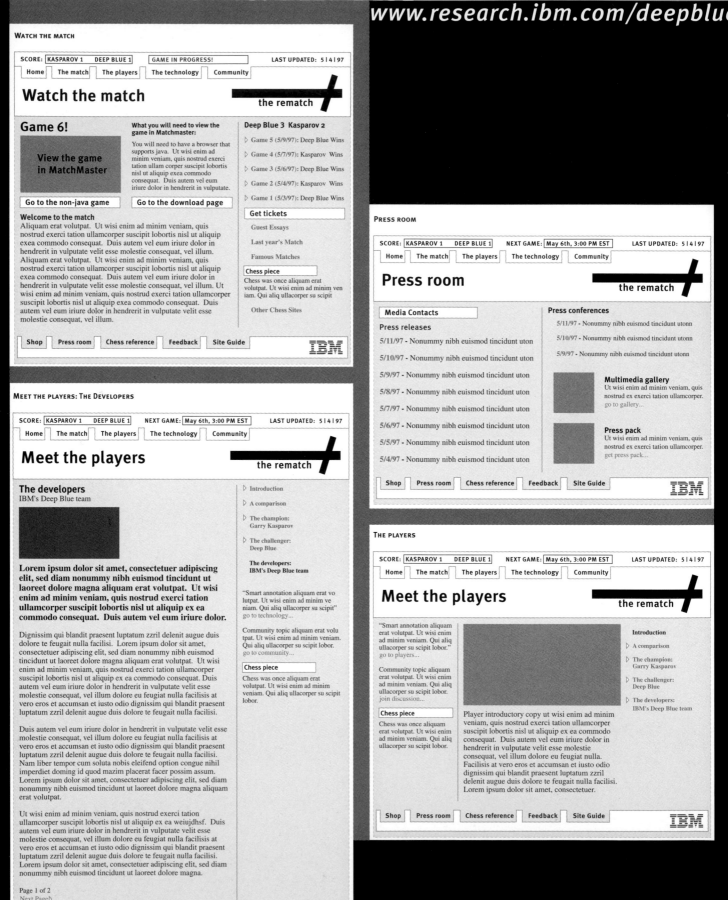

KASPAROV VS. DEEP BLUE

www.research.ibm.com/deepblue

The role mapping played in the project
• Mapping out the web site was a communication vehicle between client and team, and supported the different stages of production, broadcasting and archiving of the site.

WIREFRAMES AND FINAL PAGES
Additional wireframes show the level of detail brought to bear at this point before the final imagery and colors, shown on previous pages, were applied (left). By keeping the area flat and using basic color contrasts, the balance of the design is clear. The details of how each piece of information will be blocked in the layout is defined. Blocks of text are used as another kind of color, with different amounts of contrast between the gray and white background and the black type. Only after the compositional elements are defined do the actual color, images, and type get applied.

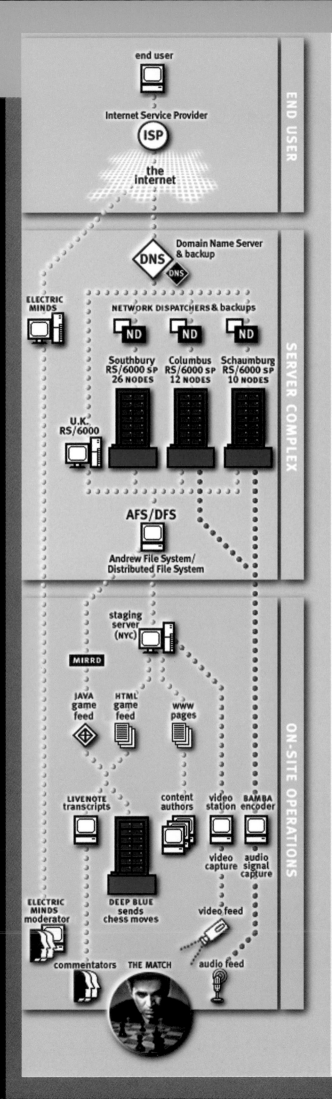

END USER

end user

Internet Service Provider

(ISP)

the internet

SERVER COMPLEX

Domain Name Server & backup

DNS

DNS

ELECTRIC MINDS

NETWORK DISPATCHERS & backups

ND ND ND

Southbury
RS/6000 SP
26 NODES

Columbus
RS/6000 SP
12 NODES

Schaumburg
RS/6000 SP
10 NODES

U.K.
RS/6000

AFS/DFS

Andrew File System/
Distributed File System

ON-SITE OPERATIONS

staging
server
(NYC)

MIRRD

JAVA
game
feed

HTML
game
feed

WWW
pages

LIVENOTE
transcripts

content
authors

video
station

BAMBA
encoder

video
capture

audio
signal
capture

ELECTRIC
MINDS
moderator

DEEP BLUE
sends
chess moves

video feed

commentators THE MATCH audio feed

SYSTEM DIAGRAM
This system diagram (left) provides a very different view of the web site. The diagram is divided into three pages to show the flow of information from the operations group following the event (On-Site Operations) to the network of web servers used to carry the event to the public (Server Complex) and finally to the web browser on the viewer's computer (End User). The purpose of the diagram is to show the flow of data from one operational group to the next. The audience for this diagram is quite broad. Unlike the Content and Architecture maps, this diagram is intended for the larger web site development team.

YELL SITE MAP
This metaphorical site map for the British Telecom Yellow Pages web site (www.yell.co.uk) (left) makes reference to the London Underground map. The mixed metaphor of sections (London, Green Fingers) as "lines" and subsections (Hotels, Q&A) as "stops" is witty, but proved difficult to maintain.

5

What is a Site Map?

The development of web sites evolved very quickly, growing exponentially between 1993 and 1997. The earliest sites were little more than a set of linked pages, often containing lists of words or titles linked to other pages, which contained little more than lists of words linked to other pages, and so on. As the ambitions of individuals and organizations to create large complex collections of linked web pages grew, so did the difficulty of navigating the collections. As is true with many aspects of the web, no individual or group planned or systematically advocated the addition of site maps to the web development vocabulary. It just happened.

If we look at the history of book design, we will see a superficial analogy. The common features we all rely on to find our way around a book developed after the printing process had increased availability and use. The folios, table of contents, and subject index were created to make the content of a book more accessible. The same need gave birth to the site map for web sites. Mosaic, the first widely available web browser, was developed in 1993. Web sites began to proliferate within the year.

When we designed our first web site for a commercial client in 1994 there were only 300 .com sites registered and most web sites were a few hundred pages at most. By the summer of 1995 it was evident to many web designers and developers that simply following links or searching for words was not enough to support navigation on most web sites. There were hundreds of thousands of web sites and many contained tens of thousands of pages. By early 1996 site maps began to appear as a regular feature of many sites. The earliest examples are drawn from that year.

A site map is a navigation aid for the visitor to a web site. The audience for the planning diagrams described in the previous chapter is primarily the planners, producers, and developers of web sites. The audience for the site map is the person trying to find his way around a specific web site. There is no common definition of a site map. It may be an index, a table of contents, an overview, or a diagram.

Our observation and practice show that there are a limited number of visual strategies for a site map.
Lists: hierarchical lists organized in horizontal and/or vertical relationships.
Progressive Disclosure: an unfolding presentation

We have organized the examples in this chapter into these four groups, though any specific site map may contain more than one approach. In combination with these strategies, there are a set of visual variables that are used to express hierarchy, association, and difference.
Type size
Type and/or background color
Proximity
Indent
Connecting lines
Symbol or icon

L. L. BEAN 1999
The L. L. Bean site map represents three levels of structure using type size, background color and indent.

ADOBE 1996

ADOBE 2000

Lists

As we have already seen in the planning diagram examples, a web site can be understood as having levels. Starting from the Home Page, the main sections of the site are at level one, the subsections at level two, the parts of subsections at level three, and so on. This information can be presented as a topic hierarchy in the form of lists. These lists can be organized in horizontal and vertical columns and in indented sequences.

The Adobe site map from 1996 was an exemplar of this approach for many years. The basic approach is a horizontal list of sections (level one), with a vertical list of subsections (level two). This has a strong visual appeal. It is easy to see the connection between the section title and the subsection titles immediately below, though this becomes less useful for very long lists (e.g., products). Subsections can be easily modified by adding or subtracting text elements in the column below the heading.

The top bar in this example has two layers. The top line represents global links which have no subsection structure (Home, Map, Index). The bottom line represents the six level-one sections of the web site (What's New, Products, Solutions). These two lines were the global navigation for the entire site. A recent redesign of the site has added to the complexity of both the global navigation and the section structure of the site as a whole. The new site map shifts the sections into two horizontal columns, making the larger list more compact by adding to the vertical rather than the horizontal space.

BOEING 1997

The same approach can be accomplished in a vertical layout, as we see in this 1997 example of the Boeing site (above). This map uses a three-column vertical table to represent the level-one and -two structure of the web site, with the third column used to explain the content of the section. The vertical orientation has the disadvantage that users have to scroll down the page to see all the sections. However, scrolling to reveal the contents of the site becomes a very difficult problem to avoid as web sites get bigger. The early Boeing map uses text in different color table cells to separate vertical sections and tie together horizontal groups.

BOEING 1999
The 1999 version of the Boeing site map lacks the color coding of the original map. It also adds an exhaustive and unlinked list

A similar use of text lists with different color table cells is used in the Netcenter site map (right). The background colors help our eye separate the columns, while the variations in indent and font size in the Channels column help us see the section/subsection structure within that column. The entire page is very fast to load, a critical issue for a high-traffic site such as Netcenter.

The Gap site directory (below) provides a quick overview of the large retail clothing web site. The hierarchy is expressed with variation in type size and style, with no indent and no color background change. The names of sections are done as graphic type, maintaining the look and feel of the Gap identity, while the subsections are linked text. The result is more neutral than the Netcenter example, and our eye is not drawn to any particular section. However, the sections are divided into two horizontal groups, so that the hierarchy of retail sections (men's department, women's department) over support sections (advertising, help) follows the expected reading of the page from top to bottom, left to right.

NETCENTER 2000

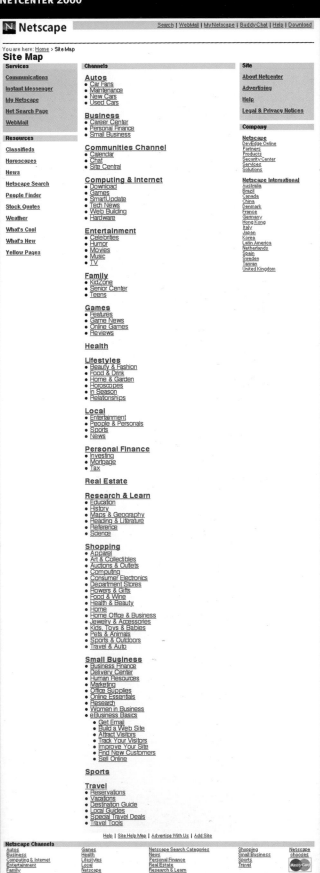

GAP 2000

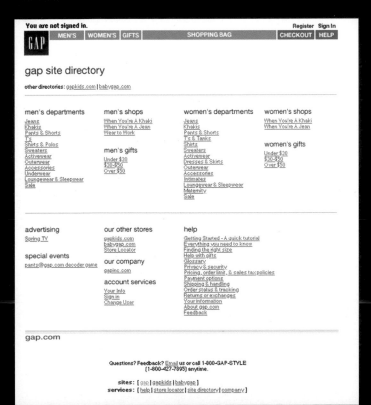

CNN.COM, FOUR SITE MAPS

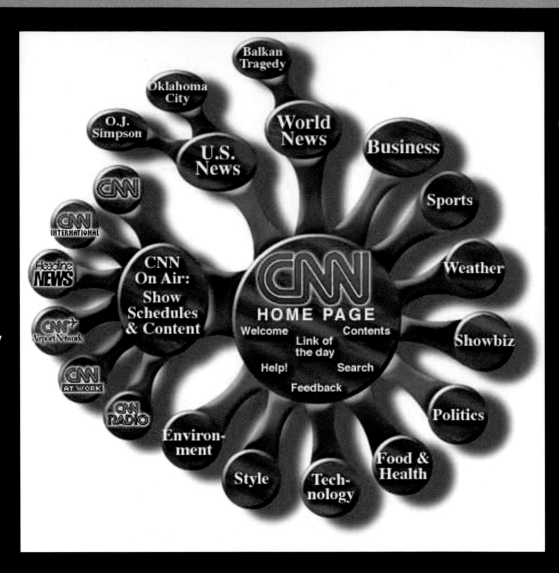

CNN 1995 (RIGHT)
This early site map appears to be the result of a creative designer and some 3D rendering software. The approach is somewhere between a circular design and a metaphor. The question is: a metaphor for what? The relationship between stone ovals, mahogany branches and an international news organization is not immediately clear. Several formal design problems also appear. Placing text on oval backgrounds causes serious legibility problems, which we will see later in the Macromedia examples. Mixing names of sections (Business, Sports) with logotypes for organizations (Headline News, CNN Airport Network) creates a large visual imbalance.

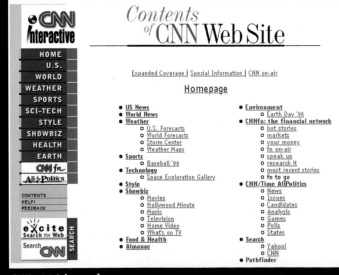

CNN 1996 (ABOVE)

Level of Detail

How much detail should a site map reveal about a web site? The answer depends on how we judge the function of the map. Should the site map help a visitor get a sense of what the web site contains or should it help him locate and navigate to a specific section? The map should offer several advantages over a simple text search. The visitor can locate things by recognition rather than by guessing the correct name. He can also discover resources he was not aware existed, such as the Quicktime collection of current television advertisements for the Gap or the Swedish-language Svenska CNN site.

A quick look at the evolution of the site map for CNN.com shows us a great deal about how difficult it can be to answer the question of how much detail should be shown. Cable News Network is one of the largest news organizations in the world, and their web site is certainly one of the largest web sites of any kind.

The first site map (1995) showed the first-level sections, similar to the sections of a newspaper, along with relationships to other CNN organizations (CNN International, Headline News). The level of detail is minimal. The next version (1996) uses a two-column indented outline.

CNN 1998 (BELOW) AND 2000 (RIGHT)

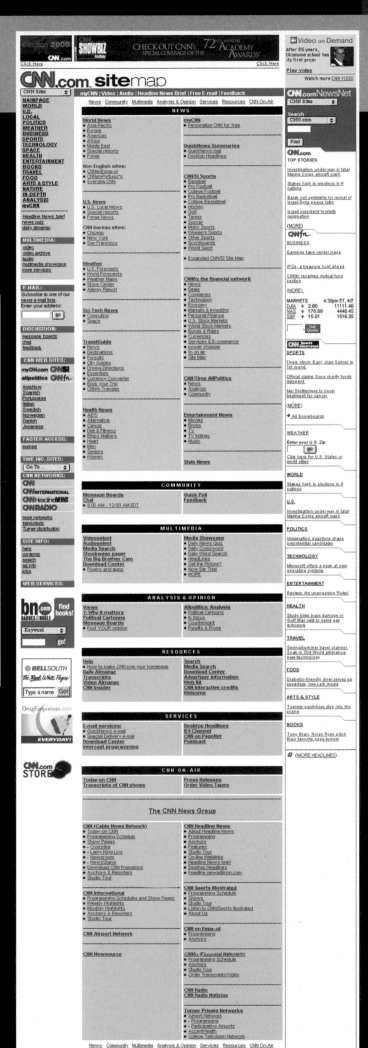

This supported a larger amount of detail and was certainly more flexible than the original design. However, the scope and complexity of the site required a further division, so that the third version (1998) introduced horizontal blocks separating stacks of the two-column indented outlines, each of which represented two levels of structure within a section (News, Multimedia). The current version of the CNN.com site map adds a left column containing the global navigation system for the entire site, and a right column containing linked headlines for current features. Just what to call this enormous page is a question that CNN.com leaves ambiguous. The link on the Home Page calls it "contents" while the page itself carries the title "site map". Whatever we choose to call it, the vertical length is 2500 pixels deep – four or five screens of scrolling for most users.

MACROMEDIA.COM, SEVEN SITE MAPS

We have chosen to review seven versions of the Macromedia web site. The evolution of this site map over the past four years illustrates some interesting variations in the use of lists, color, and position. The earliest map, from March 1996 (above), is the most visually imaginative. It packs three levels of site hierarchy into a relatively small space using combinations of type size, color background and lines. The metaphor of a wiring diagram holds the composition together. The two shaded color labels make it easy to see the first-level pages (Industry Pulse, Cool Tools) and associate the appropriate second-level pages with each group. Note how the four second-level pages under Free Toys are grouped by color, even though they are broken into two columns to fit the constraint of the rectangle. At the same time, the tightness of the design makes it very difficult to modify and maintain. As the structure and design of the site changed this first approach was abandoned.

The second map, from August 1996 (left), switched to the same horizontal/vertical list approach we saw in the Adobe site map (page 73). But in this case a more graphic system was used. The second-level pages are "hung" from the first-level pages, connected by lines. The color coding is maintained to separate five of the seven sections of the site. The color is used to group the second-level pages, which in turn correspond to the colors used in the global navigation bar on the left of the map, with some confusing variations. The problems created by placing text on ovals are dramatically present here. Note how many text labels fight with the edge of the oval or extend past the edge causing poor contrast for the type.

In the third map, from January 1997 (left), the same approach is used with several variations. The color coding is dropped, both in the global navigation and the map itself. Now all second-level pages use the same violet background. The ovals have changed to rounded rectangles, a better fit for the text. However, the uniform size of the rectangles against the one or two lines of text creates large variations in the exposure of the background color and crowds the text in many places. The "info & help" section floats unconnected.

MACROMEDIA.COM, SEVEN SITE MAPS

The fourth map, from July 1997 (above), introduces the sparser look that continues to the present. The single background color is used for the first-level pages only. The rounded rectangles have grown to accommodate three lines of text. The entire map is framed by a display ad banner and a more text-oriented global navigation on the left.

The fifth map, from June 1998 (right), introduces two innovations. The rounded rectangles become squatter and lozenge-like. The text has returned to two lines and still crowds the edges. The connecting lines have disappeared.

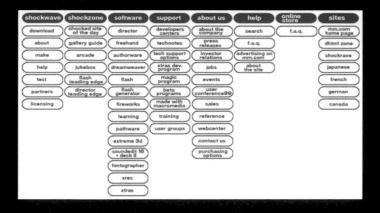

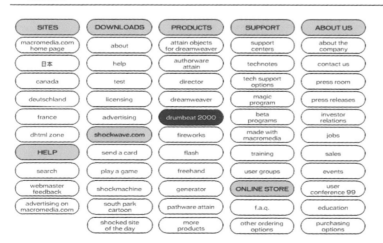

In the sixth map, from November 1998 (left), the background color is softened to a gray and the stacks are arranged in four columns, rather than a single horizontal row. The color used to define the edge of the rounded rectangle is also softened, making the crowding of the text less noticeable.

The seventh map, from April 2000 (left), tightens this design. The white space between the groups has been removed. Eight first-level pages have been fit into five columns. This reduces the size of the map, but it also makes it more difficult to see the first- and second-level pages as groups. A bright blue background is used on rollover to mark the user's interaction with a page on the map.

BELLSOUTH.COM, THREE SITE MAPS

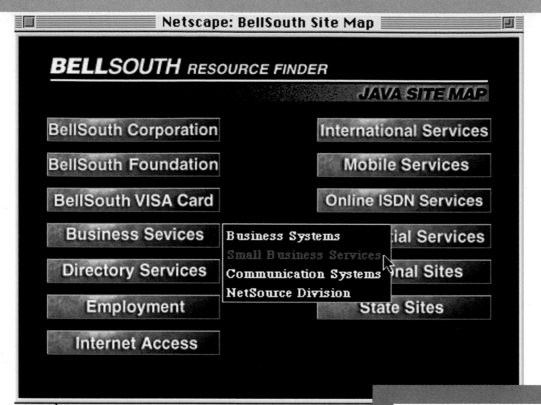

BELLSOUTH 1997–2000
The three designs for the BellSouth site map show three different approaches to this strategy. The earliest from January 1997 (left), a java applet that opened in a separate window, presented two columns of first-level section titles. Moving the cursor over a title revealed a layer containing a second-level menu.

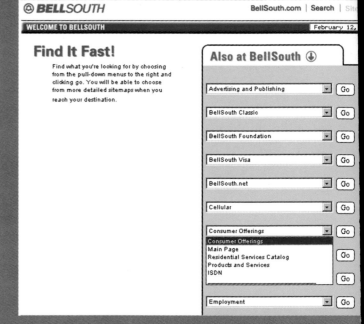

In February 1998 this was replaced with a group of pop-up lists (above). The approach was simpler, but perhaps it was too uniform. There was no visual distinction between the ten sections.

Progressive Disclosure

We have already seen that most site maps display two or three levels of the site hierarchy. The number of elements in that hierarchy can grow quite large. How can the display of this information be controlled so that the user sees enough, but does not have to scroll through many screens?

One common strategy is progressive disclosure. This is the same principal used in the basic menu interface. All the titles of menus are available on the top of the screen, but only one menu list and sub-list is displayed at a time. The same idea can be used to create site maps that show one level of information, and then reveal additional levels through user interaction. This has been extended for many application programs by optional floating palettes. While it is possible to open separate browser windows to contain a site map (we will see examples of this in the data-driven maps in the next chapter), managing multiple browser windows adds more complexity than most users will support.

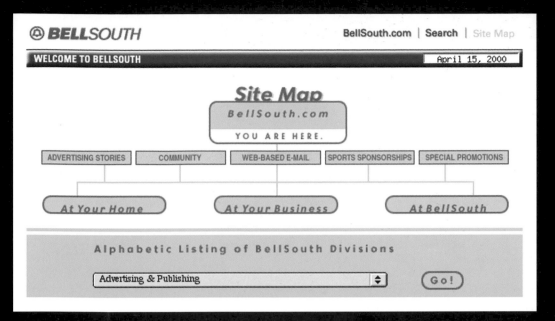

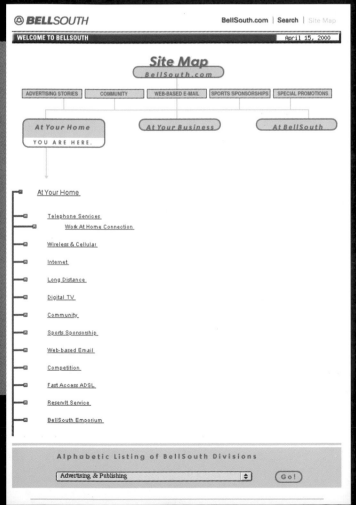

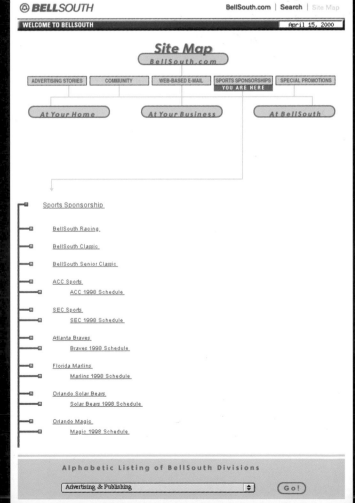

The current approach, which was introduced in June 1998, uses a more graphic approach (above). Eight level-one sections are presented in two groups. The color and type size clearly emphasize the second group of three sections (At Your Home, At Your Business, At BellSouth). Below this is a pop-up list of BellSouth divisions. Clicking on any of the first-level pages presents a list of second- and third-level pages. Lines connect the selected section to the list below. Only one list is visible at a time. The second- and third-level hierarchy is represented by color in the lines and indent in the text.

BBC ONLINE

The BBC Online site contains an extremely large hierarchy of elements. One of the first site maps from December 1998 (right) presented a two-column list of main section titles, separated into four groups by a bullet element. Clicking on a section title would reveal the subsection, and in some cases a third level as well. In this way only small parts of the web site were shown at any one time. The current map (left), which carries the title "A-Z Index of Websites", presents a daunting array of twenty-one pop-up lists. Most of these lists fill more than one screen with names of second-level pages. The lists are grouped by alphabet and category, giving the user two ways to find each section. The design trades off scrolling pages for scrolling lists.

UNITED AIRLINES 1996
United Airlines was not selling tickets for space travel in 1996, but this site map used the backdrop of the starry universe and a view of the earth from the moon. This imaginative example of progressive disclosure presented second- and third-level pages for seven first-level sections. Each section expanded by dropping a banner containing the subsection titles, with levels expressed by variations of type and indent. Up to three banners could be displayed at a time with no overlap.

Circles

The same information that can be presented as a hierarchical list or indented outline can also be presented as a series of layers around a central point. Circular organization carries with it an implied meaning. In terms of the visual impact of the map, the starting point (usually the Home Page) is at the center of the focus, rather than at the top left of a long list of items. A circular organization can be a very efficient way to present information. By radiating out from a central point, a map can combine many of the same visual clues used in lists to represent a hierarchy, such as variations in size, indent, and color, as well as strategies from progressive disclosure such as pop-up lists.

The result can be graphically appealing, inviting exploration and interaction. The key to a circular map is deciding how much detail to represent, and how literally or clearly the map should show the hierarchical relationships. Most circular maps are limited to showing first- and second-level structures. Deeper representations become crowded or too broad to present in a single screen.

Site Map

Hot News
Apple News
Apple Software Updates
Other Software Updates
Other News
Events
Tips

Products
Hardware:
Power Macintosh
PowerBooks
Displays
Servers
Imaging & Printers
Message Pad
eMate

Software:
Mac OS
QuickTime/VR
WebObjects
AppleShare IP
AppleScript
ColorSync
QuickDraw 3D
HyperCard

Design & Publishing
Masters of Media:
News
Features
Calendar
Point of View
Site Archive

Just The Facts:
Why Apple
Mac OS
Technologies
Collateral
Developer Tools
Resources
Finding Success

Technology:
AppleScript
ColorSync
QuickTime
QuickTime VR
Mac OS

About Apple
Company Information
Apple at-a-glance
Apple logo use
Investor Information

Media and Analyst Info:
Press releases
Contact info
Executive bios and photos
Apple at-a-glance

Working at Apple:
Job Search
Areas to work in Apple
Culture & Benefits
Internships & College Hires
Application Process

Sign Me Up
Product Registration:
U.S.
Canada
Europe
Africa
Asia
Australia
South America
Central America
Japan
Mexico

Publications & Mailing Lists:
Apple Publications
Related Publications

Support
Technical Support:
Mac OS and Applications
Desktop Computers
Portable Computers
Apple Displays
Printers & Imaging
Servers & Networking
WebObjects
OpenStep
QuickTime
eMate/MessagePad
Basic Troubleshooting
Downloading Software
Using Apple Support
Servicing My Computer

Education
K-12 Education:
News & Events
Product Information
Price List
Educator Home Purchase
Technology in Learning
Staff Development
Support
Convomania
Disability Resources

Higher Education:
News & Events
Product Information
Learning Community
Community Connection

Where to Buy
U.S. Retail & Service
Macintosh
MessagePad
eMate
WebObjects
Consulting
Authorized Service

Loans & Leasing
Educator Loans
Higher Ed Loans
Consumer Loans
Business Lease
Education Lease
Financing
International Information

APPLE COMPUTER

The Apple Computer site map was one of the most successful circular map designs (left). Seven first-level topics with three to six second-level pages were presented. At the center was the Apple logo, supported by a color coding of first-level sections. The design was flexible enough to last for several years. In 1997, this was replaced with a comprehensive four-column table layout (above) that was exhausting to read, only a portion of which is reproduced here. In late 1999 this was replaced by a trimmed down four-column table (right). This third design is easier to read, combining graphic text for the first-level sections with text lists for the second-level pages. A pop-up list is used to show the international web sites.

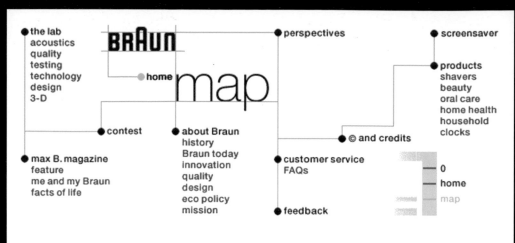

BRAUN 1997 AND 1999

Braun, a manufacturer of home appliances, emphasizes high-quality industrial design in their products. The site map from 1997 (above) used a circular design that combined type, dots and lines to convey all the first- and second-level pages on the site. The Braun logotype is off-center. The entire design plays with the grid by being both rigid and eccentric, and integrates a metaphoric element on the lower right that evokes the controls on an appliance. Color rather than size is used to distinguish the two levels. The current site map (right) abandons all of these strengths in favor of a simple list. The overexposed arrow conveys nothing about the company or the products being presented.

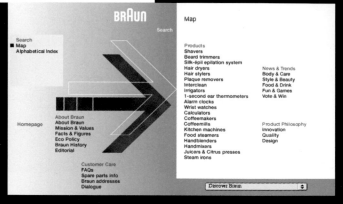

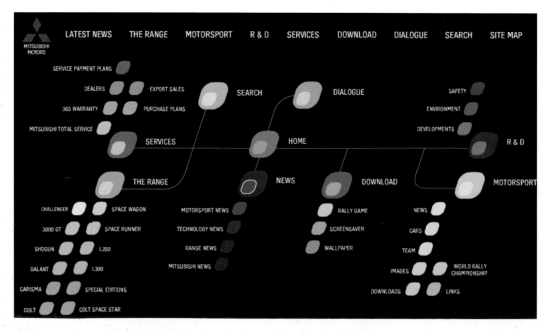

MITSUBISHI MOTORS UK 1998
This site map (left) uses a circular design, with bright color and size to group the eight first-level sections with their second-level pages. The blending of the colors from light to dark away from the center makes the second-level pages different shades, introducing some unnecessary confusion. The result is colorful, compact, and easy to interact with.

NORDSTROM s h o e s

men's women's kids' trends brands site map NORDSTROM.com

site map:

NORDSTROM

s h o e s
nordstromshoes.com

| top ten | sole's desire | log-in | site map |

men's kids' brands
women's trends

| shoe search | my picks | shopping bag | my account | ask us |

Address Book **Fit Advisor**
Order History **Customer Service**
Gift Reminder **Contact Us**
My Information **How to Shop**

shoe search my picks shopping bag my account ask us

make room for shoes

NORDSTROM SHOES 1999

The site map for the Nordstromshoes.com retail web site (above), launched in November 1999, uses some elements of a circular design. Three groups of first-level sections are represented, connected to each other by size, typography and color treatment. Rather than placing the Home Page logo in the middle, the shoe departments (men's. kids', etc.) are made central by size and position. Second-level pages are shown for the last of these sections. The connections between these groups are left intentionally vague. Compare the Home Page for the same site (left) which shows many of the same elements, but in a very different hierarchy.

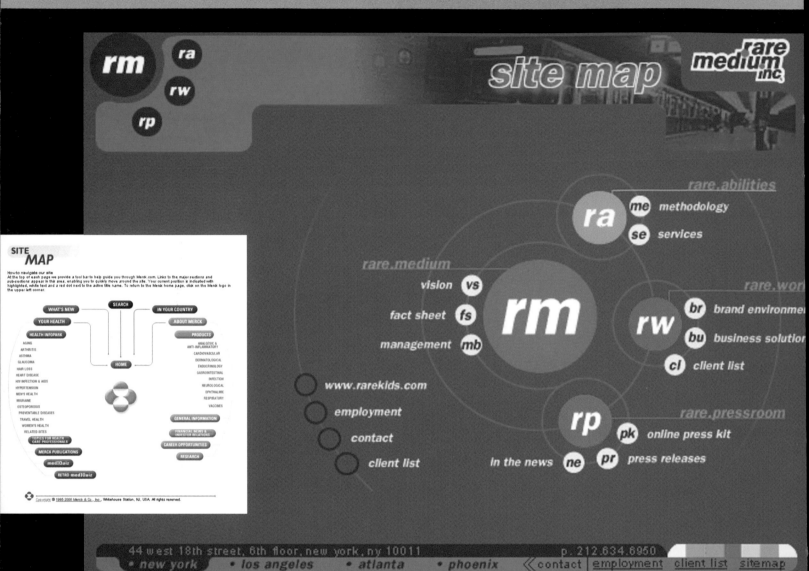

MERCK 1999

The current Merck site map (above, left), introduced in 1998, uses a circular arrangement to present three levels of structure. Here the visual distinction between the first- (Your Health) and second-level (Health Infopark) titles is difficult to see because the treatment is so similar and the circular arrangement makes them look equivalent.

RARE MEDIUM 1998

This site map for the Rare Medium web site (above) from late 1998 uses nested circles. The three main sections of the site are distinguished by size and typographic treatment. The

abstract metaphor of a solar system (star, planets, satellites) holds the composition together without burdening it with meaning. Compare this with the metaphoric Merck map from 1997 (page 92).

SCIENTIFIC AMERICAN MEDICINE ONLINE

The two linked circles (right) represent two sections of the same web site, one available to the public and the other restricted to subscribers. Five symbols for page types are represented as well.

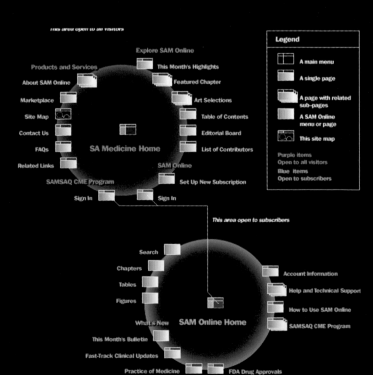

SONY COMPUTING
The site map for Sony Computing, a section of the Sony Electronics web site, uses a combination of a circular illustration and pop-up lists.

The initial view of the map (top) shows the four main sections of the site: Products, Community, Technology, Support. The titles are connected to the graphic elements that appear on the

top left of most pages. The structure within each section is hidden in a pop-up list (above). These lists vary from a single item to a screen full of choices. The overall effect is visually

attractive, though as with all progressive disclosure strategies it takes some effort by the user to get a sense of how much the site contains.

Metaphors

Metaphor is often a partial design element in the previous examples, but these site maps rely almost entirely on metaphor to convey their message. It is difficult to do well. A web site is not a solar system, as the two views of the Merck web site circa 1997 (below), suggest. Merck is the star around which the planet Disease Infopark revolves, and clicking on it reveals satellites such as Hair Loss and Asthma. The metaphor fights rather than supports the message. The map of the Israel Ministry of Foreign Affairs (far right), succeeds with a complex mixture of wit, appropriate metaphor, and visual reference. The basic image, the Star of David, is the national symbol. The star shape is divided into first-level sections, which are then connected by colored lines that represent themes that cross section boundaries. There is the suggestion of a transportation map. Studying the map enhances our understanding of relationships within the site content.

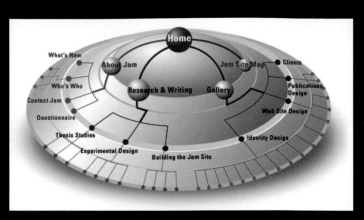

JAM Design (above) does not produce flying saucers. They do produce well-crafted, subtle 3D images as part of their web design practice. The site map, which drapes a two-level hierarchy of section titles over the image of a space craft, provides a functional overview with a touch of humor.

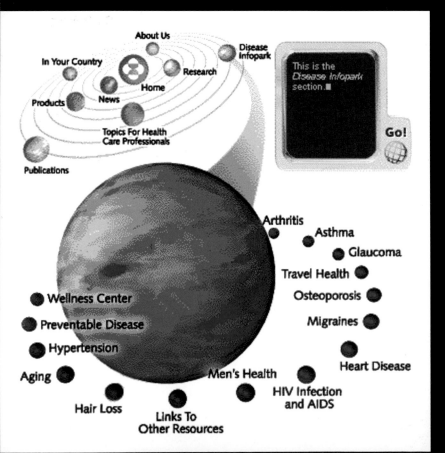

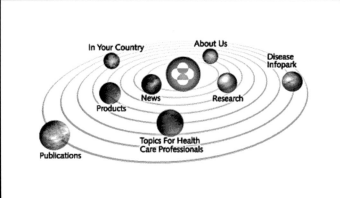

TOYOTA BELGIUM 1997

A metaphor can be inappropriate, no matter how well it is executed. This detailed rendering of a circuit board, complete with resistors and LEDs, was meant to provide an overview of the web site for Toyota Belgium (above). The items of greatest interest, the car models, are almost lost in the poor contrast of the red text against the blue background.

STAR WARS
This map of the Star Wars web site dates back to 1996 (left). The functions of the web site (Email Notification, History) are arbitrarily associated with planets in the fictional universe (Bespin, Hoth). As the site grew the metaphor wore out and the map was eliminated.

THE PARTICLE ADVENTURE ROADMAP
The Particle Adventure (above) is an educational site about the fundamentals of particle physics produced at Lawrence Berkeley National Laboratory. This early site map uses the metaphor of the patterns left by colliding particles in high-energy physics experiments. This is well suited for linking pages that are part of a "path" sequence.

d/D Portfolio of Site Maps

In our own design practice we have created site maps for a variety of web sites, most of which represent online publications. This collection of eight site maps shows the range of graphic strategies used by designers at Dynamic Diagrams over the past few years. In each case the map is intended to give the visitor a quick overview of how the web site is organized. First- and second-level pages are always shown. For additional examples, see the Britannica Online map on page 36 and the Access Science map on page 52.

AIMR
The site guide for the Association for Investment Management and Research publications web site (left) uses both color and indent to show the main sections of the site. Some of the graphic identity of the publications is graphically "quoted" as bullets.

COLOR AND INDENTS
Both the map for the American Journal of Archaeology (above) and the Annals of Internal Medicine (right) use blocks of color to group elements. Indents are used to distinguish levels. The more complex Annals map uses multiple columns to compress the vertical space required for long indented lists. The use of lines and square bullets reinforces the relationship to the navigation mechanism of the site.

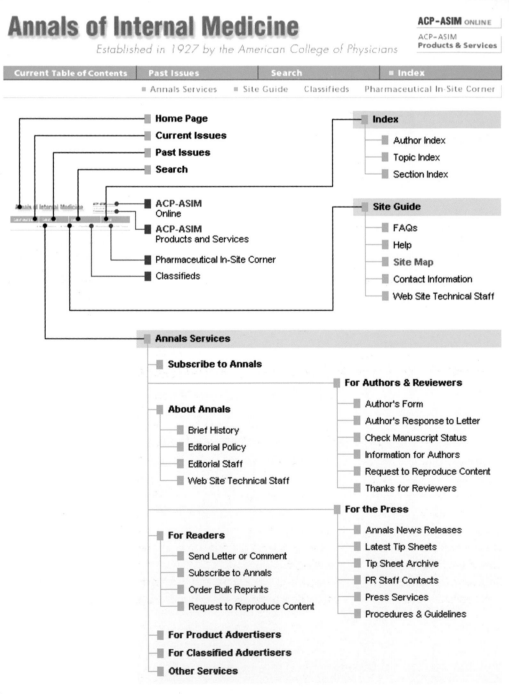

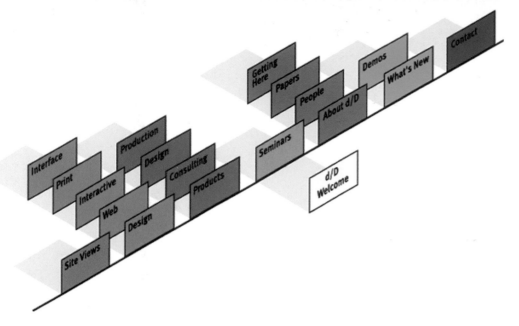

d/D SITEVIEWS

This isometric diagram of the two layers of the d/D web site was introduced in 1996. It is a simplified version of the planning diagram technique described in the previous chapter. Color is used to group sections while proximity infers links between the title page for a section (About d/D) and subsection (People). The only line is the one connecting the first-level pages.

LISTS AND LAYERS

The site map for the Publications of the American Medical Association (above) arranges the list of first-level pages into three groups, then uses pop-up lists to show the second-level pages. The entire composition uses a minimum amount of graphics. The map for Harrison's Online (top right) is a composition of colored table cells and text labels. The two colors are used to associate pages with the navigation interface. The map for the Publication of the National Academy of Science (middle right) is a simple outline contained in a four-column table. The Nature Cell Biology map (bottom right) is a flattened version of the more complex site architecture diagrams for Nature shown earlier. Here the three levels of access (Visitor, Registered, Subscriber) are shown by variations in the background color. The same map with small variations was used for six Nature publication web sites that shared the same architecture.

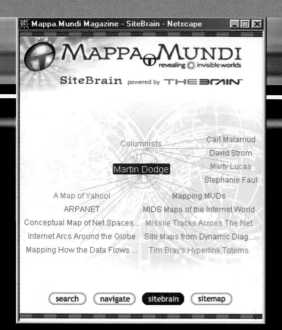

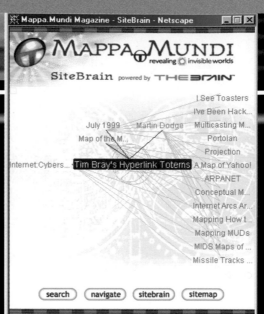

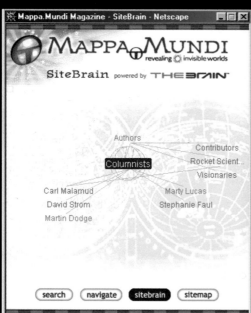

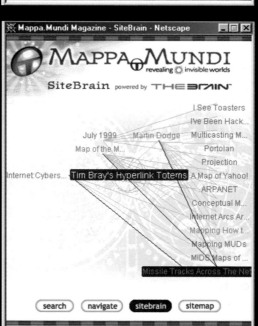

SITEBRAIN IN ACTION
The Sitebrain map for the Mappa. Mundi Magazine web site shows three levels of detail, which move and change as the user selects titles. The data for the map is categories for pages, rather than link relationships. The animation sequence moves from Authors, to Columnists, to a specific writer, to an article by that writer. Peer groups for each selection appear on the right. Lines show the multiple hierarchy relationships between a selection or article and the categories in which it appears. On the bottom right a story from the "Map of the Month" section in the July 1999 issue is in the center. The highlighted story on the bottom shows three connections shared by the selected story: the same author (Martin Dodge), the same section, and the same topic (Internet Cyberspace).

6

Data-driven Site Maps

Modern cartography is a science, as well as an art. Maps are made from geographic data, measurements of distances, heights, and depths. In a sense all maps are driven, or determined, by the data we have about the territory they represent. The planning diagrams and hand-drawn site maps shown in the previous chapters are all influenced by the actual data the web site contains. But that influence is indirect. The images we see are selected and filtered descriptions of the web site, created by the teams or individuals. What we see is what the designer thinks we want or need to see, a selection of what is actually there. But the hand-drawn site map cannot automatically change when the web site is edited. There is no unambiguous algorithm that can describe the diagrams and drawings in the previous chapters. But if we had such an algorithm, and we had the necessary data, could we write a program to draw the map from the data? Can we render a truly useful map of a web site directly from the data itself?

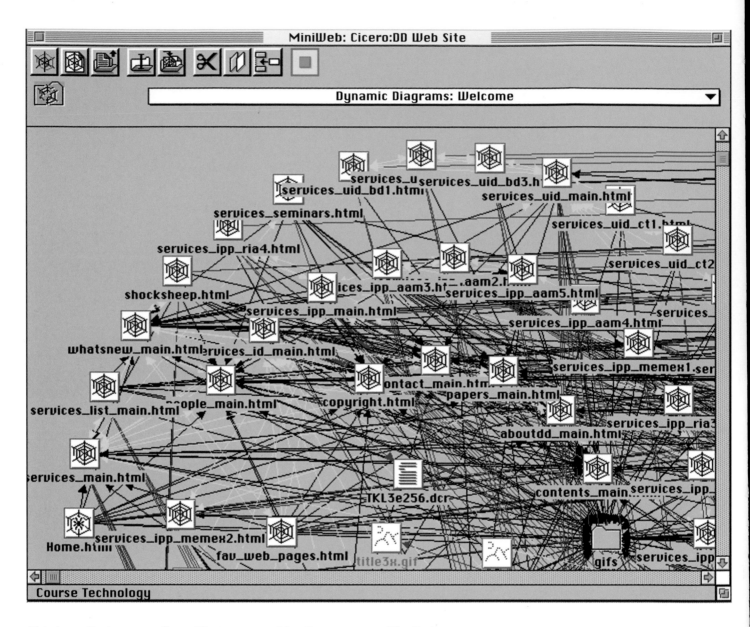

This is really two questions. First, can an objective description of the site be the basis for a map of the site? Can we make a map from the titles of all the documents it contains, the links between those documents, other document attributes such as size, date, or thematic content, and so on. Second, what should that data-driven map look like? What kind of visual patterns created from the data will have any kind of useful meaning? Answering these questions requires that we first define the data that makes up a web site and then describe how to visualize it.

The Data

We can define a web site as a collection of linked documents. The data that describes the web site is a list of the documents and their attributes, including a record of how they are linked. All programs that automatically draw site maps from link data must first gather this information in one form or another.

This is done with a web-walker program (also called a crawler or spider) that starts at a "Home Page" location and "walks" the web site. The program must access the file via the http protocol, request the size and date of the file from the file system, read the HTML source data for the file and extract information such as the page title, and link destination. As the walker program builds

FUSION SITEMAP

The first releases of Netobjects Fusion, a web site authoring tool, included a java applet that created a site map when the web site was "published" by the authoring system. The map was a simple hierarchy of pages. Rolling over the symbol for the page revealed the page title. This example from the USV Telemanagement web site from January 1997 (left) shows the entire site of twenty-three pages. The applet, which was constrained to a single size, did not handle large web sites effectively. As the number of pages increased, the size of the symbol decreased.

HIERARCHY VS. NETWORK

There are a number of approaches to displaying a large number of linked pages. AOL Press (originally Navipress) mini-web arranges pages in a spiral and then shows all links among all pages as a connecting line between nodes. The result is a useless mess of string-art. Stretch, a program by ElasticTech, bends lines representing a single hierarchy to fit many nodes into a small space. Highlighted lines focus attention on portions of the map. Only the "main" link between pages is shown. Note how the levels of the hierarchy appear to project out in space. At the same time, the title of each level is at the same distance from the viewer.

pages, it must also keep track of two things. First it must determine what constitutes the boundaries of a web site. It must be able to detect a link that goes to a page outside the current site. When it detects such a link, it may ignore the link or record information about the destination page. At that point it will stop, or else it will potentially continue following links forever, moving from one web site to the next. It must also detect which pages it has already visited, to prevent repeat visits.

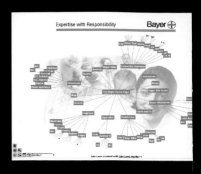

Web Browser created with Inxight Software using Hyperbolic Tree for Java.

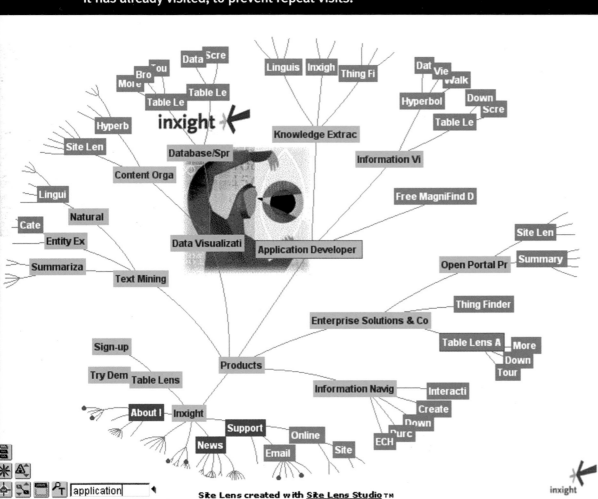

Site Lens created with Site Lens Studio ™

A program can encounter many problems gathering this data. Web servers may not respond to a request. Linked pages may have moved or been deleted. Pages may consist of framesets, or launch multiple windows. Links may be expressed in javascript, Flash, or other non-HTML forms that will work in some browser programs but cannot be interpreted by the web walker. Pages may contain forms which require user input to access databases. Personalization may create different versions of the same web site, based on user attributes that the walker program cannot supply. Any of these problems

INXIGHT SITE LENS

The most ambitious and successful product for mapping web sites is Site Lens (originally the Hyperbolic browser) from Inxight (above). The visualization is an outgrowth of research at Xerox PARC on applying 3D cone trees and fish-eye views to the presentation of large datasets. The "hyperbolic technique"

was demonstrated at the SIGCHI 1996 conference by John Lamping and Ramana Rao. "We lay out the hierarchy plane, and then map this mathematically onto a circular display region. The hyperbolic plane is a non-Euclidian geometry where parallel lines diverge from one another." The result is a hierarchy that appears to bend around a

Site Lens Studio

The Site Lens Studio product, released in 1999, includes all these features and supports various graphic customizations of the same display. Variations in the color and image in the examples from Inxight (far left), Bayer (top left), and Porche (below) create strong variations even though the same visualization is behind

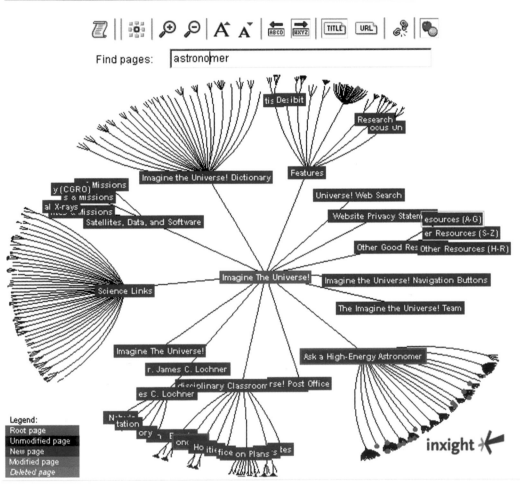

them all. In a paper published at SIGCHI 1995 the authors identified the inspiration for the visualization as a drawing by M.C. Escher (below).

hidden sphere. "Distant" information is visible around the edges of the map, while the elements in the center are larger. A number of different versions of the product have been brought to market. A generic version allows the user to control the size of link lines, label and type size, and orientation of the map.

Altavista Discovery

Discovery (1998) allows a user to map any public web site and view the results with the Inxight hyperbolic browser. It includes a search function that highlights pages with titles containing specific words, highlighted in red. The map of the "Imagine the Universe!" web site (above) is the same

link data shown in the Powermapper and WebAnalyzer programs (pp. 108–109).

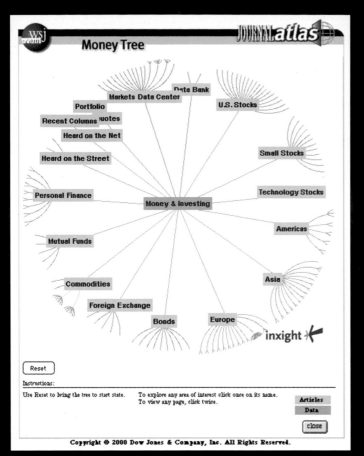

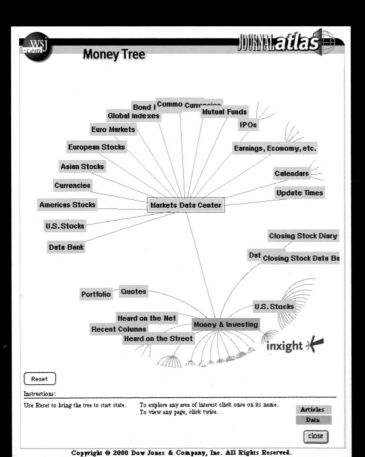

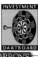

can cause fatal flaws in the link data. Once the links have been collected they have to be organized. Any page can be linked to any number of pages on a web site. While that information may be recorded, the "location" of the page in the map has to be determined by a primary link. In the simplest sense, the network of all the link relationships must be transformed into a hierarchy. This can be done heuristically, allowing the hierarchy to be determined by the order in which the walker "discovers" links following a breadth-first traversal of

WALL STREET JOURNAL INTERACTIVE MONEY TREE
The Money & Investing section of the Wall Street Journal Interactive web site contains the most high-profile application of a data-driven site map. The Money Tree, launched from a link midway down the list of features in the very long left column of the Money & Investing main page under the

the entire web site. Thus the level-one pages are those pages linked from the Home Page, level-two pages are those pages linked from level-one pages, and so on. A level-two page linked from more than one level-one page is placed when it is first discovered. Whether this method creates a useful map of a web site depends partly on how the link structure of the site is designed and partly on chance.

One way to effect the data is to provide controls for the web walker. Limiting the walk to a set number of levels prunes the tree and simplifies the map. The walker programs for Merzscope and Webmapper included interactive controls, allowing the operator to determine which pages are encountered or ignored. A web site could be incrementally explored and mapped in this way. This may not be practical for large web sites.

Journal Atlas features for finding information on this enormous web site, is a version of the Inxight hyperbolic browser. This launches a separate window (top far left) containing the map. The reader sees the main sections of Money & Investing, revealing clusters of content in each section. Pages containing news articles are distinguished from those containing financial data by a color code. Selecting the Markets Data Center (bottom far left) reveals the name of the subsection, as well as further subsections under IPO. Double-clicking on the title "IPO Pipeline" goes to the page containing data on current IPO offerings. This map is updated on a daily basis.

THREE VIEWS OF A WEB SITE
StarNine LiveIndex (below) presented a web site in the form of an expanding outline browser, similar to Windows Explorer. It is difficult to see the relationships between pages when the outline is expanded. It was also difficult

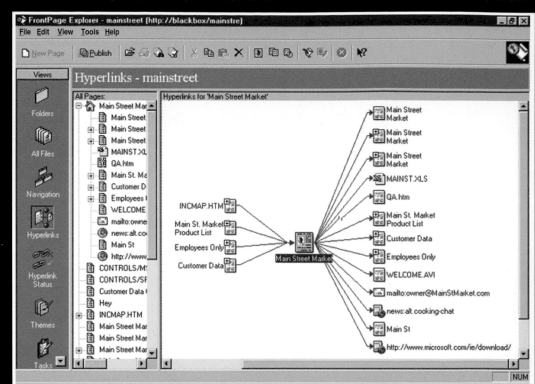

to understand why pages that led to other pages were represented as folders. The Microsoft FrontPage Explorer hyperlink view (top right) showed links leading to and from individual pages on the web site being edited. This star pattern could also get very deep, and the same pages would repeat on both sides of the diagram. The Astra SiteManager (bottom right) draws clusters of linked pages into patterns that resemble dandelions gone to seed. The pan window provides context for zooming in on a part of the diagram.

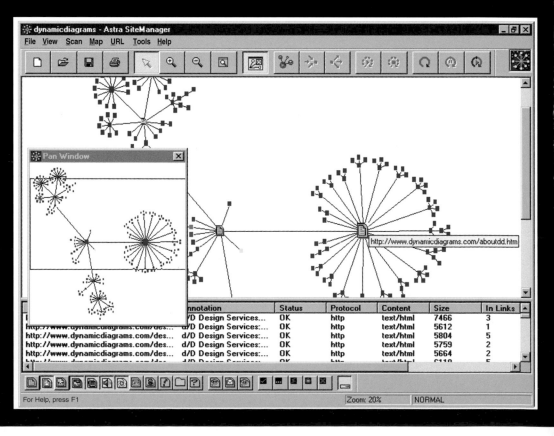

Another way to draw the map is to gather information about each page, and use that meta-data to determine or influence the layout of the link structure. The MAPA program used the META tag to store and retrieve parent-child information associated with pages and links. This is described in the paper by Durand and Kahn in Hypertext '98. Many programs record and use the path-name to influence layout decisions, assuming that documents in the same directory are more related than those in different directories.

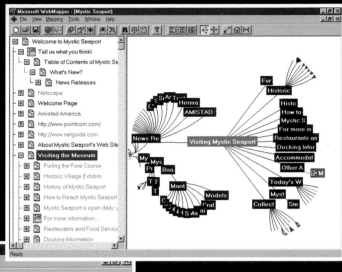

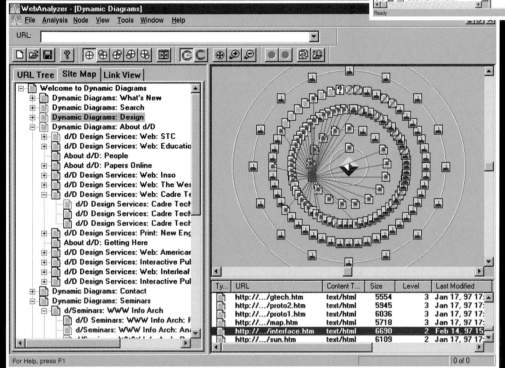

The Visualizations

Just as we group the hand-drawn site maps by visual technique in the previous chapters, we can group the data-driven site maps into a finite number of types. Most of the maps present some form of hierarchy. This hierarchy can be presented in the form of an outline, concentric circles, or an isometric pattern. The presentation can vary a great deal, depending on the application of 3D and animation. The maps that do not show hierarchy do not attempt to show a large part of the web site. For example, the explorer view of Microsoft FrontPage uses a star pattern to represent links coming in and going out from an individual page.

Multi-pane Views

Administrative tools that map web sites give an administrator several views of the same data. Often the views are placed in separate panes of the same application window. Selecting a document title from a list in one pane will highlight its location in the diagram in another pane. Incontext WebAnalyzer (left) organizes pages into an expanding outline in the left pane and a "Wave Map" of concentric circles in the right pane. The left pane offers two other views, including the link view similar to the one used by FrontPage shown in the example opposite. Below the Wave Map is a list of documents that can be sorted in various ways. Colored lines in the Wave Map indicate links from and to a selected document. Netcarta WebMapper (above) presented a similar expanding outline on the left, synchronized with a hyperbolic tree view on the right. As documents were selected in the outline, the diagram on the right would rotate to focus on the selection.

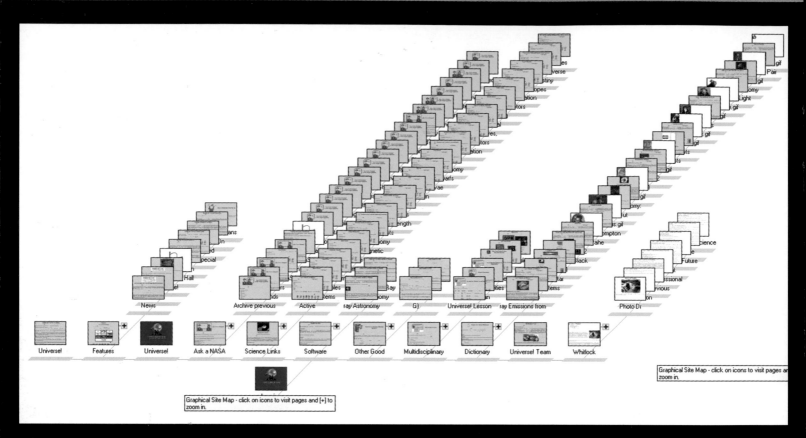

THREE VIEWS IN POWERMAPPER
After visiting all the pages on the site, Electrum PowerMapper arranges them into a single hierarchy. The program supports five different views of the same web site data, three of which display miniature images of the pages: Isometric (above), Page Cloud (right) and Electrum (far right). The three examples are all from the same data, a high-energy physics educational web site of about 1,000 pages called "Imagine the Universe!" Comparing the three shows how the different techniques take up very different amounts of screen space. Only three levels of structure are shown, with plus signs indicating where additional levels of structure can be explored.

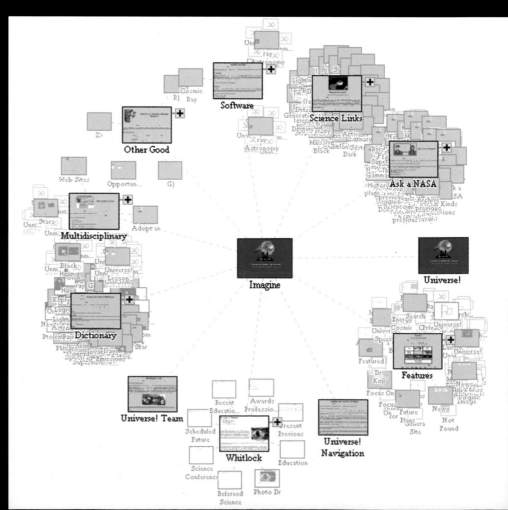

WAVE MAP OF THE SAME DATA
A view of the "Imagine the Universe!" web site as visualized by WebAnalyzer shows the weakness of the concentric circle algorithm (above). The large number of second- and third-level pages pack the second and third rings. Even when zooming in for a closer view it is difficult to get a sense of quantity. The link view for the selected document on the left is synchronized with the overview diagram. The green link lines in the overview reveal how this page (placed in the fifth level) is linked to many level-one pages.

creates clusters of dots in a circular pattern. Both programs use multiple panes to show synchronized views of the same data. The innovative Netcarta Webmapper product combined an expanding outline with an early version of the Inxight hyperbolic tree as early as 1996. Electrum Powermapper supports five different visualizations of the same hierarchy data. In each case, the map can be used to navigate to the pages themselves. The visualizations in FrontPage and AOL Press are aids for authoring and reviewing the web site, aimed at a similar audience.

The other audience for data-driven maps is visitors to web sites. These maps are meant to give a visitor an overview of the site and support the navigation and discovery process. Mapping programs for this audience include MAPA, Site Lens, SiteBrain, and Thinkmap, each of which is described in more detail elsewhere in this chapter. These programs create a data-driven navigation aid from the data about the pages on the site. The visualization is presented in a separate window or integrated within the page. In all these examples the interactivity is provided by a program written in the Java programming language.

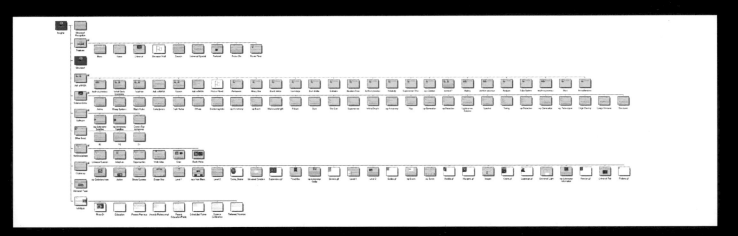

Mapping programs can be designed for two different audiences. The administrative tools are targeted at the webmaster who wants to gather and examine data about a web site. InContext WebAnalyzer, Astra SiteManager and Netcarta Webmapper fall into this category. These products feature extensive lists of information gathered about all pages on a web site. The graphic visualization of the site is less for navigating than for highlighting specific relationships, such as locating broken links or showing how a specific page is linked to other pages on the site. WebAnalyzer organizes levels into concentric circles, while SiteManager uses a layout algorithm that

The interactive nature of these map programs is largely what makes them interesting. There is never enough space on the screen to show all the information at once. Some form of progressive disclosure must be used to reveal additional detail as the user explores the map. Animated transition between map states makes this exploration both understandable and enjoyable. Without the animation, having details disappear to be replaced with new material is difficult for most users to grasp. Wherever possible we have tried to communicate these transitions with sequences of screen shots.

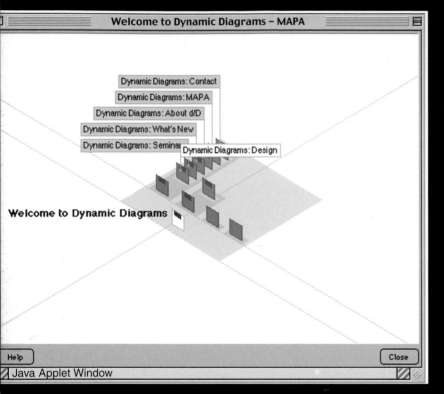

MAPA ANIMATION
This sequence of four screens shows the MAPA transition animation.
(1) The user selects a page on the second level of the web site "Dynamic Diagrams: Design".
(2) The pages that remain reconfigure in the underlying carpets for the new map.
(3) The new pages rise up from the carpets.
(4) The children and grandchildren of the selected page are available to explore.

MAPA

This dialog between Martin Dodge, a researcher in the Centre for Advanced Spatial Analysis, University College London, and the author was background for an article written by Dodge in Mappa.Mundi magazine.

Martin Dodge: Who invented the Z-Form style of diagrams?

Paul Kahn: The first Z-diagram we created was the result of a conversation between Krzysztof Lenk, my partner for the past decade, and the designer Peter Bradford. Kris was visiting Peter's studio in New York early in 1995, presenting material for our contribution to Richard Saul Wurman's *Information Architects* book. Peter challenged Kris to explain a series of screen shots from the Encyclopaedia Africana prototype. We had just completed a prototype, a design and technology demonstration, for the group at Harvard's Dubois Institute of African American Studies. Peter wanted to understand how these screens went together. So Kris started to sketch it out on paper, more or less in three dimensions. The structure of the encyclopedia was there, but the content was limited to three articles, a few maps,

and a timeline. There was a single path we had developed for the demonstration.

It was based on an earlier diagram that Kris had done for an art museum prototype we had designed for Interactive Home Systems back in 1991. In that original diagram, which Peter reproduced in his introduction to the book, Kris had shown a kind of slide tray in the form of an isometric projection to represent a collection of art. When Kris came back to the studio, he developed the idea in Illustrator and showed it to us, then to Peter, who liked it very much. Peter used the technique to present a number of contributions in the book. This was largely before any of us were doing web site design. In 1995 what we had done on the web was hardly what we wanted to show anyone. The first Z-diagrams were representations of CD ROM applications and prototypes. Interestingly, the Z-diagram technique was used very effectively for the navigation map of Au Cirque avec Seurat, a wonderful CD ROM by Frédéric Sorbier with the assistance of the Musée D'Orsay.

There was a very direct influence on our work from the Turgot map of Paris. This wonder of eighteenth-century design depicted the entire city in an elevated isometric projection so that both the street map and building elevation and details were visible (see pp. 26–27). This use of depth without a vanishing point is the key. It is the point that is missed by many applications of 3D graphics for navigation. The distortions of vanishing point perspective are often counter to the principles of information design.

Dodge: What was the motivation behind the development of the MAPA system?

Kahn: The MAPA system was our attempt to solve a

problem that had developed on large web sites as early as 1996. You arrive at a page somehow, following a link, doing a search, and you have no clue where you are on the web site. What is this page related to? What section of the site is this? What does this belong to? Where could I go from here?

We were working for IBM who had an enormous web site at that time. The best we could figure it was about 75,000 individual pages, with over a dozen base URLs living on servers literally on every continent. It was changing all the time. We proposed to create a system that would map this site by reading the link data, organizing it in a database, and then drawing a map for any page on the site.

We assumed that making a map that showed everything

was useless. I had worked on the IRIS Intermedia system at Brown in the mid-eighties and had been through the research questions around global and local link maps. I thought Intermedia had shown how valuable a local link map to support navigation can be, created on the fly as you went from page to page. We wanted to make the map from the link data, and make that map for any page. We wanted to do it on a large, industrial scale. Fortunately we had wonderful partners at the IBM Internet Program who had faith in us. We had the Z-diagram model that Kris Lenk had developed, which we felt could be used to represent the parent-child structure of the web site in a space-efficient manner. We had innovative software that David Durand created to organize the link structure of a web site into a coherent hierarchy. Several talented programmers worked with us to implement the visual model in Java, which had just

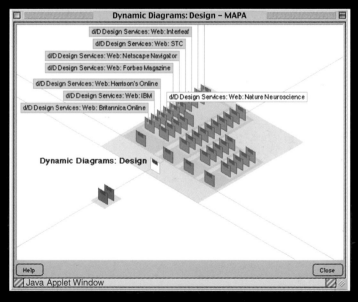

been released by Sun and implemented by Netscape in the browser.

Dodge: What are the main strengths and weaknesses of MAPA?

Kahn: The main strength of MAPA is the animated transition from one view to the next. This is both the major "wow" factor and the most innovative feature, in my opinion. We wanted to prune the view of the entire site to always show a focus page and the portion of the site one and two links below that page in the hierarchy. Moving from one view to the next without the animation would be incomprehensible. With the animation most people can get it. And it is fun to watch the pages march

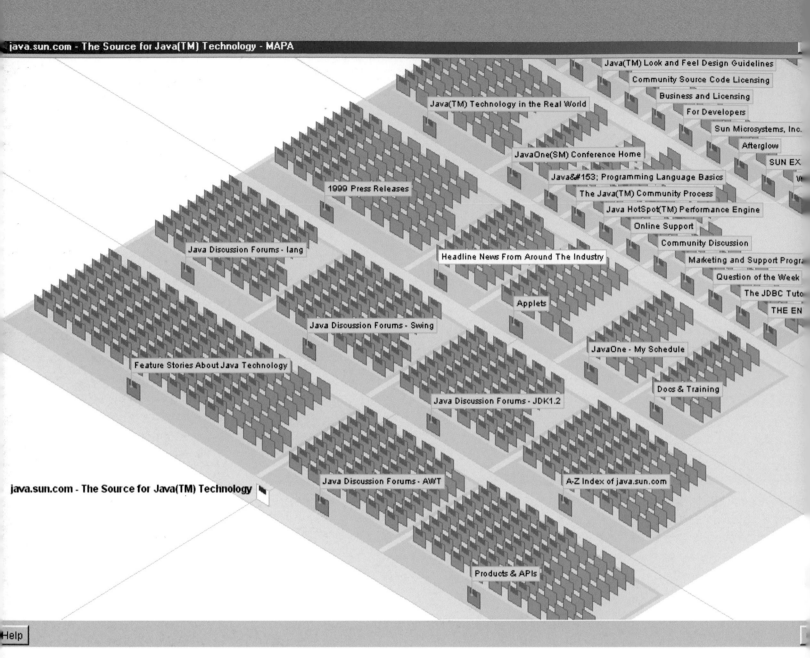

Java(TM) Look and Feel Design Guidelines

Community Source Code Licensing

Business and Licensing

For Developers

Java(TM) Technology in the Real World

Sun Microsystems, Inc.

Afterglow

SUN EX

JavaOne(SM) Conference Home

Java™ Programming Language Basics

The Java(TM) Community Process

1999 Press Releases

Java HotSpot(TM) Performance Engine

Online Support

Java Discussion Forums - lang

Community Discussion

Headline News From Around The Industry

Marketing and Support Progra

Question of the Week

The JDBC Tuto

Applets

THE EN

Java Discussion Forums - Swing

JavaOne - My Schedule

Feature Stories About Java Technology

Docs & Training

Java Discussion Forums - JDK1.2

java.sun.com - The Source for Java(TM) Technology

Java Discussion Forums - AWT

A-Z Index of java.sun.com

Products & APIs

Help

across the screen and rise up out of the carpet before our very eyes.

On the computer science side, the main strength is David Durand's program for organizing the link structure into a single hierarchy, which is described in "MAPA: a system for inducing and visualizing hierarchy in websites" from the Hypertext '98 conference. The system allowed us to insert META tags into the documents to influence the organization of the link structure in the map, or to edit the link structure in the database and have this persist even as the web site changed. To my knowledge this is still a unique feature.

The weaknesses were both technical and conceptual. On the technical side, the problem of gathering the link data from a web site on a consistent and reliable basis turned out to be much more intractable than we ever imagined.

We thought that visualizing the link information was the big problem, but gathering the link information took up most of our time. Framesets and database systems for generating pages were impossible to map this way. People did not use title tags in a consistent fashion. Data-driven maps of the web are very much garbage-in/garbage-out – there's a lot of garbage out there.

On the conceptual side, we assumed that people would find this kind of abstract location useful. In fact, most people just want to look at the big picture, the overview of the site. They would rather see what the site is supposed to be, rather than what is actually there. The view we developed that did not require Java, showing the location of the current page in the site hierarchy along with a list of all incoming and outgoing links, was rarely used. The interface was obscure.

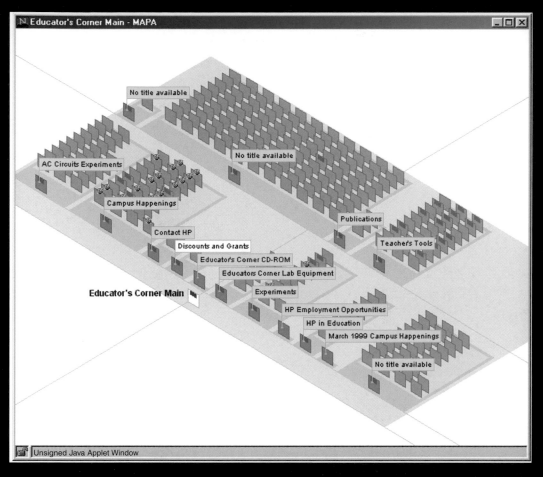

Educator's Corner Main - MAPA

No title available

AC Circuits Experiments

No title available

Campus Happenings

Contact HP

Discounts and Grants

Publications

Educator's Corner CD-ROM

Teacher's Tools

Educators Corner Lab Equipment

Educator's Corner Main

Experiments

HP Employment Opportunities

HP in Education

March 1999 Campus Happenings

No title available

Unsigned Java Applet Window

Find pages: Enter text in titles/URLs of pages

sics

ics

t II: Practice
posium
Reference Tools

I: Theory tion
tive_exp.html

semin ucators Corner Lab Equipment

s Experiments

Contact HP

Teacher's Tools

Campus Happenings
1998 Campus Happenings
y 1998 Campus Happenings
uary 1999 Campus Happenings
ber 1998 Campus Happenings
1998 Campus Happenings
8 Campus Happenings

Campus Happenings

Educator's Corner Main

http://www.tmo.hp.com/tmo/iia/edcorner/English/Categories.html

arch 1999 Campus Happenings

scounts and Grants

scount Schedule periments

HP i corner/English/c_CartoonOfMonth.html

eriment Categories

claimer formed

ve Time ney ve

ot is a st ny s c b s a"

n"

Legend:
Root page
Unmodified page
New page
Modified page
Deleted page

inxight

Sitemap Viewer created using
Hyperbolic Tree™ for Java from Inxight Software

LARGE-SCALE MAPS WITH MAPA
The top-level of the java.sun.com web site (far left) is very broad, with over thirty level-one pages and hundreds of second-level pages. Despite that scale, most of the map can be viewed within a single high-resolution screen. Rolling over a first-level page reveals the titles of all the first-level pages, with the selected page highlighted in a different color.

COMPARING MAPA AND INXIGHT SITE LENS
These two maps show the top level of the same web site, Educator's Corner, a resource web site for engineering educators run by Aligent (formerly Hewlett-Packard). MAPA (top) is limited to the top two levels of the site. Titles for the first-level pages are shown, but no titles for second- or third-level pages are visible. The different color (orange) symbols indicate links to pages on other web sites. The dark bars on some pages show third-level structure, but tell us nothing about the extent of that structure.
Site Lens (left) shows us more about the structure of the entire site. We can see clusters of page titles as well as branches leading to other page titles around the edges of the hyperbolic tree. The "Find" function can be used to highlight page titles that contain specific words. At the same time, the titles of individual pages are more difficult to read. We have used the Altavista Discovery version of Site Lens to create this map.

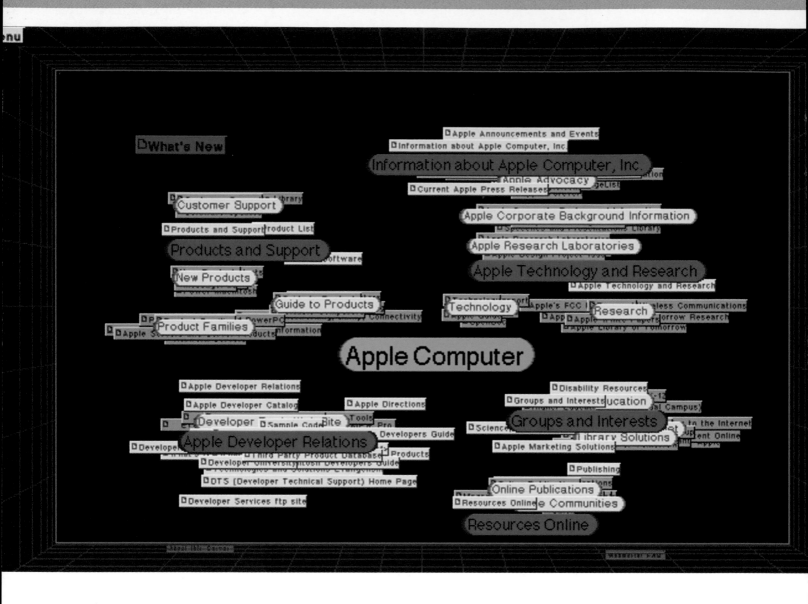

HOTSAUCE IN THE THIRD DIMENSION

In the fall of 1996, Apple Computer rushed HotSauce to the market. The program displayed hierarchy information stored in Meta Content Format (MCF), a proposed standard for describing file systems and web site structures. The HotSauce browser (above) distinguished the level of a page title by color and size. The user interaction was a fly-through of the page titles in 3D space, similar to a video game. Once a page would fly by it was lost from view, since the interface did not support turning around.

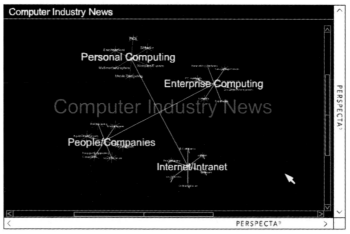

PERSPECTA

In late 1997 a group of graduates from MIT's Media Lab applied some of the research on presentation of type in 3D space. The PerspectaView product presented clusters of linked pages, with the size of the type growing smaller for pages on a "distant" level. Smooth animation allowed the user to fly into the clouds of page titles. The Perspecta product was intended for the Online Analytical Processing (OLAP) and data mining market, not for mapping or analyzing web sites *per se*. The titles in this example did not necessarily represent web pages.

SiteBrain

**SiteBrain (above) is a browser
for pages on a web site that
share one or more keywords.
These shared keywords can
also map to link relationships.
This example is drawn from the
web site for the Columbia
University Graduate School of
Architecture and Planning
(GSAP). The map shows
relationships among
departments and courses.
Course titles in the map link
to pages describing the course.**

Thinkmap

**The Thinkmap browser from
Plumb Design, a Java applet,
supports browsing of items
that are linked by several
relationships, rather than a
single hierarchy. The Visual
Thesaurus (right) displays a
word or phrase, and all the
related words or phrases in
3D space. As words swing away
from the surface they grow
smaller and dimmer. The same
technique can be applied to
navigating a web site, as
shown in the example from
the Bacardi Martini web site
(above). The map is constrained
to the frame on the lower right
of the screen.**

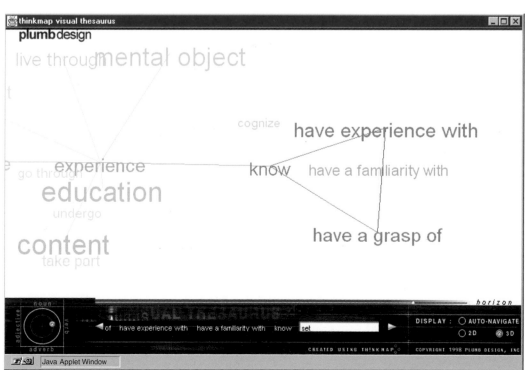

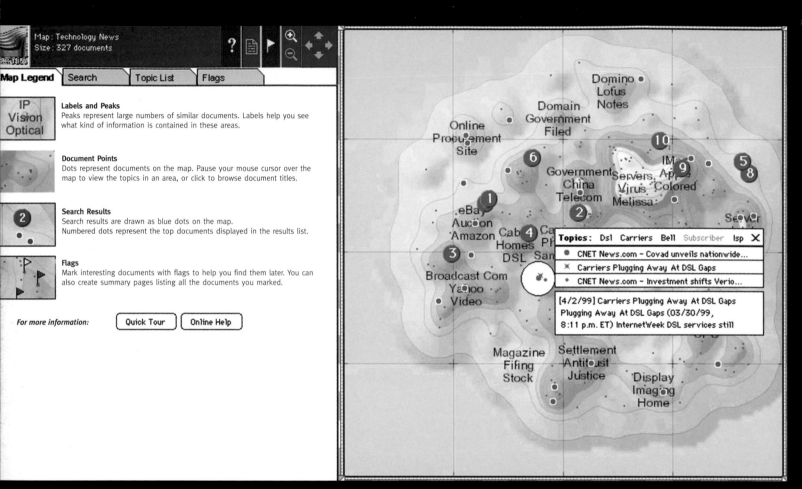

Information Maps

As we have seen in earlier chapters, the idea of generating a web map from the linked nodes of a hypertext network is one way of trying to see and understand the collection of documents. Building maps to represent the link relationships is also just one of many approaches to visualizing the contents of a site. Information retrieval research has sought methods for organizing large groups of documents based on calculating attributes of the document content. The web has done a great deal to increase awareness of what we can do with large document collections. As the global collection of web sites grows, so with it grows the market for tools and techniques that can be applied to locating, analyzing and organizing large collections of information. Terms such as Knowledge Mapping, Online Analytical Processing, and Data Mining all allude to the same basic challenge: revealing

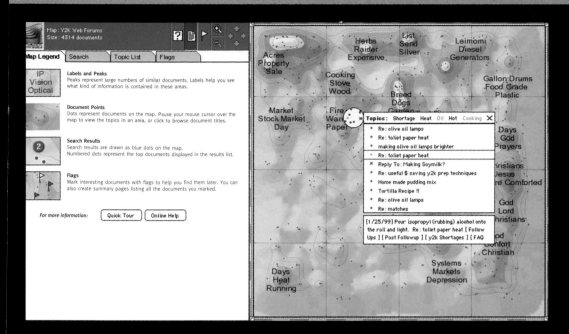

CARTIA THEMESCAPE

The information island created by Themescape locates documents along a topographic surface, with sets of controls in the left pane organized by tabs. Each document in the set appears as a small dot, clustered around major terms on the surface. The locations of search results are marked with numbers. Flags can also be set to mark documents of interest. The landscape is interrogated by a combination of searches, roll-overs and magnifications. In the examples the stories from the Y2K discussion map, clustered under the topic "Fire Warm Paper" are revealed, followed by a summary of the highlighted story. Below that a search for "food" reveals many blue dots indicating documents that contain this word, while the ten most relevant documents are marked with numbers in large blue circles. The search result selected in the left pane is highlighted in the map with a different color.

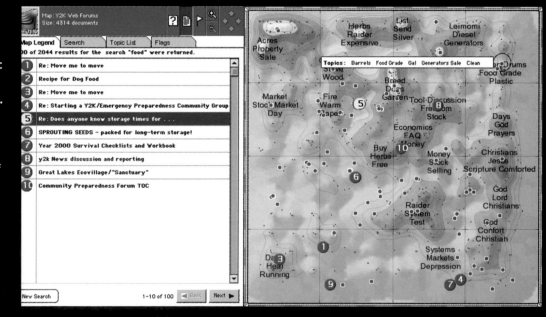

understandable patterns in large collections of data. The resulting map is less a map of a web site itself than it is a representation of a collection of information that may reside on a web site, or in a database, or in any other repository.

Products such as Thinkmap and SiteBrain are designed for this kind of task, as the relationships shown in their maps are shared attributes, such as keywords, rather than navigational links coded in the documents themselves. Products such as Cartia's Themescape and SmartMoney's MarketMap take on the challenge of mapping the information itself. They share concepts with experimental systems such as Xia Lin's Visual Sitemap (see page 130).

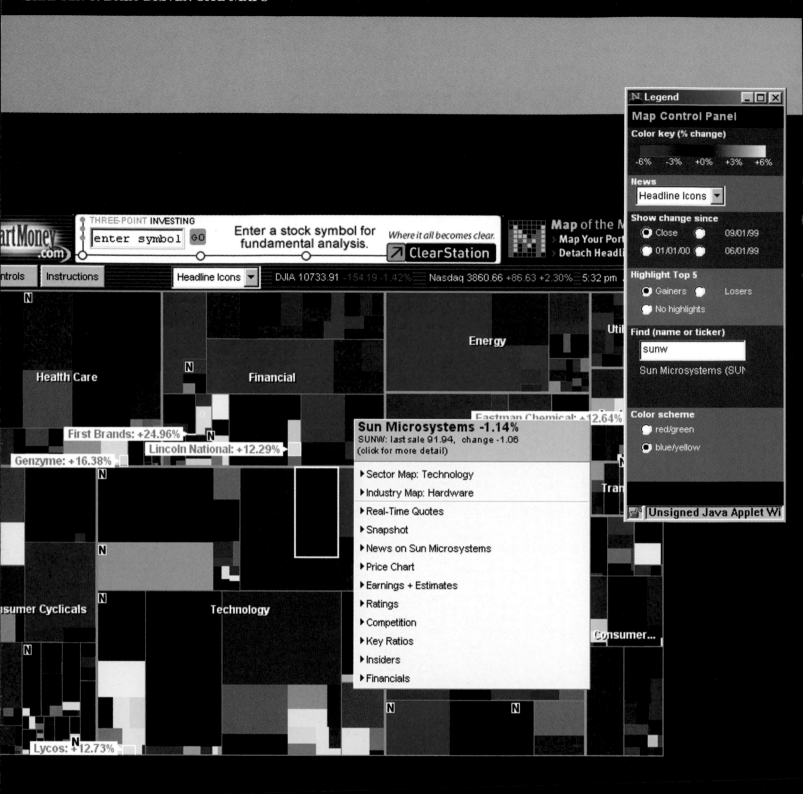

The Themescape product groups documents based on their full text content. This is hardly unique, as there are many information-retrieval systems that transform the similarities and differences of text content within documents into vector information. What makes Themescape so remarkable is the literal application of cartographic metaphor. The text data is presented as green islands with peaks and valleys, surrounded by blue water. The surface goes from green to rocky gray to snow-capped peaks.

The principle is clear enough, that our experience with topographic maps, from sports such as mountain climbing, hiking, and sailing will help us understand the "data landscape" that results from the program's analysis of a document set. While the capabilities of the program are very impressive, we find the realism of the metaphor distracting.

The abstraction of Map of the Market, by contrast, is easy to grasp and easy to use. The space on this map represents the value of publicly traded companies. The companies are organized by industry. Within the industry, the size of a company's rectangle represents its market capitalization. The color of the rectangle represents the loss or gain of value on its stock within a trading period. The mechanism allows for several other layers of information to be placed over the structure.

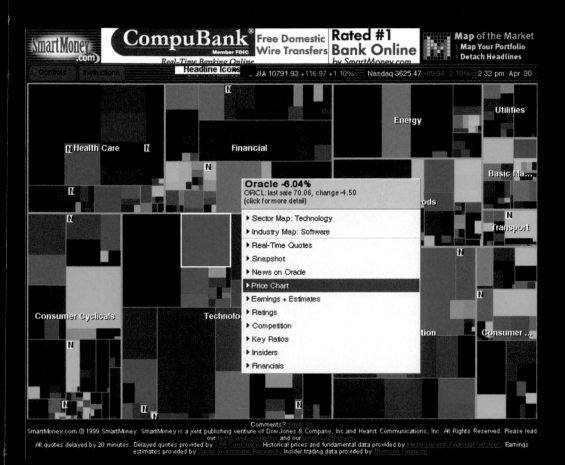

SMARTMONEY.COM
MAP OF THE MARKET
Map of the Market uses a small control window to separate display options from the information being presented. The organization of the map is intended to prevent the need for scrolling. The user explores the map by searching for a ticker symbol in the control panel, or rolling over regions of the map to reveal the name of the company. Clicking on the name (left) presents a menu of information available about the company. News stories are marked with an N. Rolling over a news story (below) shows the headline and a summary.

The overall visual impact makes it easy to read trends of stock value by industry and draws attention to the companies whose value has changed the most. The metaphor is found in the use of color, with shades of green representing gains and shades of red representing loss. Even here the design of the map is not constrained by a literal interpretation of metaphor. Green is a much better contrasting color for red than black, even though we say "in the black" for financial gain. The creators of Map of the Market also account for color preference, offering a blue/yellow color scheme as well. The point is not the literal meaning of the color, which is subjective, but the contrast of the color pairs, a more objective form of information.

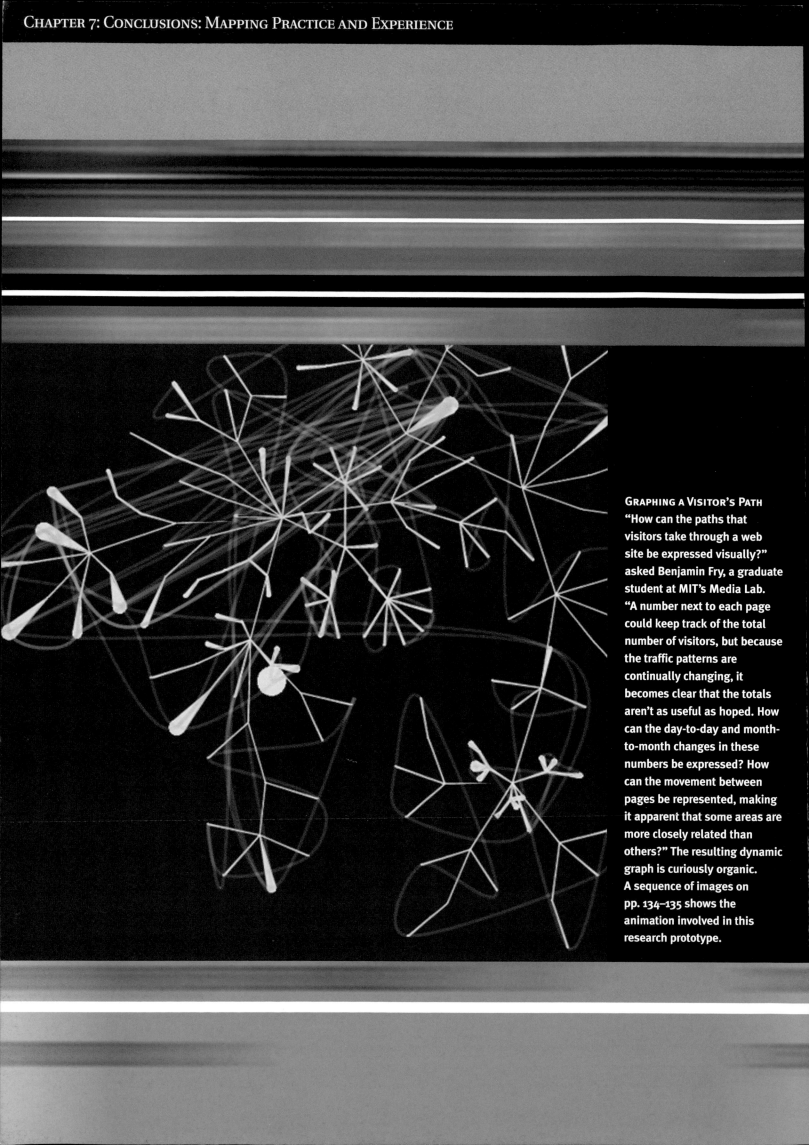

GRAPHING A VISITOR'S PATH
"How can the paths that visitors take through a web site be expressed visually?" asked Benjamin Fry, a graduate student at MIT's Media Lab. "A number next to each page could keep track of the total number of visitors, but because the traffic patterns are continually changing, it becomes clear that the totals aren't as useful as hoped. How can the day-to-day and month-to-month changes in these numbers be expressed? How can the movement between pages be represented, making it apparent that some areas are more closely related than others?" The resulting dynamic graph is curiously organic. A sequence of images on pp. 134–135 shows the animation involved in this research prototype.

Conclusions: Mapping Practice and Experience

Practice of mapping web sites grows from the same need that has driven traditional cartography: the need to extend our understanding of the world in which we live. The web did not exist a decade ago but, like the New World facing Renaissance Europe, it is today's reality. We must both discover and create it. The better the information we have about its terrain, its boundaries, its resources and transport mechanisms, the more likely it is that we will achieve our goal, whether that goal be exploration or empire building. This concluding chapter is drawn from a discussion between the authors and two members of the Dynamic Diagrams staff, Piotr Kaczmarek and Magdalena Kasman. The goal of our discussion was to describe to each other what we have learned about mapping from our personal experiences and from reviewing the range of work collected in this book.

Krzysztof Lenk: Different kinds of maps and diagrams are created for different purposes. It is possible to group maps this way. One group is the map designed to communicate between the designer and the client. This is a group that visitors to web sites seldom see. It is a very general map that describes the entire domain with an emphasis on the structure and organization of the site. The purpose of the map is to show the hierarchy rather than the details within that hierarchy. Those details, such as the specific list of pages and what goes on those pages, come later. If we put too many details on this kind of map, the visual presentation becomes too dense and the result is difficult to grasp.

The most complex map of this kind that we have designed was the map of Nature (www.nature.com). The first one represented click depth of pages in front-to-back order and the business model in vertical layers. The second version added details about different page templates and links from citations in articles to external databases (see pp. 38–39). Even with this density, people in the organization who were not familiar with all of what they were doing did get a sense of scope. If we let it get too complicated, the audience needs to spend too much time trying to figure it out.

The maps that use the Z-factor are very effective in opening this relationship between the designers and the clients. They create credibility. They help managers and IT people see that graphic designers know what they are doing.

Paul Kahn: Our client is rarely a specific person. It is a group of people playing different roles in a complex project. This kind of diagram creates a common image, a shared mental model, among the various people that make up the client group. Some of the Studio Architype diagram examples from the Kasparov vs. Deep Blue case study (see pp. 62–69) and work by Kognito Visuelle Gestaltungin in Berlin serve another audience – the designers themselves. These diagrams are more like floor plans and elevations used by builders. Every page is shown, every detail the designer will need is included. This is not what the client wants to see, or the user of the web site, for that matter.

Piotr Kaczmarek: The fact that the isometric diagrams limit the amount of information we can present makes them easier to read, less technical. It is easier for an unprepared audience to read this information.

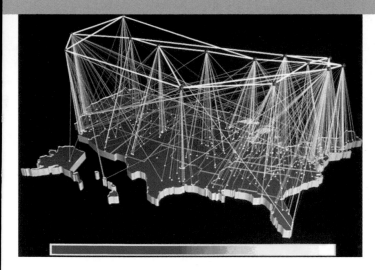

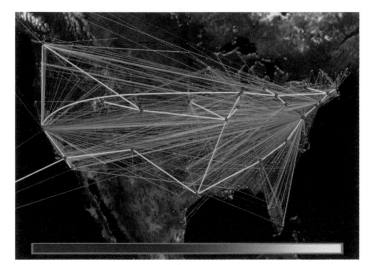

A DESIGNER'S MAP
The photographs on the left show a map of the web site for Bank Gesellshaft Berlin under development at Kognito Visuelle Gestaltungin. This map is for the designers themselves to annotate and interact with, in the process of designing and building the web site. The large map is a visualization tool, to be worked with directly.

STILLS FROM NSFNET VISUALIZATION
The image at the top is a still from animations showing the growth of traffic on the NSFNET T1 backbone in September 1991. Traffic is shown by a range of colors from purple (zero bytes) to white (100 million bytes). The image below it is from a later visualization of the ANS/NSFNET T3 backbone in December 1994. Color and position are used to convey meaning. Individual lines are visible because of brightness and contrast between the colors. The dimension of height is used to place the abstraction of network traffic in geographic space.

Magdalena Kasman: These maps are also easy to read on many levels. You can see the level of information that you want to focus on, in a similar way to how we are used to reading a political map. How does this relate to our experience of geographical and historical maps?

Paul Kahn: A large part of our experience of these maps is based on our sense of topology. We have a sense of east and west, or coastline, or state or national boundary. The shape of Texas or the shape of Manhattan has visual meaning because these are familiar shapes. It is less than obvious how we can transfer this kind of experience to representations of web sites.

Wonderful examples of successful data visualization are the maps of the network traffic created by Donna Cox and Robert Patterson of National Center for Supercomputer Applications at the University of Illinois. Cox and Patterson took data on network traffic during the early years and showed the dramatic growth of the Internet. Their juxtaposition of the national and state boundaries overlaid with points and lines representing network traffic was easy to understand because the topology of the underlying geography was familiar and it related to the meaning of the map. The earliest animation was the most abstract, with the underlying map entirely flat and cut up by state boundary lines. I found that to be the easiest to read and the most dramatic. The later simulations used a more literal image of the North American continent as seen from space, practically a satellite photo. This is harder to read if you want to relate the dots and lines to physical places because a realistic image of Texas and Mexico, for instance, does not show the boundary. Without that shape as a point of reference it is very hard to figure out which dot is Houston, and so on. When you were organizing the map of the 150 web sites run by the parts of Verlagsgruppe Georg von Holtzbrinck, how did you create a topology?

HOLTZBRINCK WEB SITES MAP
This map is a catalog of the web sites run by the companies that made up Verlagsgruppe Georg von Holtzbrinck in the spring of 1999. The map was a summary of research on about 150 web sites run by the various companies. Background color shows the company type (newspaper, scientific publisher, television station, etc.). Various symbols show the presence of features such as catalog or access control. The language of the site and the country of origin are also clearly marked with symbols and flags.

The lines connecting the sites are records of navigational links between the web sites. One goal of the project was to show how the various web sites do or do not show the connections among the related companies. The color of the lines, the thickness, and the kind of arrow at the terminus all carry information as well. Names of the operating companies or business groups are placed over background color tints to show how the web sites are grouped among related companies. The background color groups are repeated in miniature on the upper left, to make these relationships more visible. An alphabetic catalog of names at the top of the map is coded to a labeled grid, to help the reader locate individual web sites.

Holtzbrinck Web Map
Version 1, May 1999
Prepared for Verlagsgruppentagung / Annual Meeting 1999 in Stuttgart
copyright © 1999 Verlagsgruppe Georg von Holtzbrinck

Legend:

Company Type
- Newspaper Publisher
- Magazine/Journal Publisher
- Educational Book Publisher
- Scientific Book Publisher
- Trade Book Publisher
- Electronic Media Company
- Television Company
- Radio Station/Company
- Service & Production Company

Country
- Australia
- Austria
- Brasil
- China
- France
- Germany
- Ireland
- India
- Italy
- Japan
- USA
- Mexico
- New Zeland
- Peru
- Poland
- Spain
- Switzerland
- United Kingdom
- Venezuela

Language
- German
- ENG English
- FRA French
- ESP Spanish
- JAP Japanese
- CHI Chinese
- POL Polish
- ITL Italian
- PTG Portugese

Features
- Electronic Commerce
- Full Text Search
- Catalog Search
- Online Version
- Access Restrictions
- Online Advertising
- Site Under Construction
- Two Way Connection
- One Way Connection

Prepared by Dynamic Diagrams in collaboration with ACTIV-CONSULT Multimedia und Training

Piotr Kaczmarek: In that case we used geographic topology. The United States is on the left and Germany is on the right and between them are web sites from the United Kingdom. It was more of a suggestion than a literal topology. There was no purpose in introducing boundary lines to refer to the countries in which the companies operated. Instead we introduced boundary lines to mark off operational units of companies. These business associations were much more important, they overwhelm the geographic arrangement as an organizing principle. The presentation was entirely flat. There was no reason for applying a third dimension, as the strong use of background color grouped the business units.

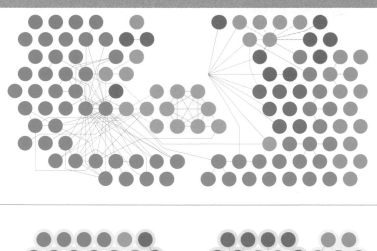

GRAPHING A VISITOR'S PATH

The shape of the Holtzbrinck map evolved as the map was created from the research data. The first layout (top left) was centered on the pattern of connections among the Nature magazine web sites. The lines connecting the glyphs appear tangled because they did not follow a grid.

The second version organized the lines along a grid. The placement of the Nature web sites in the center caused crossing lines.

Background colors were introduced to group-related companies. The Macmillan group was the single largest group of businesses, and also the most well connected by navigational links. The black background for this group created too strong a contrast.

The final arrangement (bottom left) was tightly packed, with a minimum of crossing lines. The "parent" web site was introduced at the center top and a key for the business groups was added to the upper left.

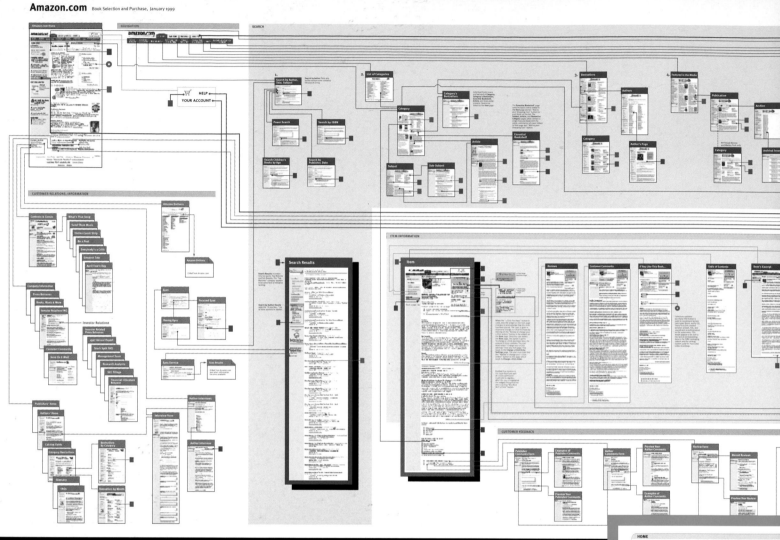

Amazon.com Book Selection and Purchase, January 1999

Process Catalogs of Amazon.com and CBS Healthwatch

The diagram above is a large portion of the Amazon.com web site in January 1999. Only the information and purchase paths for books are shown, since the variation between how books and other items such as music and videos were accessed and purchased was not important to the client audience. Major groupings are shown with tones of background and foreground colors. The organization of the Amazon.com diagram is based on the major functions of the site. The Healthwatch diagram is organized by groups shown across the very top of the Home Page.

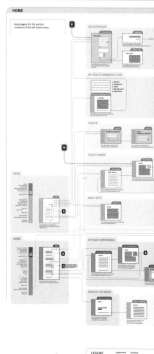

CBS HealthWatch
April 2000

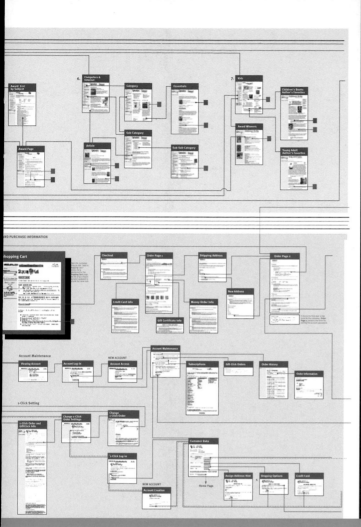

In other cases, such as the map we created of Amazon.com, it was the buying process that served as the organizing principle. The client wanted to know how the online-purchasing experience was being managed. The map was designed to make that as clear as possible. We assume that the audience reads the map left to right from top to bottom. Again everything was entirely flat. This is because from the user's point of view the entire process takes place on the same plane. The map of CBS Healthwatch was more of a catalog. The usage process was less important to the client than in the Amazon.com example. This map was done for clients considering the merger of several web sites. They want to know what is already there. An inventory of features was the most important goal. In this case the information is organized according to a structure suggested by the user interface of the Home Page. They clearly have four main areas, so we started with that and let the map organize around it.

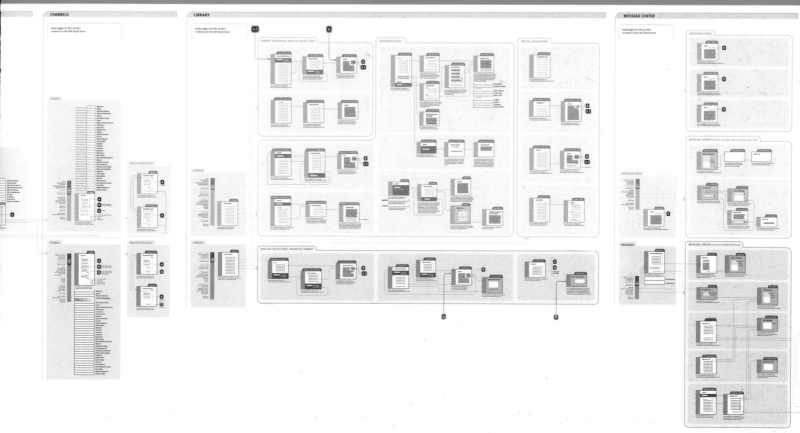

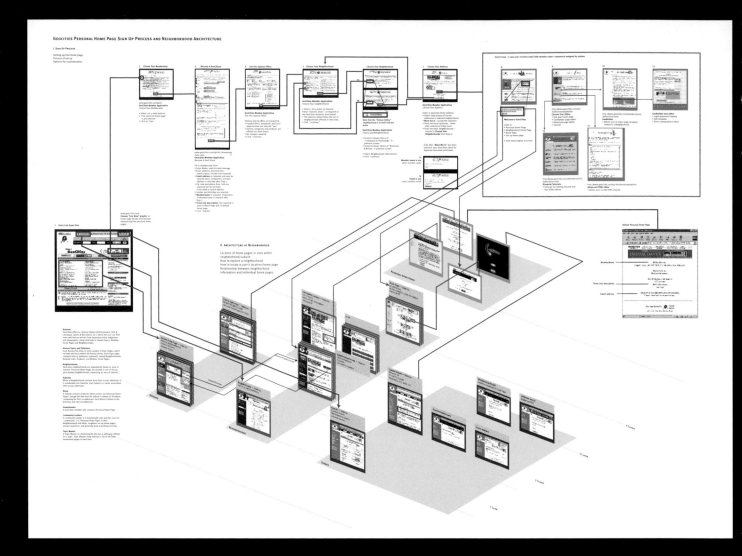

HOME PAGES ON GEOCITIES
The diagram of Geocities (above) mixes the process of making a personal Home Page, shown as a flat sequence, with a Z-factor diagram of how the Home Pages are placed in "neighborhoods" on the web site.

VISUAL SITEMAP
The Visual Sitemap program (left), an experimental mapping system by Xia Lin of Drexel University, is based on the content of a web site rather than the link relationships. The program organizes the vocabulary of the web pages into a vector space using Self Organizing Map (SOM) algorithms, and then creates color boundaries.

Paul Kahn: In fact we have rarely combined the isometric and the flat process technique for two reasons. First, they serve such different purposes. The isometric view emphasizes spatial relationships, click depth, and an awareness on the user's part in locating certain features in terms of levels and parallel or peer-group relationships. The flat topology of the other technique emphasizes the process when the user experiences the web site as a sequence of pages. The second reason for using one or the other but not both is that the two techniques tend to undermine one another visually. They create two different kinds of space in the viewer's mind, and this can lead to confusion.

There was one case where we put the two together. We were mapping out the technique used by Geocities for setting up personal web pages. This was a set-up process that the user saw as a sequence and a spatial arrangement of pages that the user experienced as a neighborhood. We used lines to connect the two spaces. We needed some visual signal to say "this action here in the set-up process results in this page here in the organization hierarchy of the web site." It was a stretch.

Piotr Kaczmarek: Deciding on the coding sequence for a map like CBS Healthwatch is a complex process, though it can be described. As I said, there are four major areas on the site, the map has to show every page. We can see that sets of pages share some basic functions. So I decided that function will be my bottom-level grouping. The pages are grouped in sets of functions that have something in common. The resulting map has four levels:

1) main areas
2) subgroups of similar features
3) features
4) pages in a feature

Paul Kahn: This is quite different from the process of building a map from the link data. You are looking at the information from the top down when you assess the main groups. You are looking at it from the bottom up as you group the individual pages into features. And you have to mediate between the two as you find and sort the similar features. You have to use a multitude of cues to build up the groups: links, visual design, functions, user experience. How different is this from your experience as a surveyor?

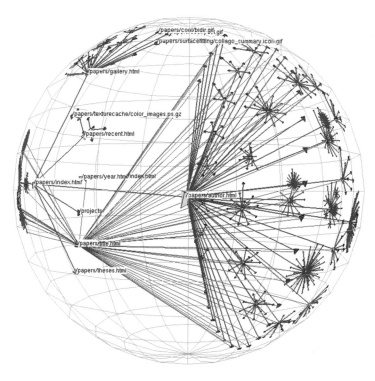

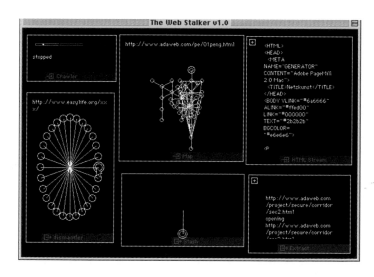

EXPERIMENTS IN VISUALIZING LINKS IN 3D

The Web Stalker program created by I/O/D creates a visualization of a web site as the user explores a web site. The 2D graph of the link structure grows as the web crawler explores the site.

The H3 prototype, developed by Tamara Munzner of Stanford University in 1997, is a directed graph of the pages on a web site laid out in a 3D hyperbolic space. This was developed for the Silicon Graphics workstation.

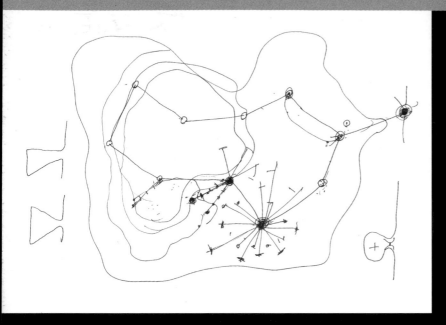

EXPLAINING THE OMEGA SURVEY
This pen sketch (left) was
drawn by Piotr Kaczmarek
during his explanation of how
a survey team creates a map.

Piotr Kaczmarek: There is some similarity to the way surveying is done. When you are surveying an area first you define the boundary of the area you have to survey. You have to create a precise map. To do this first you create a set of points that will be your basic structure for precise measurements. These points are usually determined in relation to a precise reference point with a known longitude, latitude and elevation. That reference point can be located in relation to a similar reference point outside the mapping boundary. Second the team makes extended measurements in relation to the base points. Usually this is done in a sequence, a closed circle, to reconfirm the relation between the base points. There is a lot of judgment needed to determine where to put your base points and how many extension points to measure from each one. Finally, when you have coordinates for all points in relation to base points, you start making the map. The drawing is made by applying angle and distance measurements. As you draw out the measurements you find out where the contours will fall. The most interesting part of the process is how new shapes appear. It is like looking for patterns.

When I was a student we were involved in making a map of a deserted area of mountains in Poland. This area used to be populated but was not populated any more. There was an omega-shaped bend of the river that defined the region. A student organization had found money to build a tourist shelter here, and we did the map *pro bono* as a summer project. In fact the area was known as "omega". When we completed the map

we were very surprised to find that the shape of the bend in the river was actually almost triangular. But you couldn't see it in the mountains. We saw this when we came back to Warsaw, the shape was not obvious at all. We find similar things that are not obvious when we do our diagrams.

Paul Kahn: There is an analogy to the planning process.

Piotr Kaczmarek: Is urban planning mapping or planning? Can you make a map of something that doesn't exist yet? I think so. A plan is a map. Architects used to create plans that were perfectly legible for other architects, but not necessarily for the client. You would build the house and the client would be disappointed. The kitchen is too low and the living room is not cozy enough. Now 3D designs help support better client communication. Architects can create a 3D walk-through of the space before it is built. We are also trying to come up with something that is understandable for our clients, to create common understanding.

Magdalena Kasman: I still have trouble thinking of the My Excite diagram as a map (pp. 42–49). It was made for different purposes. The My Excite diagram explains a process. It is like a plumbing diagram, less for upper-level management, and more for the software engineers.

Krzysztof Lenk: All the work we did for Netscape was for a very specific audience. The purpose was always to present the bare bones of information. They became very interested in including screen shots and applying larger scale so each screen shot could "read". This audience actually wanted to read the text on the images. It is interesting to see how this detail, the text on the screen shots, became significant for users of these diagrams.

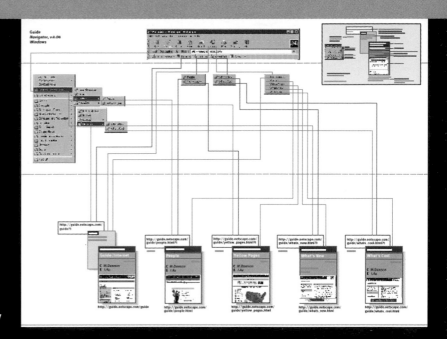

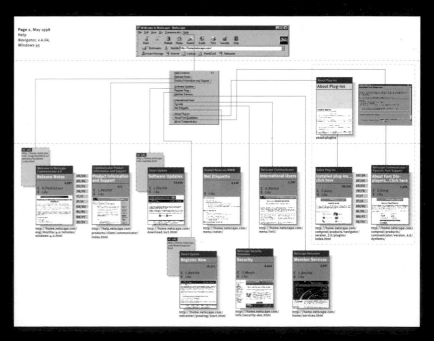

Paul Kahn: How do you represent navigational links in these maps? There are so many links between each page. The NicheWorks program from Lucent Technology creates patterns from enormous networks of linked documents. Shapes appear that remind me of cross-sections of giant redwood trees. Benjamin Fry's work at MIT Media Lab is very promising. He uses 3D space and organic, almost vegetable-like forms to show link patterns and traffic between pages on a web site. The action, the motion of building the graph is fascinating.

Piotr Kaczmarek: The lines are difficult to show. More than four parallel lines are hard for the eye to follow.

Krzysztof Lenk: This is one of the cognitive aspects of mapping. Our own cognitive limits create boundaries for us. We lose users if we put more information on the map than the reader can see.

Paul Kahn: Why can't we make these maps automatically? Why can't we just do it from the data?

Magdalena Kasman: A map is a very interpretive creation. It is always a solution to a particular problem. A software program does not talk to the client. The information architect, analyst, designer, whatever we would like to call her, talks to the client. If we use a software package to generate the map there is always a limit to how much interpretation you can do to adjust or manipulate the result.

Krzysztof Lenk: Most of the diagrams are not the ultimate result. The process of diagramming between designer and client is more important than the final diagram. The final diagram is just a report of the process. We finally show what is significant and what is not.

Magdalena Kasman: I suppose we could come up with a very expensive CAD application to make the maps.

NETSCAPE CHROME DIAGRAMS
These two diagrams (above) are taken from a series showing all the pages on the Netscape web site connected to portions of version 4.04 of the Navigator program. The menus and buttons, known as the "chrome" connect to many pages in many ways. These diagrams, the first of many created in collaboration with Hugh Dubberly of Netscape, established a system for relating menus to pages for the Navigator program during a period of rapid change.

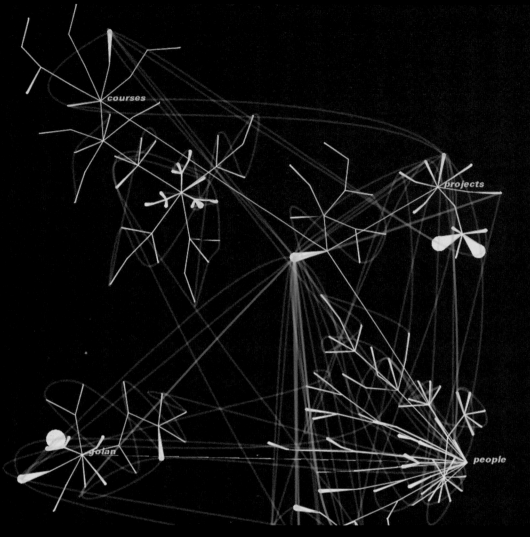

ORGANIC VISIONS OF WEB SITE TRAFFIC

Ben Fry's description of an experimental graph explains the program shown here in three screen shots:

Individual branches (the white parts) grow based on input from the data. As the program is reading the usage log, new branches are grown whenever new parts of the site hierarchy are "discovered" (because they have been visited). This means that the program does not need to continually "crawl" the site for new structure, and that the structure as it exists is built based on what is actually being looked at, regardless of how it is placed on the site. The tips of branches are web pages.

Each time a user hits a page (a "node"), the knob at the tip gets thicker just slightly. If lots of users are hitting a particular section, that group of nodes will collectively thicken, drawing attention to themselves.

This phenomenon can be watched as it propagates back through the site structure, i.e. lots of people come to the site from a link to someone's web page that was in Yahoo, and that traffic can be watched as it propagates outward as some percentage of users become interested in the rest of the site. In addition, these parts "self-regulate". The program is watching for "changes" in usage, and expresses these by fattening the ends of nodes.

To balance this growth is the notion of "atrophy". Branches associated with areas of the site that have not been visited will slowly atrophy, causing them to gradually thin out. Eventually they will "die", and be removed from the system. This reinforces an implicit way to build and modify structure, based on "usage". It is impossible for site tracking software to keep in mind which pages may or may not have been deleted explicitly. The visualization as shown in the pictures uses directory structure instead of link structure for the white areas, then link structure for the orange. The directory structure makes sense and is roughly related to link structure in the particular example (the Aesthetics and Cognition Group

web site) for which the visualization was created. There are problems with this model, of course, as it does not work for all sites. It is a simple matter, however, to switch from directory structure to link structure for the growth of the "tree" (the white area). It's just that things become a little more muddled. User interaction is an important part of the research agenda. The user is able to click nodes to find out what web page they are, and move them around as a way to "peek inside" the data set, to take a closer look at what is happening. Nodes can also be dragged about the screen, to be pinned down and watched relative to other, still-moving, parts.

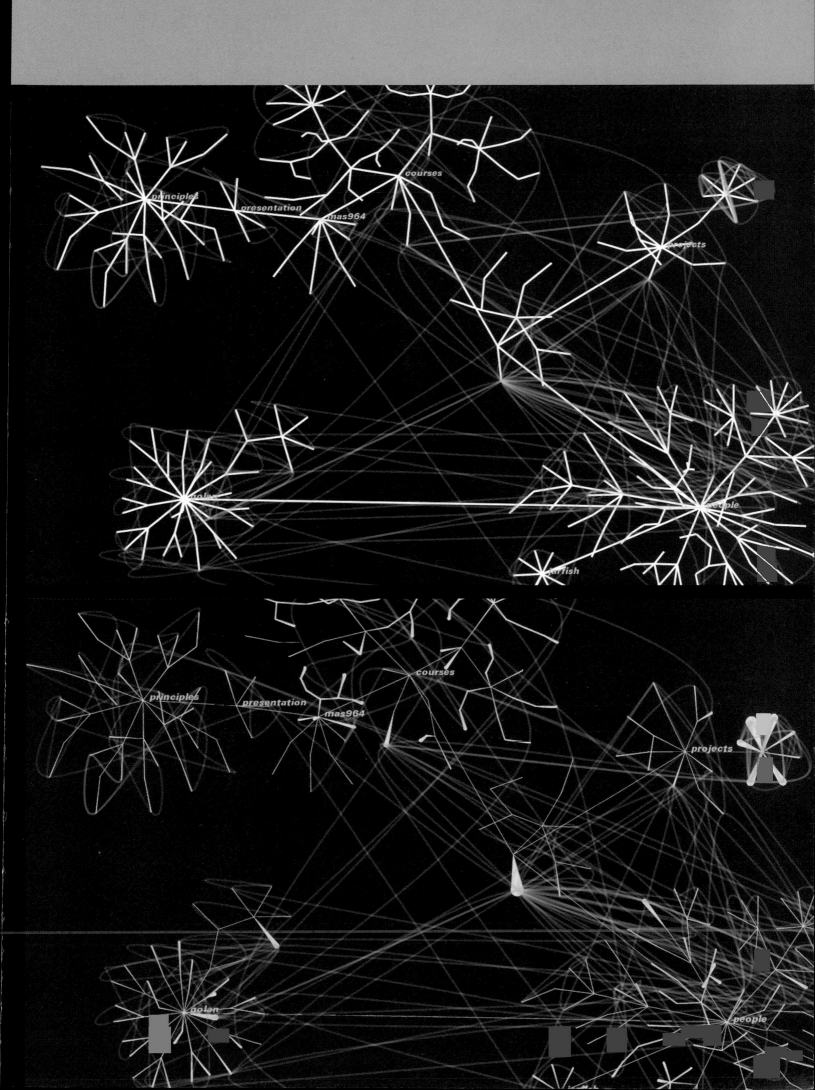

Piotr Kaczmarek: One defense for doing this by hand is that the work is mostly in adjusting the task for what we can show. You are working on certain size paper with a certain density of information, then adjust for that limit. There are so many judgments that you are making, so much custom design.

Krzysztof Lenk: One should avoid too many colors, avoid too many connections. A large part of the design is what we call visual logic. The map is created by grouping parts of a large, complicated structure. We are making a logical use of visual means. We practice the separation of information layers. We decide how to group them into large and smaller units. The technique is driven by the syntax of visual logic. Each of us has our own sense of color. There is a creative aspect in this kind of control. The value is very personalized.

I am reminded of a particular time when we were designing diagrams for Netscape. We had already sent several versions to the project manager. These were being sent by overnight delivery, and they were not always on her desk in the morning. We had some problems with the address and how Netscape was distributing the mail after it arrived. So the next afternoon we called her to check on the delivery. The tube with the diagrams had just arrived as we were on the phone. We could hear them unroll the paper, and then there was a long silence. I was in a panic. "Do you have it," I asked. "Yes, I see it," she replied. "What is your reaction?" I asked. "Oh, it is beautiful," she said. She was a very professional person but her first reaction was aesthetic. She enjoyed it, then we discussed it.

Magdalena Kasman: The biggest fan of the Holtzbrinck diagram is David Durand's seven-year-old daughter, Despina. She just liked the visual pattern and insisted that her parents put one up on her room. While we don't have it down to a programmatic level, we do have a grid, we have a language. We have a drawing program and a repeatable technique.

Krzysztof Lenk: These diagrams are not created from scratch. I created a grid and gave it to Chihiro Hosoe, who in turn gave it to others. Piotr got his from another designer. It is a semi-industrial production process.

Paul Kahn: Still, the system relies on the same cognitive principles as those that determined Jacques Bertin's seven retinal variables in *Semiology of*

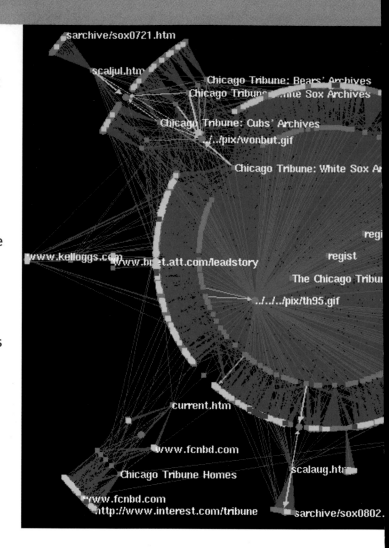

Graphics. Bertin proposes that seven retinal variables can be used to encode visual contrast: size, value, hue, orientation, texture, shape, and position. Maps are built from this language of contrasts. These are the kinds of difference we can see on a map. Each of the variables has its own carrying capacity. Our job is to use them wisely, to balance them.

Piotr Kaczmarek: When we made our maps in school they had no shading, just flat colors to show contours. The old maps had shading. Now the light shading has been reintroduced. This shading appeals to general experience, it does not require the experience of learning how to read. Basing our designs on something that is familiar in the real world like the isometric view works because it uses a technique for organizing space that we already know. We don't have to learn it, we just know it.

sip.gif

go Tribune: Comdex Live: Day 4

al

mailto:JMasek@aol.com
mailto:Achy@aol.com
email2.h m
mailto:Bannt@aol.com
mailto:Jansson435@aol.co
mailto:Fastlede@aol.com

Chicago Tribune: Jordan Archive

0731

homes

homes/homes.htm

NicheWorks
NicheWorks (left) by Graham Wills of Lucent Technologies is a program for visualizing very large graphs. This image is taken from a visualization of the Chicago Tribune web site. Such graphing techniques can be used in large data mining applications.

Illustrating Our Application of Bertin's Variables
The figure below shows how size, position, value, and shape – four of Bertin's seven "retinal variables" – are used in a fragment of the Healthwatch diagram (see pp. 128–129).

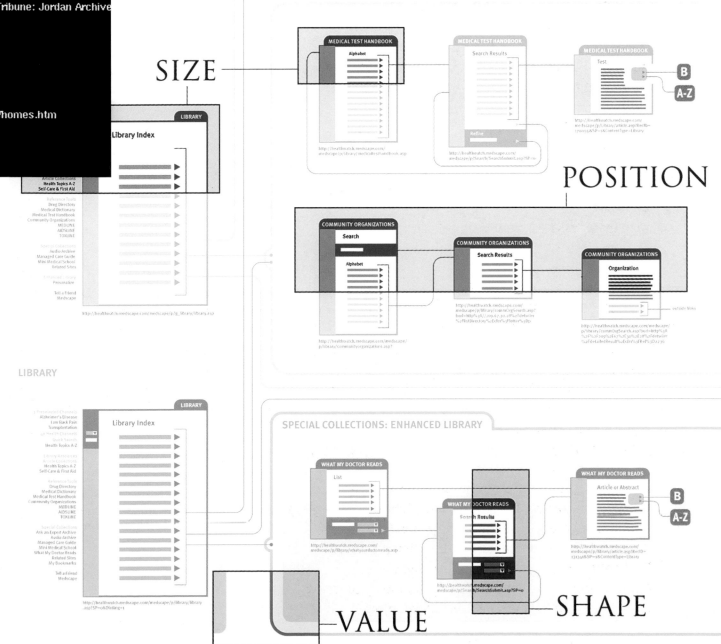

Glossary

TERM	MEANING
Axonometric projection	A method of graphic representation in which figures are drawn with horizontal and vertical axes to scale, but with curved lines and diagonals distorted. For example: Z-diagrams.
Bandwidth	A figure assigned representing the amount of data that can be passed along a communications channel during a given period of time. The relative bandwidth will affect the speed with which web pages appear on different systems.
Browser	A progamme which allows the user to see and retrieve files from the World Wide Web, by displaying HTML files and associated graphics and applications.
Click depth	A term used to indicate the number of mouse clicks needed to reach a stored page, thereby assigning it a hierarchical level. The click depth of a page demonstrates the distance of information from the Home Page, the logical point of entry.
Code	Instruction in a computer programming language which is compiled or interpreted into an application.
Data-driven site maps	A map of a site compiled predominantly from the arrangement of the information it contains, and usually for the specific purpose of displaying the location and retrieval mechanism for that information.
Diagrams	A plan or outline that simplifies and clarifies the location and nature of information, and explains the interrelation of that data with the pages around it.
DBMS (Database Management System)	Software system implemented to administer and regulate a collection of digital information.
DHTML (Dynamic HTML)	Newer version of standard computer language, which fuses Javascript with HTML and allows for an increase in interactive features within the browser program.
Euclidean geometry	Geometric principles, as concocted by Euclid, based on planar and spatial relationships. It is generally accepted as the geometry of common, 3D experience. N.B. NON EUCLIDEAN GEOMETRY is especially divergent in that it contravenes the principles of parallel lines.
Glyph	A symbol or figure that imparts non-verbal information.
Hierarchy	The organization of information whereby certain data is assigned a more prominent position. It is thereby rendered "above", containing or governing other data, as in the more traditional understanding of hierarchy. An example is a directory hierarchy, where each directory may contain other files or further directories.
Hypertext	An interactive system of connecting and retrieving text and other digital information, which allows for information to be extensively cross-referenced. Hypertext systems are interactive through direct manipulation of easily accessible data objects, such as clicking on words or pictures.
Interactive	When communication is bilateral, direct and continual between the user and a computer program. N.B. The opposite of interactive is a batch program where the user submits a request and data to a program and then returns after a period of time when the data has been processed.
Interface	The point of interaction or communication between the computer and the user, usually referring to the screen and the information and graphics displayed upon it.
Java applet	A small application written in Java language which automates one or a few simple functions.
Java	A cross-platform computer language which allows the user to write a single application that can be run on many computers from a web page displayed in a browser.

TERM	MEANING
Javascript	A scripting language interpreted by most web browsers, embedded in the HTML code of a web page.
Link	The means by which hypertext connects pages of data, text or graphics. In the context of the web, a navigational connection between two web pages.
Metadata	Data that provides information about or documentation of information, usually managed within the same application or environment.
Navigation	The way by which a web user understands his or her position, locates pages upon which relevant data is stored, and moves toward that data in abstract space.
Netscape	Shorthand for Netscape Communicator or Navigator, a commercial browser formerly made by Netscape Communications Corporation, now AOL Netscape.
Node-linked diagram	A map which assigns pages of information as nodes, plots them in space and demonstrates their inter-connection with branching links.
Projection	A system of intersecting lines, such as a grid, by which an area is represented as a plane surface.
Schematics	A simplified diagram which represents information through symbols.
SGML (Standard General Markup Language)	International standard language for encoding text with descriptive markers, such as layout and structure, which can be then manipulated to be viewed in any format.
Site map	An attempt to describe the abstract space of a group of pages and their relationships through a diagrammatic representation.
Space	The abstract dimensions communicated on the flat surface of the interface. Spatial applications for the web can be particularly useful for maps of web sites as in axonometric diagrams which mimic real 3D space, in an attempt to orient the user within the site. The web also uses an abstract sense of space in that physical place is less relevant than relationships and connections, making it difficult to grasp in 3D experience.
Tag	A label format used in HTML and SGML to distinguish data to be interpreted from data to be displayed. This is done using a sequence of characters in a markup language used to provide information, such as formatting or structure specifications about a document.
Two-and-a-half D	A computer graphic term which describes the use of screen space to render depth with strategic distortion, without the use of vanishing-point perspective. Architecturally height is shown along parallel lines, with no vanishing point. When the viewpoint is elevated, information can be seen in rich detail, but with an economy of space.
URL (Universal/Uniform Resource Locator)	The address, given through alphabetical letters, numbers, and/or symbols of any page on the World Wide Web.
Vector information	Information which is graphically represented using outlines.
Web master	A person who designs, develops, markets and/or maintains web sites.
Web site	A series of pages linked together with coherence of producer, and/or purpose.
Web walker	A programme which gathers information from a web site by systematically reading the content of pages as they are discovered.
Z-factor	Web site diagrams which use isometric perspective.

Bibliography

Andrewes, William J.H., ed. *The Quest for Longitude: The Proceedings of the Longitude Symposium, Harvard University, Cambridge, Massachusetts, November 4–6, 1993*. Cambridge, Mass.: Collection of Historical Scientific Instruments (Harvard University), 1996.

Bateson, Gregory. *Steps to an Ecology of Mind: Collected Essays in Anthropology, Psychiatry, Evolution, and Epistemology*. Chicago: University of Chicago Press, 2000.

Bertin, Jacques. *Semiology of Graphics*. Madison, Wis.: The University of Wisconsin Press, 1983.

Conklin, Jeff. "Hypertext: An Introduction and Survey," *IEEE Computer*, 20, September 9, 1987.

Durand, David, and Paul Kahn. "MAPA: A System for Inducing and Visualizing Hierarchy in Websites." In *Proceedings of the Ninth ACM Conference on Hypertext and Hypermedia: Links, Objects, Time and Space-Structure in Hypermedia Systems*, 66–76. New York, N.Y.: Association for Computing Machinery, 1998.

Engelbart, Douglas. "Augmented Knowledge Workshop" video, 82 minutes, 1986.

Fleming, Jennifer. *Web Navigation, Designing the User Experience*. Cambridge, Mass.: O'Reilly, 1998.

Harvey, P.D.A. *The History of Topographical Maps, Symbols, Pictures and Surveys*. London: Thames and Hudson, 1980.

Hodgkiss, A.G. *Understanding Maps, A Systematic History of their Use and Development*. Folkestone, England: W.M. Dawson & Son, 1981.

Kahn, Paul, and Nicole Yankelovich. "Intermedia: A Retrospective" video, 1990.

Kahn, Paul, Krzysztof Lenk and Magdalena Kasman. "Real Space and Cyberspace, A Comparison of Museum Maps and Electronic Publication Maps." In *Museum Interactive Multimedia 1997: Cultural Heritage Systems Design and Interfaces*, D. Bearman and J. Trant, eds. Pittsburgh: Archives & Museum Informatics, pp. 99–113.

Kahn, Paul, and Krzysztof Lenk. "Principles of Typography for User Interface Design." In *Interactions*, Vol 6. November & December 1998, pp. 15–29.

Lamping, John, Ramana Rao and Peter Pirolli. "A Focus+Context Technique Based on Hyperbolic Geometry for Visualizing Large Hierarchies." In *Conference Proceedings on Human Factors in Computing Systems*, 401. New York, N.Y.: Association for Computing Machinery, 1995.

Landow, George P., *Hypertext 2.0: The Convergence of Contemporary Critical Theory and Technology*. Baltimore: Johns Hopkins University Press, 1997.

Landow, George P., ed. *Writing At The Edge*. Watertown, Mass.: Eastgate Systems, 1995.

McKelvey, Roy. *Hypergraphics*. Hove: RotoVision, 1998.

Mok, Clement. *Designing Business, Multiple Media, Multiple Disciplines*. Indianapolis: Macmillan Computer Publishing, 1996.

Müller-Brockmann, Josef. *A History of Visual Communication*. Teufen, Switzerland: Arthur Niggli, 1971.

Mullet, Kevin, and Darrell Sano. *Designing Visual Interfaces: Communication Oriented Techniques*. Englewood Cliffs, N.J.: Prentice Hall PTR, 1995.

Nelson, Ted. *Computer Lib/Dream Machines*. Redmond: Microsoft Press, 1987.

Ronan, Colin A. *Science: Its History and Development Among the World's Cultures*. New York, N.Y.: Facts On File Publications, 1982.

Rosenfeld, Louis, and Peter Morville. *Information Architecture for the World Wide Web*. Cambridge, Mass.: O'Reilly, 1998.

Southworth, Michael, and Susan Southworth. *Maps: A Visual Survey and Design Guide*. Boston: Little, Brown and Company, 1982.

Trigg, Randall H., and Peggy M. Irish. "Hypertext Habitats: Experience of Writers in NoteCards." In *Hypertext '87 Proceedings*, 89–108. New York, N.Y.: Association for Computing Machinery, 1989.

Tufte, Edward. *Envisioning Information*. New Haven: Graphics Press, 1990.

Utting, Kenneth, and Nicole Yankelovich. "Context and Orientation in Hypermedia Networks." In *ACM Transactions on Information Systems 7*. 58–84, 1989.

Webs!te Graphics Now. Douglas, Noel, Geert J. Strengholt, and Willem Velthoven, eds. London: Thames and Hudson, 1999.

Wildbur, Peter, and Michael Burke. *Information Graphics: Innovative Solutions in Contemporary Design*. London: Thames and Hudson, 1998.

Wurman, Richard Saul. *Information Architects*. Peter Bradford, ed. New York, N.Y.: Graphis, 1996.

Acknowledgements

This book began as a seminar on web site maps in the fall of 1996. We began to assemble it in the spring of 1999 and it has taken over a year to complete. During this time many people have helped the authors identify and locate imaginative and useful examples of site maps on the web. Many of these same people have helped make this book possible by offering further suggestions and comments on the material in written form. While we are certain we cannot recall everyone who has helped us in this regard, we would like to single out several individuals who have given us more than we can repay.

Peter Bradford's challenging dialog helped to develop the early Z-diagrams. John Thackara's innovative workshop on Knowledge Mapping at the Netherlands Design Institute helped push these ideas along. Gong Szeto provided many pointers to interesting examples on the web. Martin Dodge, the editor of the wonderful Atlas of Cyberspace web site (www.geog.ucl.ac.uk/casa/martin/atlas/), provided constant examples, encouragement, and constructive criticism of the work in progress. We were given opportunities to present our work at many conferences. We would like to thank Charles Altschul, Doris Mitsch, and Justine Jentes of American Center for Design, Peter Simlinger of the International Institute for Information Design, Richard Saul Wurman of TED, and Mark Walter of Seybold Seminars for these opportunities.

Many of our colleagues in other design companies and research institutions gave generously of their time and expertise. We would like to thank Randy Trigg of Xerox PARC, Ramana Rao of Inxight, Neil Budde of the Interactive Wall Street Journal for talking with us and answering our questions. Isabel Ancona of Studio Archetype New York (now Sapient Corporation) provided case study material. Marta Pasiek of kognito Visuelle Gestaltung Berlin provided images of planning maps. Ben Fry of the MIT Media Lab's Aesthetics and Cognition Group provided images from his thesis work.

We owe a great debt of gratitude to our clients, those people who challenge, inspire, and employ us. Carol Moore of the IBM Internet Program provided unflagging support for the development of MAPA. Stefan von Holtzbrinck, Nick Kemp and Mary Waltham of the Nature Publishing Group helped us develop these ideas. Evelyn Sasmor of McGraw-Hill has given us opportunities to apply our technique in many projects. Hugh Dubberly's pressing questions and expansive assignments pushed our understanding to new regions of visual communication.

The work at Dynamic Diagrams has been made possible by people of enormous talent and dedication. All of the work collected here is a matter of collaboration, and the number of designers and analysts who have worked on the images shown in this book includes: Elaine Froehlich, Chihiro Hosoe, Tim Roy, Kerry Fishback, Nathan Kendrick, Jack Lenk, Nancy Birkhölzer, Piotr Kaczmarek, James Wynn, Christian Nagelstrasser and Azusa Hino. The programmers who made MAPA work were David Durand, Matthew Ayers, and Andrew Gilmartin. Sheila Shovelton, Gwen Jones, Neela Chattopadhyay-Vermeire, and Emma Hynes have worked to make this book a reality. Magdalena Kasman, more than any other colleague and friend, has encouraged, edited, assembled, and cajoled this book into existence.

Finally we would like to thank Angie Patchell and Brian Morris of RotoVision for making this possible. We hope our effort repays their generous patience and support.

Paul Kahn & Krzysztof Lenk, June 2000

Credits

CHAPTER 1

Educational Testing Service Network analysis diagram, Dynamic Diagrams for ETS. **pp. 8/9**
Three Home Pages: www.ets.org **pp. 8/9**
Process of perception, Process of creation/production, Dynamic Diagrams **pp. 10/11**
Process of communication, Dynamic Diagrams **pp. 12/13**
Map of www.bfdg.com, Jennifer M. Chan, Rhode Island School of Design **pp. 14/15**

CHAPTER 2

Map of Mecklenburg West Pomerania, Facts About Germany CD ROM, Dynamic Diagrams for Siemens Nixdorf Information Systems. **pp. 16/17**
Calculating latitude, from Cosmographia (1539) by Peter Apian. **pp. 16/17**
TO Map, from *Orbis Brevorium* **pp. 18/19**
World Map from Ptolemy's *Geographia*, Ulm 1482 **pp. 18/19**
Cartia Themescape, www.cartia.com **pp. 18/19**
Global Projections of the European Renaissance by Norman J.W. Thrower, in Andrewes (ed.) *The Quest for Longitude*, Harvard, 1996 **pp. 20/21**
Tokyo Train Map, Richard Saul Wurman, Tokyo Access Guide, **pp. 20/21**
Satiric Map of Europe, Hadol 1870 **pp. 20/21**
Harrison's Online planning diagram, Dynamic Diagrams for McGraw-Hill **pp. 22/23**
Ile de la Cité looking east from Pont Neuf from Michel Turgot's plan of Paris, 1734. **pp. 22/23**
Nuremberg Map, Erhard Etzlaub, early 16th century **pp. 24/25**
Merzscope Map of Kunst- und Ausstellungshalle der Bundesrepublik Deutschland, www.kah-bonn.de **pp. 24/25**
London Underground Map, Harry Beck, 1933. **pp. 24/25**

CHAPTER 3

Map of "Adam's Bookstore" by Adam Wenger, from *Writing at the Edge*, edited by George Landow, Eastgate Systems, 1995. **pp. 26/27**
Stills from NLS video, Douglas Engelbart, 1968 **pp. 28/29**
NoteCards browser card, from "Hypertext Habitats: Experience of Writers in NoteCards" by Randall H. Trigg and Peggy M. Irish, *Hypertext '87*. **pp. 28/29**
Stills from Xerox NoteCards video, 1987. **pp. 30/31**
Stills from Intermedia: A Retrospective video, 1990.
Screen shot of *The Dickens Web*, edited by George Landow
Global map, Intermedia, from "Hypertext: An Introduction and Survey," by Jeff Conklin, *IEEE Computer*, 20, 9 Sept. 1987. **pp. 32/33**

CHAPTER 4

Analysis of Netscape Software Download Area, Dynamic Diagrams for Netscape Communications Corp. **pp. 34/35**
Britannica Online analysis diagram, 1996, Dynamic Diagrams for Encyclopedia Britannica **pp. 36/37**
Britannica Online new architecture diagram, 1996, Dynamic Diagrams for Encyclopedia Britannica **pp. 36/37**
Britannica Online site map, 1997, Dynamic Diagrams for Encyclopedia Britannica, www.eb.com **pp. 36/37**
Nature web site overview diagram, Dynamic Diagrams for Nature Publishing Group **pp. 38/39**
Nature article diagram, Dynamic Diagrams for Nature Publishing Group **pp. 38/39**
Revised Nature web site overview diagram, Dynamic Diagrams for Nature Publishing Group **pp. 40/41**
My.Excite.com analysis diagram, Dynamic Diagrams **pp. 42/43**
My.Excite.com analysis diagram (detail), Dynamic Diagrams **pp. 44/45**

My Excite Home Page, www.excite.com **pp. 44/45**
My.Excite.com analysis diagram (detail), Dynamic Diagrams **pp. 44/45**
My Netscape Home Page, my.netscape.com **pp. 46/47**
My Yahoo Home Page, my.yahoo.com **pp. 46/47**
My Lycos Home Page, my.lycos.com **pp. 46/47**
My.Excite.com analysis diagram (detail) , Dynamic Diagrams **pp. 46/47**
My.Excite.com analysis diagram (detail), Dynamic Diagrams **pp. 48/49**
West's Legal News Home Page, www.wln.com **pp. 50/51**
West's Legal News page diagram, Dynamic Diagrams for West Publishing **pp. 50/51**
West's Legal News overview diagram, Dynamic Diagrams for West Publishing **pp. 50/51**
Product marketing overview diagram, Dynamic Diagrams for Merrill Lynch **pp. 50/51**
Product marketing prototype page, Dynamic Diagrams for Merrill Lynch **pp. 50/51**

CHAPTER 4, CASE STUDY 1

AccessScience screen shot, www.accessscience.com, Dynamic Diagrams for McGraw-Hill **pp. 52/53**
EST overview, Topic page, and Article page diagrams, Dynamic Diagrams for McGraw-Hill **pp. 52/53**
EST Print / CD ROM / Online process diagram, Dynamic Diagrams for McGraw-Hill **pp. 52/53**
AccessScience screen shot, www.accessscience.com, Dynamic Diagrams for McGraw-Hill **pp. 54/55**
EST overview diagram, Dynamic Diagrams for McGraw-Hill **pp. 54/55**
AccessScience screen shot, www.accessscience.com, Dynamic Diagrams for McGraw-Hill **pp. 56/57**
AccessScience Site Map, Dynamic Diagrams for McGraw-Hill **pp. 56/57**
AccessScience Subscriber Home Page, Dynamic Diagrams for McGraw-Hill **pp. 56/57**
AccessScience screen shot, www.accessscience.com, Dynamic Diagrams for McGraw-Hill **pp. 58/59**
EST Topic page diagram, Dynamic Diagrams for McGraw-Hill **pp. 58/59**
AccessScience Topic page design, Dynamic Diagrams for McGraw-Hill **pp. 58/59**

AccessScience screen shot, www.accessscience.com, Dynamic Diagrams for McGraw-Hill **pp. 60/61**
EST Article page diagram, Dynamic Diagrams for McGraw-Hill **pp. 60/61**
AccessScience Article page designs, Dynamic Diagrams for McGraw-Hill **pp. 60/61**

CHAPTER 4, CASE STUDY 2

Kasparov vs. Deep Blue screen shot, www.research.ibm.com/deepblue/, Studio Archetype for IBM **pp. 62/63**
Kasparov vs. Deep Blue web site concept map, Studio Archetype for IBM **pp. 62/63**
Kasparov vs. Deep Blue screen shot, www.research.ibm.com/deepblue/, Studio Archetype for IBM **pp. 64/65**
Kasparov vs. Deep Blue site architecture maps, Studio Archetype for IBM **pp. 64/65**
Kasparov vs. Deep Blue screen shot, www.research.ibm.com/deepblue/, Studio Archetype for IBM **pp. 66/67**
Kasparov vs. Deep Blue main event site maps, Studio Archetype for IBM **pp. 66/67**
Kasparov vs. Deep Blue page wireframes, Studio Archetype for IBM **pp. 66/67**
Kasparov vs. Deep Blue page wireframes, Studio Archetype for IBM **pp. 68/69**
Kasparov vs. Deep Blue system diagram, Studio Archetype for IBM **pp. 68/69**

CHAPTER 5

YELL site map, British Telecom Yellow Pages, www.yell.co.uk **pp. 70/71**
L.L. Bean site map, L.L. Bean, www.llbean.com **pp. 72/73**
Adobe site maps, Adobe Systems, www.adobe.com **pp. 72/73**
Boeing site maps, Boeing Corp., www.boeing.com **pp. 74/75**
The Gap site map, The Gap, www.gap.com **pp. 74/75**
Netcenter site map, AOL Netscape, home.netscape.com **pp. 74/75**
CNN Interactive, CNN.com site maps, www.cnn.com **pp. 76/77**
Macromedia site maps, Macromedia, www.macromedia.com **pp. 78/79**
Macromedia site maps, Macromedia, www.macromedia.com **pp. 80/81**